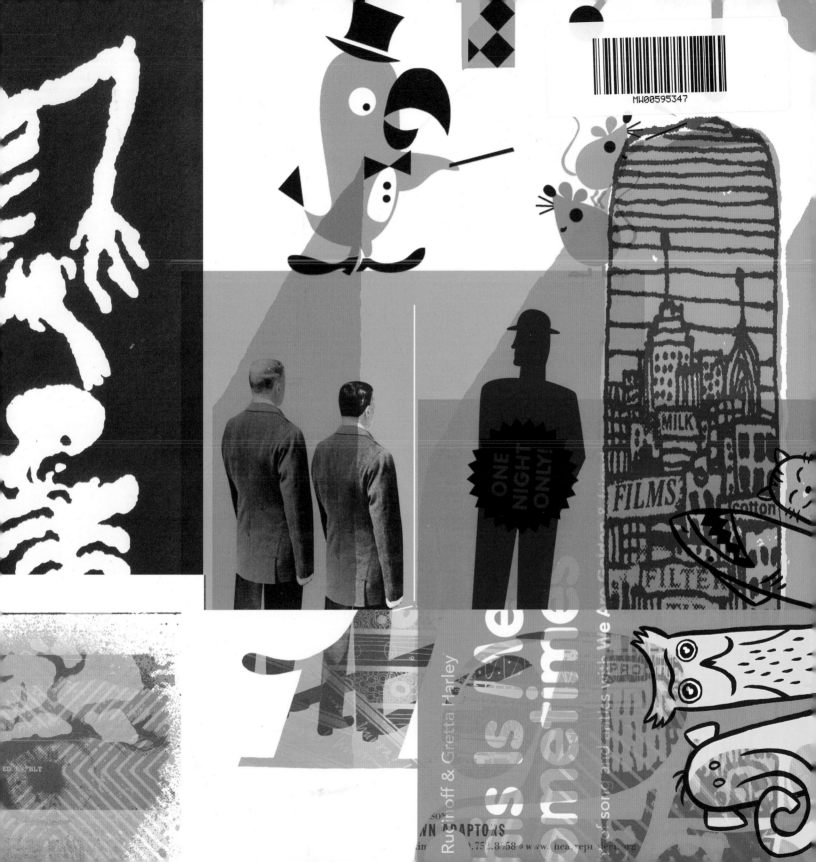

10

JOHN FOSTER

1000
INDIE
POSTERS

ROCKPORT

First published in the United States of America by

Rockport Publishers, a member of Quayside Publishing Group

100 Cummings Center, Suite 406-L, Beverly, Massachusetts 01915-6101

Telephone: (978) 282-9590

Fax: (978) 283-2742

www.rockpub.com

Library of Congress Control Number 2010933487

ISBN-13: 978-1-59253-656-6

ISBN-10: 1-59253-656-5

10 9 8 7 6 5 4 3 2 1

Design: John Foster, Bad People Good Things LLC

www.badpeoplegoodthings.com

Printed in China

BEVERLY MASSACHUSETTS

ROCKPORT
PUBLISHERS

CONTENTS

...........................

INTRODUCTION

I AM A POSTER JUNKIE. Always have been; always will be. My chief worry in life is which six prints to rotate on my office walls. (At the time of this writing, I have a Pink Panther litho, a Jesse LeDoux, a Haley Johnson, a Seripop, a Lichtenstein, and a Keith Haring, with a Jeff Kleinsmith framed and waiting in the wings.) When I moved my office, not only did I have to transport well over 1,000 prints, but also it was the only thing I was worried about. My love for the poster is unending. I often tell the tale of taking my first studio job based on the abundance of poster work in the portfolio, only to find out that they hadn't done one for nearly a year. I would have to donate my time to local organizations just to bring one in to lavish with my attention. However, that experience would heavily inform my desire to show the rest of the world the wonders being produced.

When I was pitching the book idea for *New Masters of Poster Design* years ago (it should be noted that Rockport Publishers was the only one willing to take the plunge with me), numerous publishers confirmed my worst fears. The poster was considered a dead form of communication and a book compiling them couldn't possibly sell. It seemed as if I was the only one who could see the value in what is arguably the most important medium for design over the last one hundred years. I knew that small outposts had kept the poster alive with amazing work—even if it was mostly being done for tiny clients in an underground fashion. Soon, corporate giants began to adopt the poster as a point-of-sale tool and the music industry replaced many of their pieces of merchandise with perhaps the most personal of all—the gigposter. The email blast and microsite would remain, but it couldn't swallow the large printed sheet shining on our walls.

The poster was back.

Since the publication of *New Masters*, the design world has undergone numerous upheavals, including a huge return to hand-produced work, as well as small and personalized productions. A fascination with archaic printing methods like letterpress and silk-screening, coupled with the pure, unadulterated satisfaction of producing your final piece using your own hands, has built a cottage industry for poster makers. The movie poster has even seen resurgence, as not only have the larger studios produced more challenging visuals, but the drafthouse circuit has commissioned a new set of jaw-dropping visuals. Political messaging continues to push and pull the very best out of the world's designers. Creatives of all stripes can't resist the large format and becoming part of the history of the magical format.

One of the toughest aspects of curating a collection of work is that you have to leave some of your favorite pieces on the sidelines. When I was asked to assemble *1,000 Indie Posters*, I leapt at the chance to put together a fuller snapshot of what is happening in the world of poster design. The funny thing is that I will inevitably have to do the same thing once again. The wealth of work is that great. Pouring out of all corners of the world, posters carry your hopes and dreams, fears and nightmares, joys and jollies. They serve as a mirror, and reflected in their glory is a battalion of inspired souls—so many using it as a vehicle to achieve greatness; so many succeeding.

Just when I think this golden age of the poster has crested, a 100-foot (30.5 m) wave of bracing visuals show me that we are just getting started.

1,000 posters? The next volume might need a million (and someone will still find it lacking). The most challenging design work continues to take place on these simple sheets of paper and there seems to be no end in sight. There is only one thing that I know for certain: The walls of the world are a richer place. Now we can say the same about your bookshelf.

Enjoy.

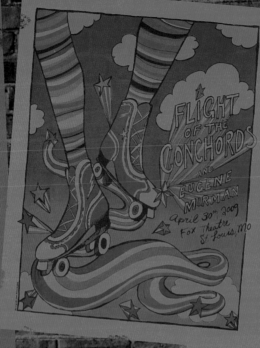

FLIGHT
OF THE
CONCHORDS
AND
EUGENE
MIRMAN
April 30th 2009
FOX Theatre
St Louis, MO

CALIFONE

ALL MY FRIENDS ARE FUNERAL SINGERS
2009 FALL TOUR

2008 / 0
MARGOLIS BR
tre Project ∗ 45 West Preston Street ∗ Ba

16 ~

CYCL

AWOOOOGA BEEP,
BEEP!
HONK

CMON!

HANDMADE, HAND-PULLED

"THE CRAZE THAT'S SWEEPING THE NATION!"

GENUINE

PONZI

STARTER KIT

MAKE FRIENDS

PUBLIC SERVICE MESSAGE no. 02

100

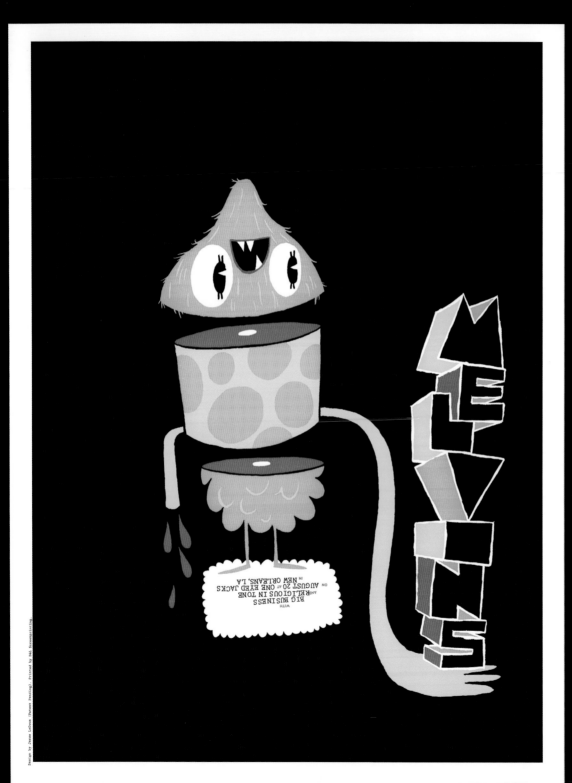

MELVINS

WITH
BIG BUSINESS
AND RELIGIOUS IN TONE
ON AUGUST 20 AT ONE EYED JACKS
IN NEW ORLEANS, LA

Design by Jesse LeDoux (Patent Pending). Printed by D&L Screenprinting

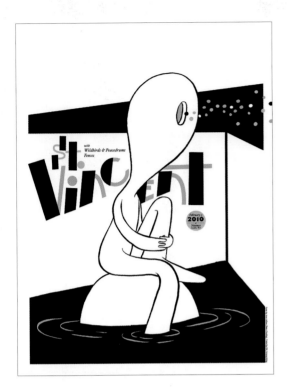

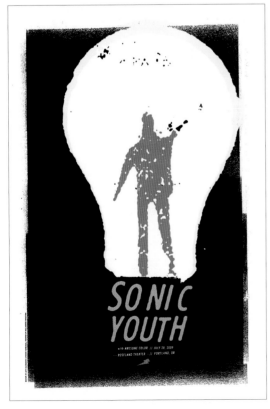

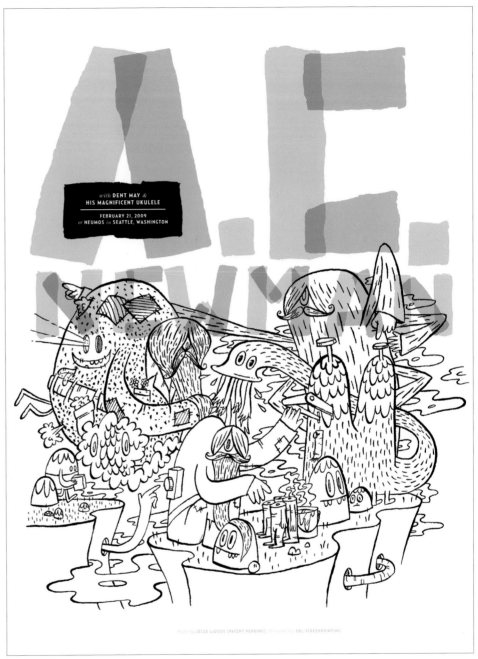

0001—0004 > PATENT PENDING DESIGN

upper left OOO5 > **PATENT PENDING DESIGN**
upper right OOO6 > **DOE EYED DESIGN**
bottom right OOO7 > **LANNY SOMMESE**

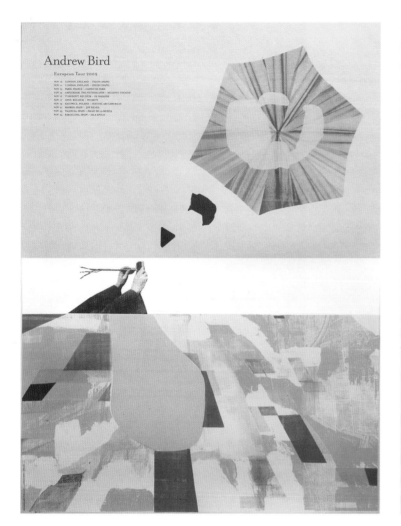

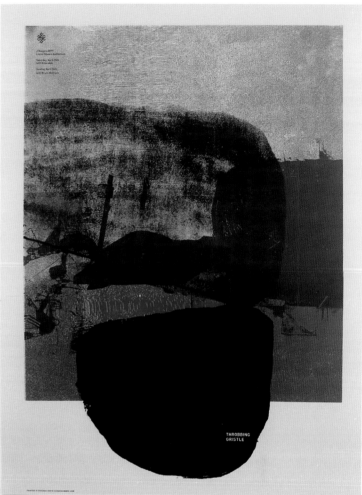

Old Idea

JOSH BERMAN

Performing at

Date

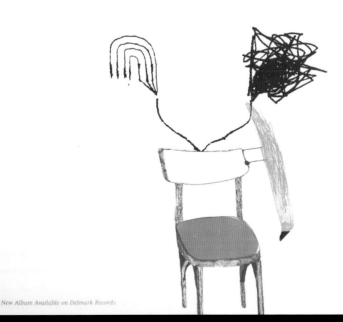

New Album Available on Delmark Records

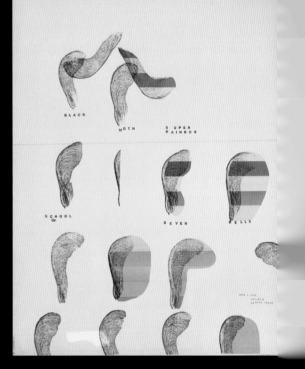

BLACK MOTH SUPER RAINBOW

SCHOOL OF SEVEN BELLS

CANYONS OF STATIC

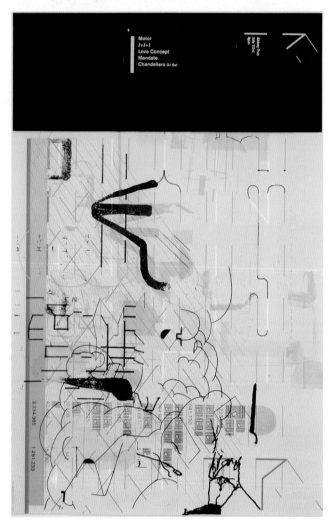

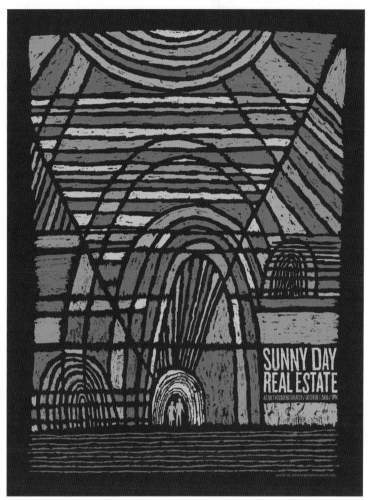

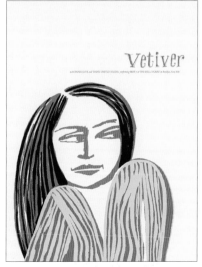

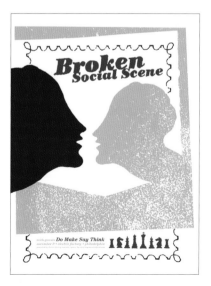

upper left 0013 > **SONNENZIMMER**

right 0014–0016 > **LARGEMAMMAL**

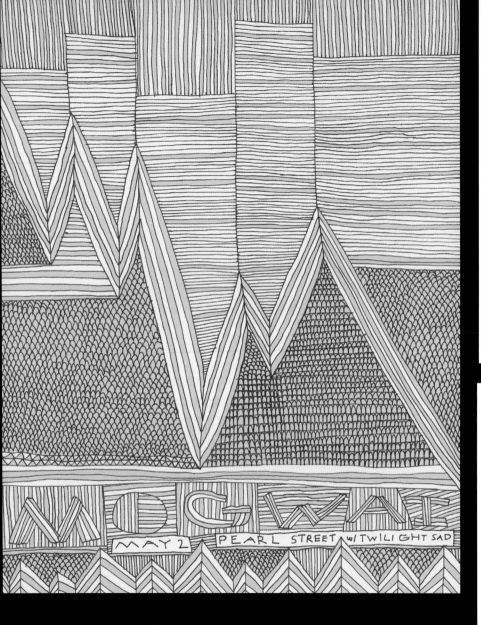

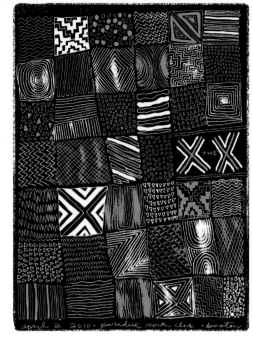

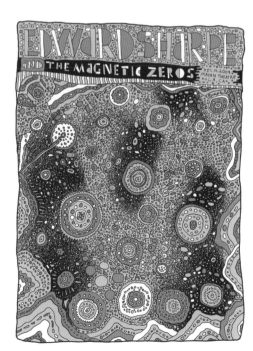

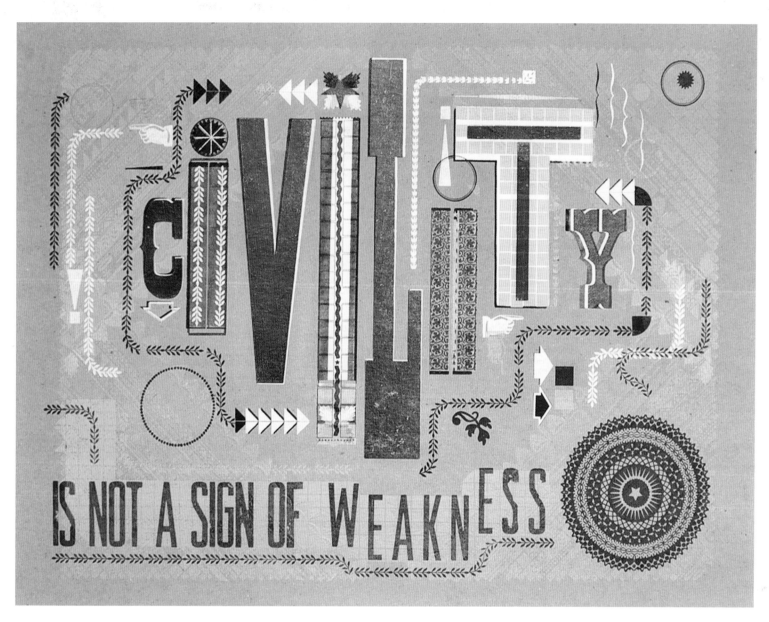

CIVILITY IS NOT A SIGN OF WEAKNESS

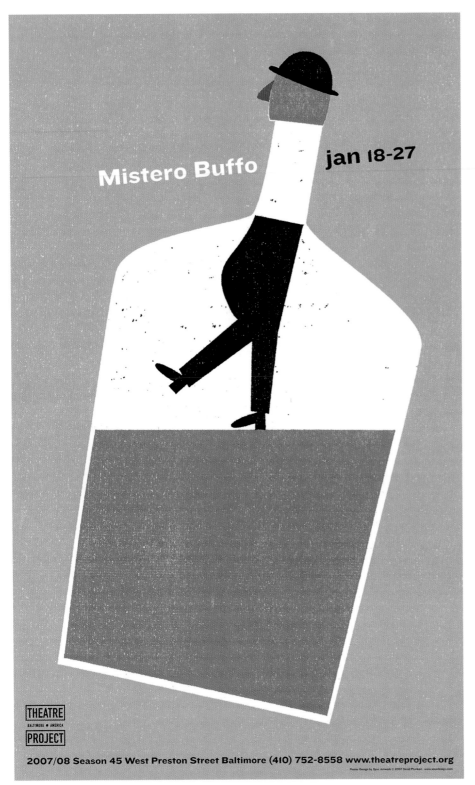

Mistero Buffo jan 18-27

THEATRE
BALTIMORE • AMERICA
PROJECT

2007/08 Season 45 West Preston Street Baltimore (410) 752-8558 www.theatreproject.org

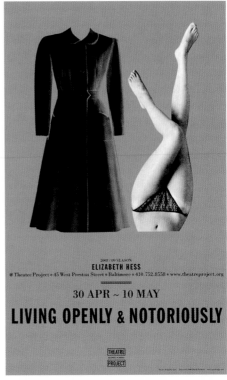

2008/09 SEASON
ELIZABETH HESS
★ Theatre Project ★ 45 West Preston Street ★ Baltimore ★ 410.752.8558 ★ www.theatreproject.org

30 APR ~ 10 MAY

LIVING OPENLY & NOTORIOUSLY

THEATRE
PROJECT

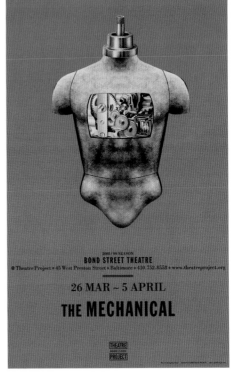

2008/09 SEASON
BOND STREET THEATRE
★ Theatre Project ★ 45 West Preston Street ★ Baltimore ★ 410.752.8558 ★ www.theatreproject.org

26 MAR ~ 5 APRIL

THE MECHANICAL

THEATRE
PROJECT

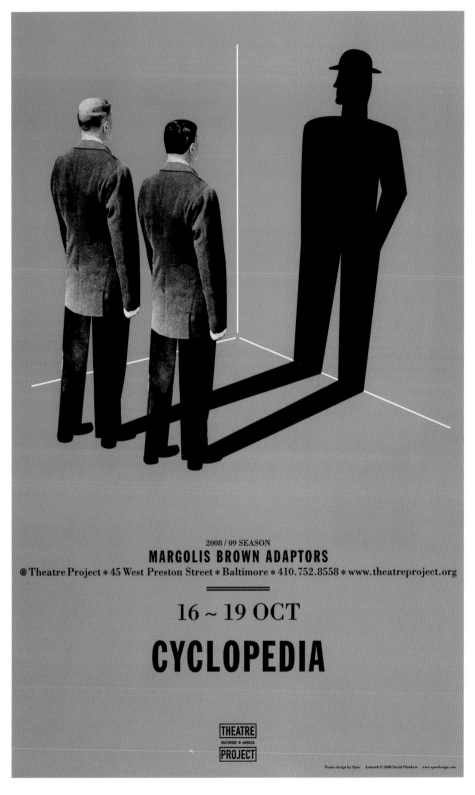

2008 / 09 SEASON
MARGOLIS BROWN ADAPTORS
@ Theatre Project ∗ 45 West Preston Street ∗ Baltimore ∗ 410.752.8558 ∗ www.theatreproject.org

16 ∼ 19 OCT

CYCLOPEDIA

THEATRE
BALTIMORE ∗ AMERICA
PROJECT

Poster design by Spur Artwork © 2008 David Plunkert www.spurdesign.com

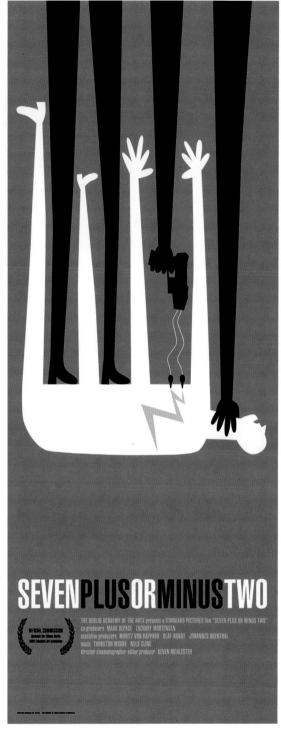

SEVEN PLUS OR MINUS TWO

OFFICIAL COMMISSION
Akademie der Künste Berlin
2008 Animation Art Installation

THE BERLIN ACADEMY OF THE ARTS presents a STANDARD PICTURES film "SEVEN PLUS OR MINUS TWO"
co producers MARK DEPACE ZACHARY MORTENSEN
executive producers MORITZ VON HAPPARD OLAF ARNDT JOHANNES ODENTHAL
music THURSTON MOORE NELS CLINE
director cinematographer editor producer KEVEN McALESTER

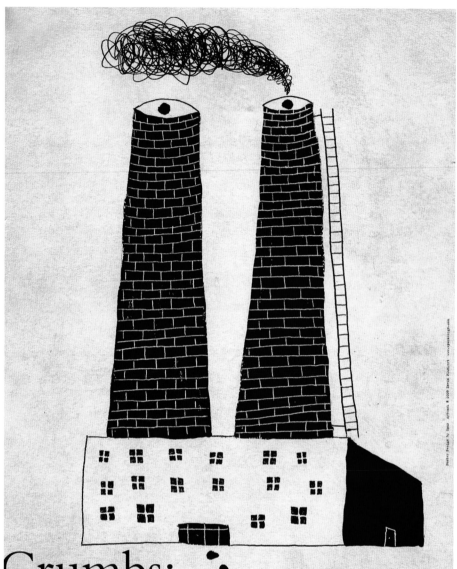

Crumbs:
a possibly true story

Performed by
AL LETSON

● Comedy ● Drama O Dance O Multimedia O Music

THEATRE
BALTIMORE ■ AMERICA
PROJECT

May 10 to 23

2009-2010 SEASON

6 of 6

45 West Preston Street Baltimore MD 410.752.8558 www.theatreproject.org

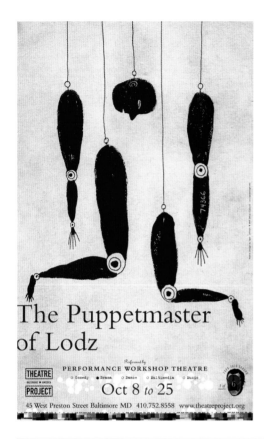

The Puppetmaster of Lodz

Performed by
PERFORMANCE WORKSHOP THEATRE
○ Comedy ● Drama ● Dance ● Multimedia ○ Music
Oct 8 to 25
45 West Preston Street Baltimore MD 410.752.8558 www.theatreproject.org

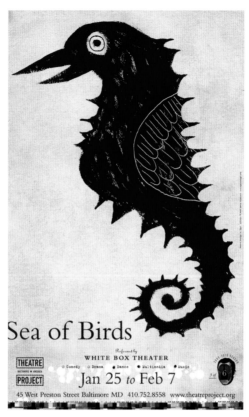

Sea of Birds

Performed by
WHITE BOX THEATER
○ Comedy ○ Drama ● Dance ● Multimedia ● Music
Jan 25 to Feb 7
45 West Preston Street Baltimore MD 410.752.8558 www.theatreproject.org

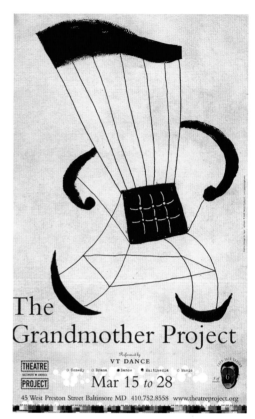

The Grandmother Project

Performed by
VT DANCE
○ Comedy ○ Drama ● Dance ● Multimedia ○ Music
Mar 15 to 28
45 West Preston Street Baltimore MD 410.752.8558 www.theatreproject.org

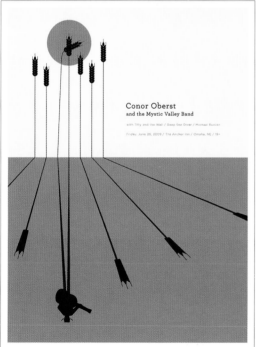

Conor Oberst
and the Mystic Valley Band

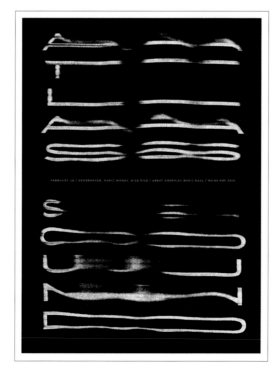

upper 0027—0029 > **SPUR DESIGN**
lower 0030—0031 > **THE SMALL STAKES**

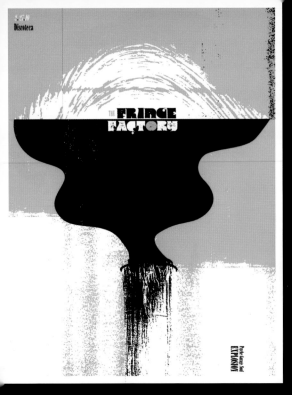

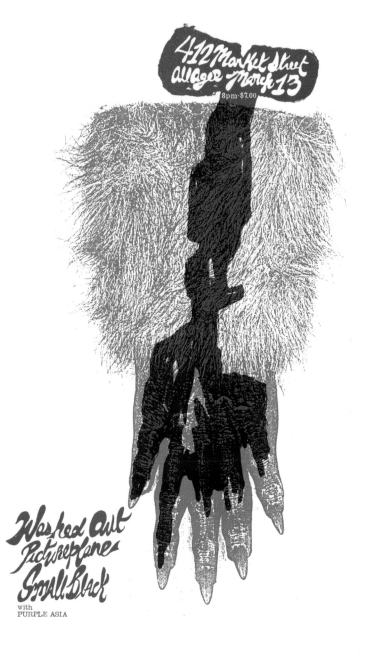

0034–0036 > ZELOOT

CALIFONE

ALL MY FRIENDS ARE FUNERAL SINGERS
2009 FALL TOUR

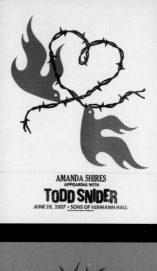

AMANDA SHIRES
APPEARING WITH
TODD SNIDER
JUNE 28, 2007 • SONS OF HERMANN HALL

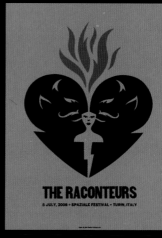

THE RACONTEURS
5 JULY, 2008 • SPAZIALE FESTIVAL • TURIN, ITALY

THE SWELL SEASON

RACHAEL YAMAGATA

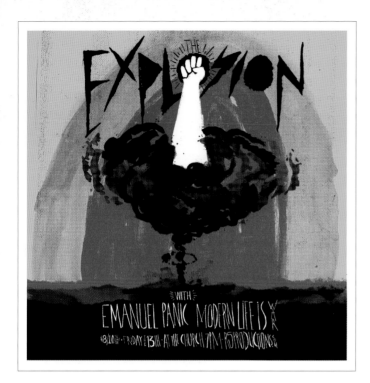

0041–0043 > **TIM GOUGH**

MATES of STATE & black kids

with Sunbears! • April 6 • Webster Hall • NYC

MOTION CITY SOUNDTRACK

WITH MAE • ANBERLIN • METRO STATION • DECEMBER 4 • WILTERN THEATRE

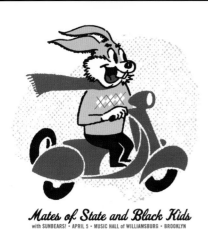

Mates of State and Black Kids

with SUNBEARS! • APRIL 5 • MUSIC HALL of WILLIAMSBURG • BROOKLYN

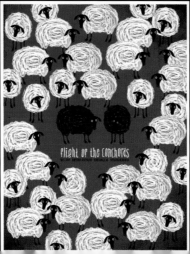

flight of the conchords

0044–0046 > MY ASSOCIATE CORNELIUS
lower right 0047 > TODD SLATER

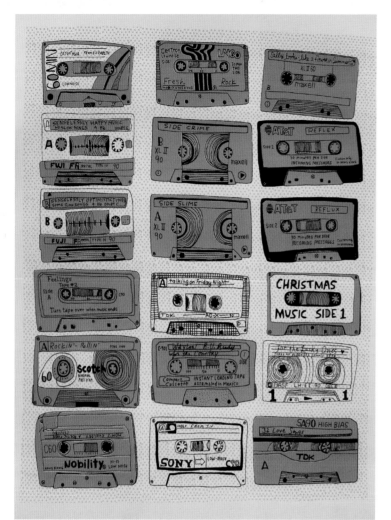
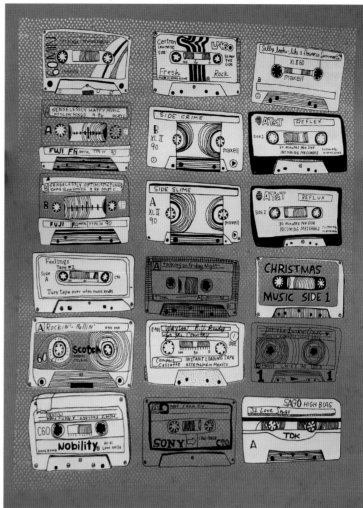

0048–0049 > **KATE BINGAMAN-BURT**

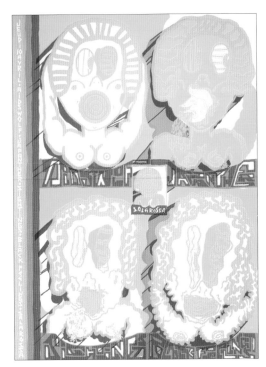

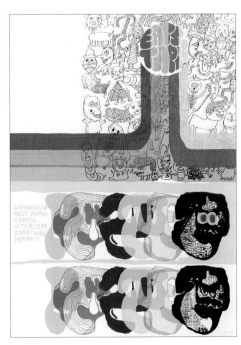
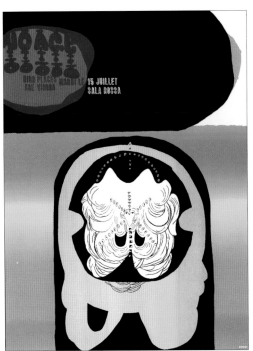

0059–0064 > **SERIPOP**

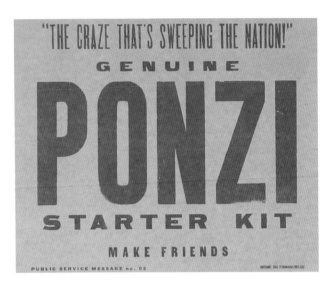

"THE CRAZE THAT'S SWEEPING THE NATION!"
GENUINE
PONZI
STARTER KIT
MAKE FRIENDS
PUBLIC SERVICE MESSAGE no. 02

STORETRY
NO. 140
VOLUME ONE
LUMPY GRAVY
TUESDAY

I CAN'T FIND MY HAIR MOUSSE. THE ROBOTS ARE BACK FROM TIJUANA. THIS REQUIRES MY IMMEDIATE ATTENTION. A HANKY IS NOTHING WITHOUT A PANKY. I NEVER KNOW WHERE I AM GOING TO BE AT 6:00. TAKE A BREAK FROM POETRY AND RUB ME. THERE IS NO P IN AMMUNITION. YOU HAVE TO GO THROUGH A LOT OF PAIN TO BE INTERESTING. THAT EYE-TWITCH OF YOURS REALLY TURNS ME ON. "HEY COWBOY, WHERE'S YOUR HORSE?" WHAT HOMEWRECKER ARE YOU MIXED UP WITH NOW? IT'S ANOTHER FRIENDLY-FIRE DISASTER. I'M EXHIBITING SOME NEW TRANSISTORS AT THE CONVENTION CENTER. I SPEAK A LITTLE ESPANOLE. DID SOMEONE ORDER AN EMOTIONAL PAINTER?

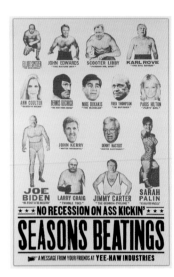

NO RECESSION ON ASS KICKIN'
SEASONS BEATINGS
A MESSAGE FROM YOUR FRIENDS AT YEE-HAW INDUSTRIES

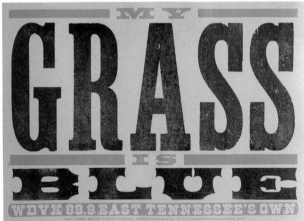

MY
GRASS
IS
BLUE
WDVX 89.9 EAST TENNESSEE'S OWN

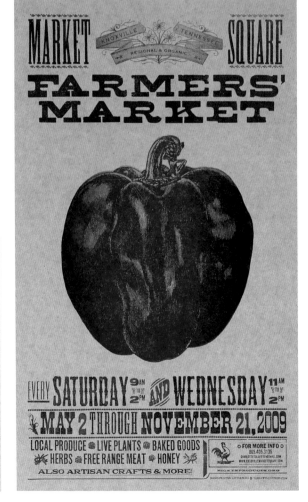

MARKET SQUARE
KNOXVILLE TENNESSEE
REGIONAL & ORGANIC
FARMERS' MARKET

EVERY SATURDAY 9AM TO 2PM AND WEDNESDAY 11AM TO 2PM
MAY 2 THROUGH NOVEMBER 21, 2009
LOCAL PRODUCE • LIVE PLANTS • BAKED GOODS
HERBS • FREE RANGE MEAT • HONEY
ALSO ARTISAN CRAFTS & MORE!
FOR MORE INFO

"KNOXVILLE, TENNESSEE
THE
BERMUDA
TRIANGLE
OF THE
APPALACHIANS"
- R.B. MORRIS

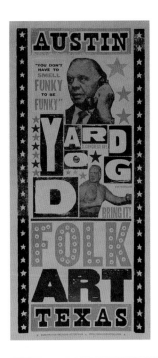

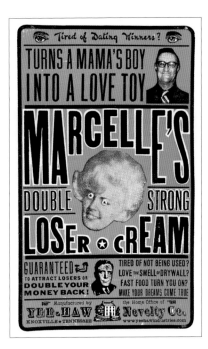

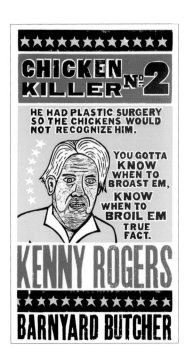

0065–0075 > YEE-HAW INDUSTRIES

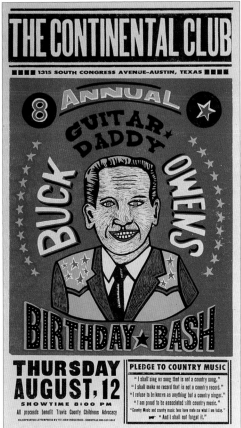

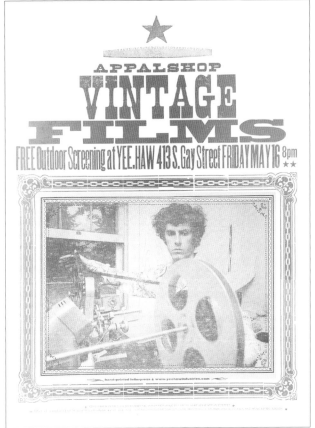

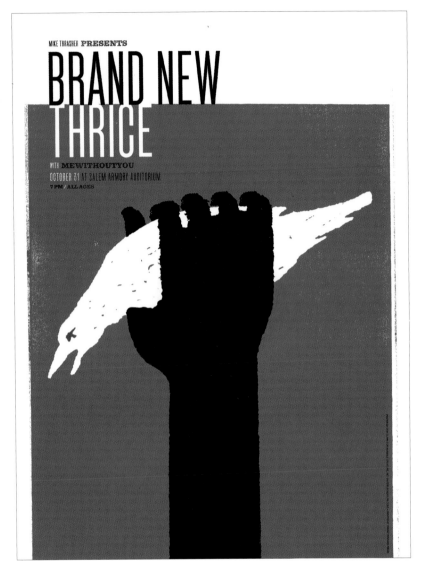

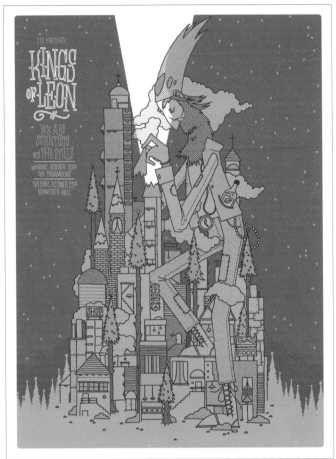

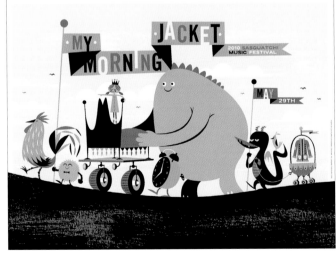

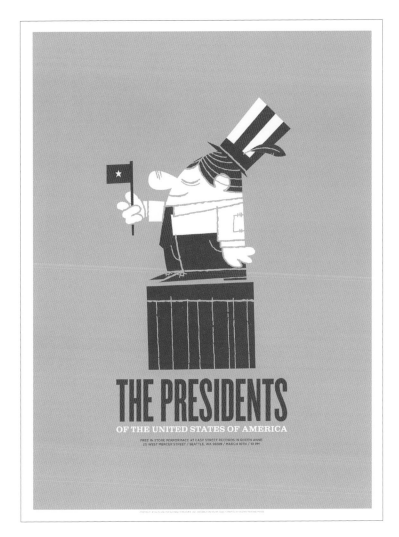

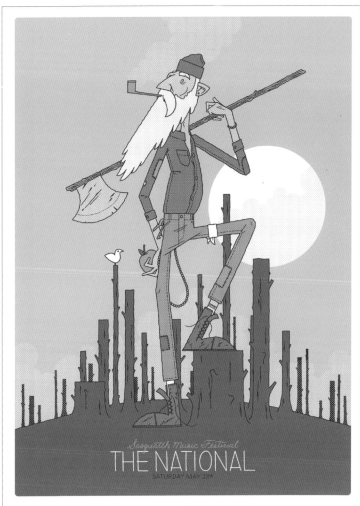

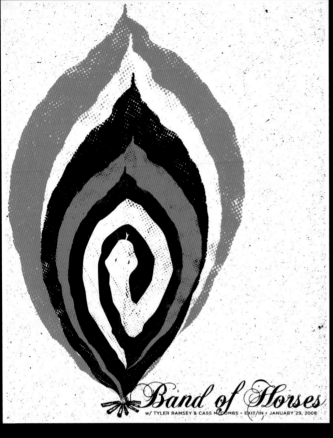

Band of Horses
w/ TYLER RAMSEY & CASS McCOMBS • EXIT/IN • JANUARY 29, 2008

ROGUE WAVE
AVI BUFFALO • JBM • MARCH 9 2010 • MERCY LOUNGE

The Swell Season
with Bill Callahan
September 24, 2008
Ryman Auditorium
Nashville, Tn

HOT CHIP

SEPTEMBER 21 & 22, 2008 with IO ECHO & DRUMS of DEATH at the WILTERN LOS ANGELES, CA
PRESENTED BY LIVE NATION

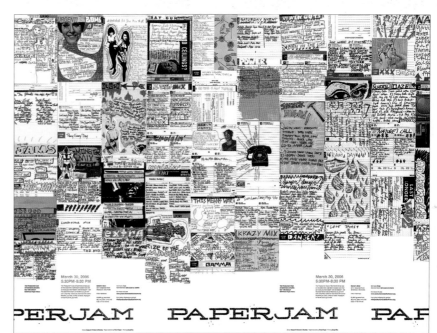

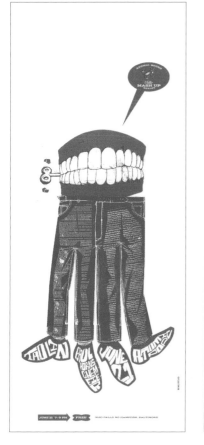

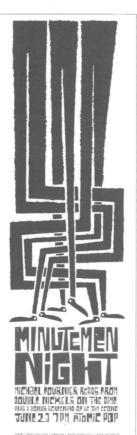

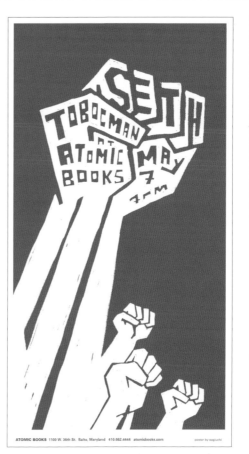

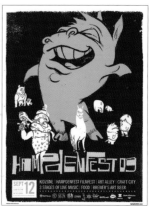

0085–0090 > **EXIT10**

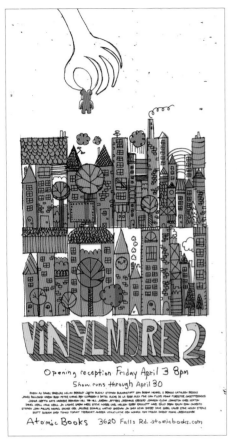

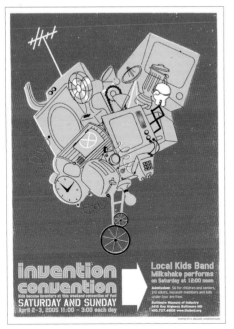

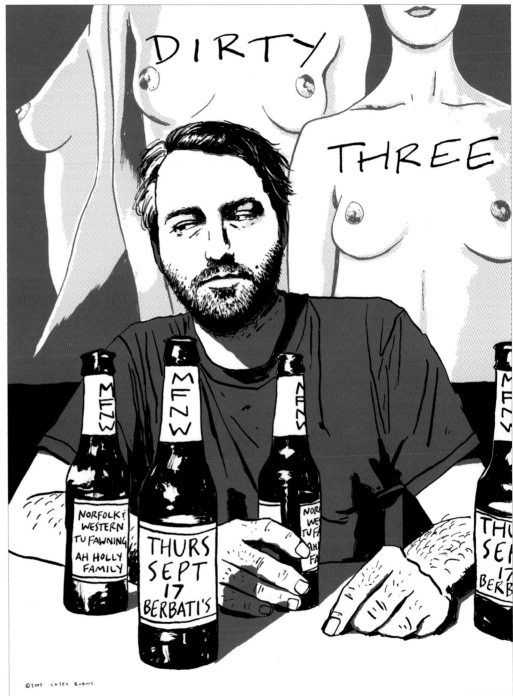

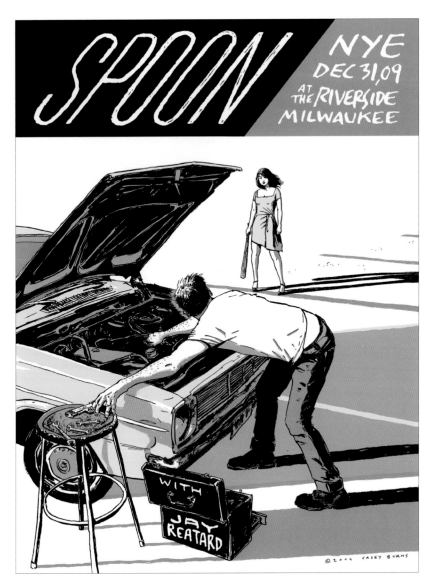

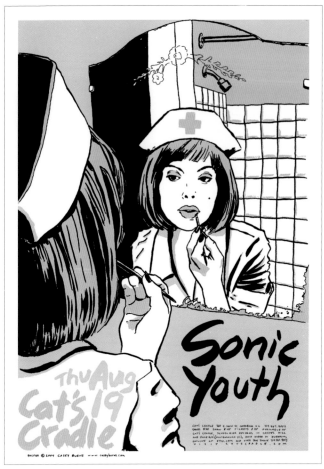

0094–0095 > CASEY BURNS

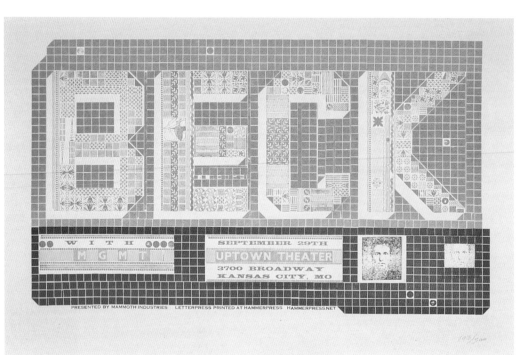

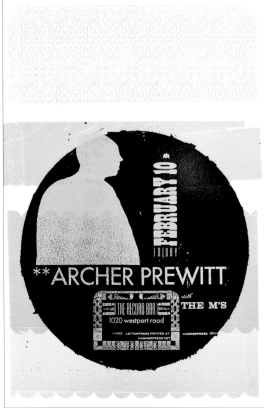

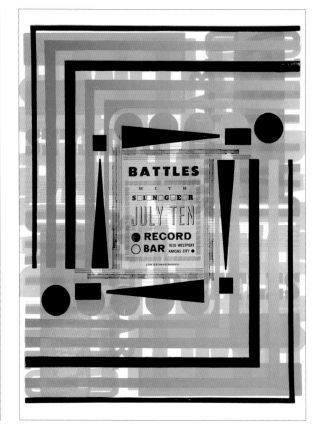

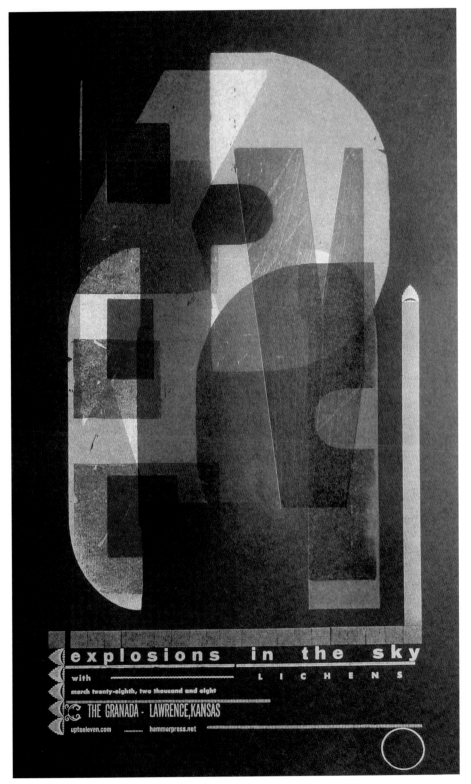

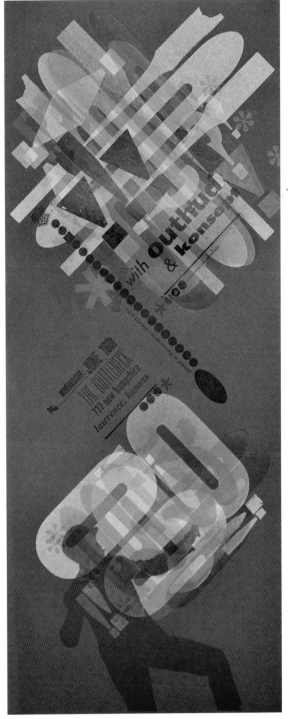

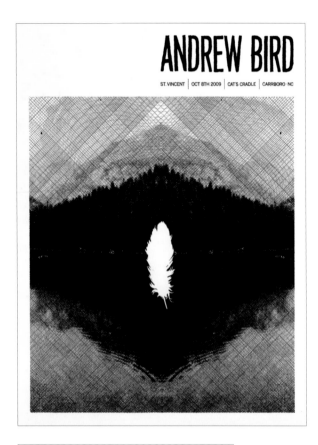

ANDREW BIRD

ST. VINCENT | OCT 8TH 2009 | CAT'S CRADLE | CARRBORO · NC

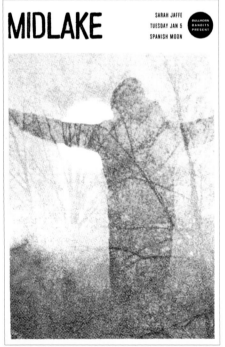

MIDLAKE

SARAH JAFFE
TUESDAY JAN 5
SPANISH MOON

BULLHORN BANDITS PRESENT

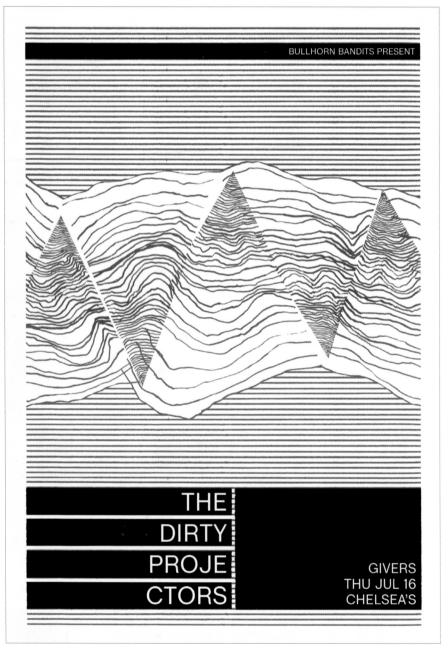

BULLHORN BANDITS PRESENT

THE
DIRTY
PROJE
CTORS

GIVERS
THU JUL 16
CHELSEA'S

0102—0107 > SCOTT CAMPBELL

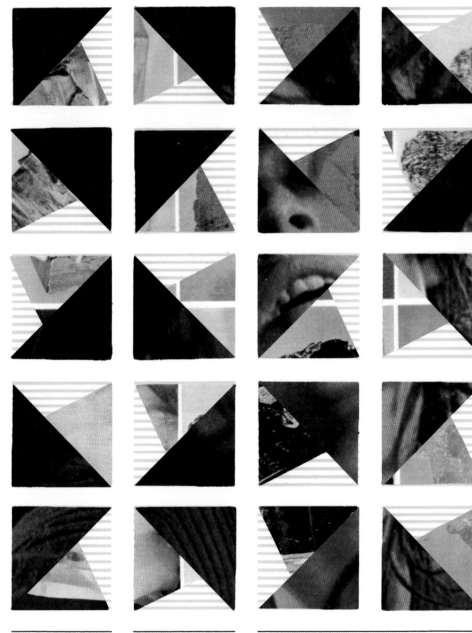

BULLHORN
BANDITS
PRESENT

FRI JAN 22
SPANISH
MOON

CADDYWHOMPUS
MAN PLUS BUILDING
SMILEY WITH A KNIFE

CRYS
TAL

ANTL
ERS

AUDACITY
WED DEC 16
SPANISH MOON

BULLHORN
BANDITS
PRESENT

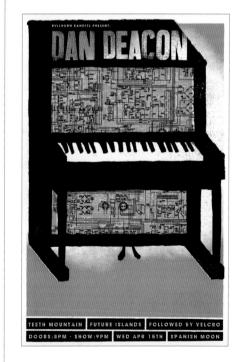

BULLHORN BANDITS PRESENT:

DAN DEACON

TEETH MOUNTAIN | FUTURE ISLANDS | FOLLOWED BY VELCRO

DOORS:8PM · SHOW:9PM | WED APR 15TH | SPANISH MOON

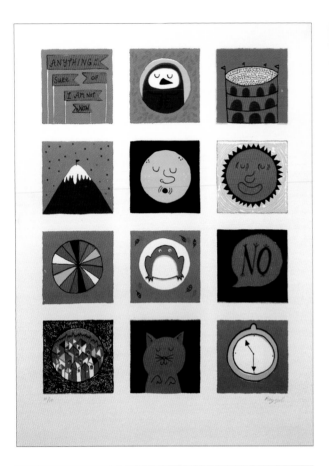

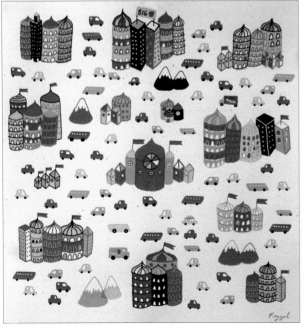

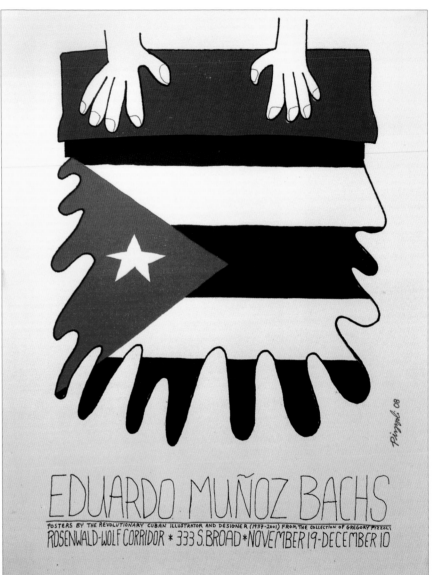

EDUARDO MUÑOZ BACHS
POSTERS BY THE REVOLUTIONARY CUBAN ILLUSTRATOR AND DESIGNER (1937-2001) FROM THE COLLECTION OF GREGORY PIZZOLI
ROSENWALD-WOLF CORRIDOR * 333 S.BROAD *NOVEMBER 19-DECEMBER 10

00108—0111 > GREG PIZZOLI

18/20 "AWOOOOGA" Pizzoli

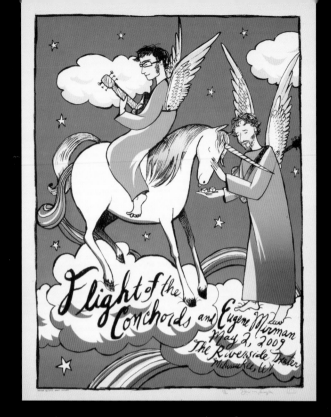

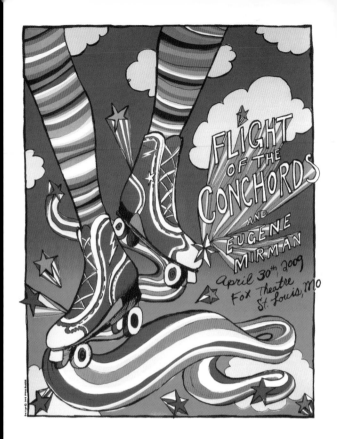

upper 0112—0113 > **DIANA SUDYKA**

below 0114 > **BENNETT HOLZWORTH**

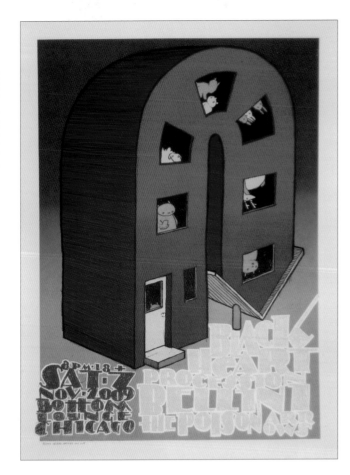

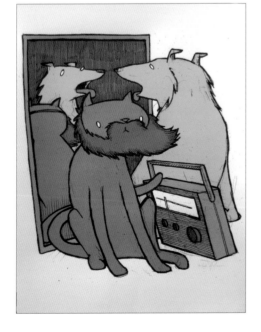

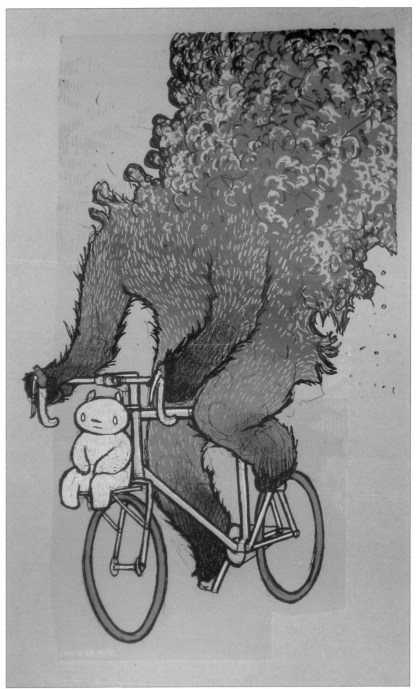

GRIZZLY
BEAR

JULY 19, 2009 | PITCHFORK MUSIC FESTIVAL | UNION PARK | CHICAGO, IL

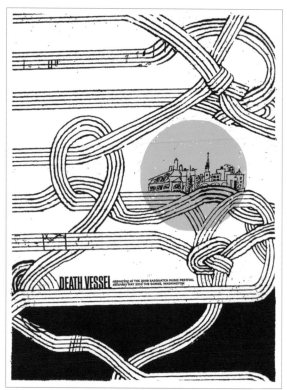

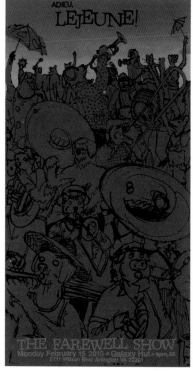

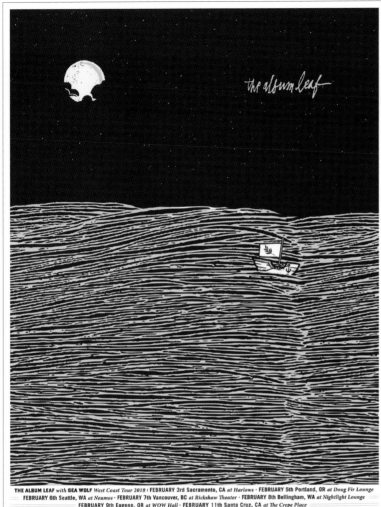

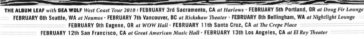

THE ALBUM LEAF *with* SEA WOLF *West Coast Tour 2010 :* FEBRUARY 3rd Sacramento, CA *at Harlows* · FEBRUARY 5th Portland, OR *at Doug Fir Lounge* · FEBRUARY 6th Seattle, WA *at Neumos* · FEBRUARY 7th Vancouver, BC *at Rickshaw Theater* · FEBRUARY 8th Bellingham, WA *at Nightlight Lounge* · FEBRUARY 9th Eugene, OR *at WOW Hall* · FEBRUARY 11th Santa Cruz, CA *at The Crepe Place* · FEBRUARY 12th San Francisco, CA *at Great American Music Hall* · FEBRUARY 13th Los Angeles, CA *at El Rey Theater*

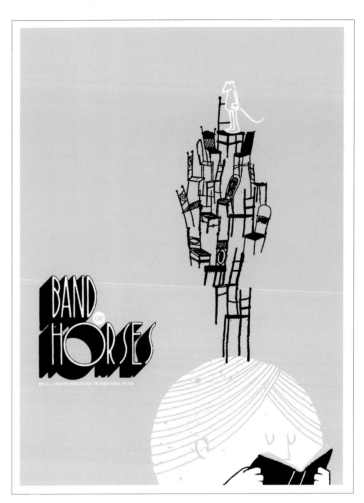

00121–0123 > **THE NEW YEAR**

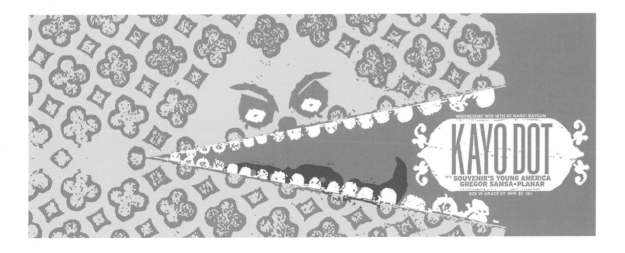

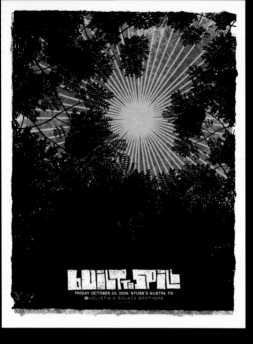

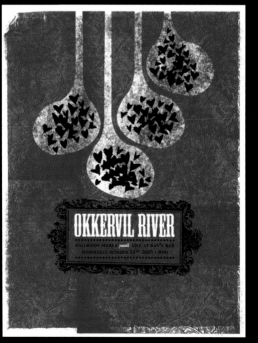

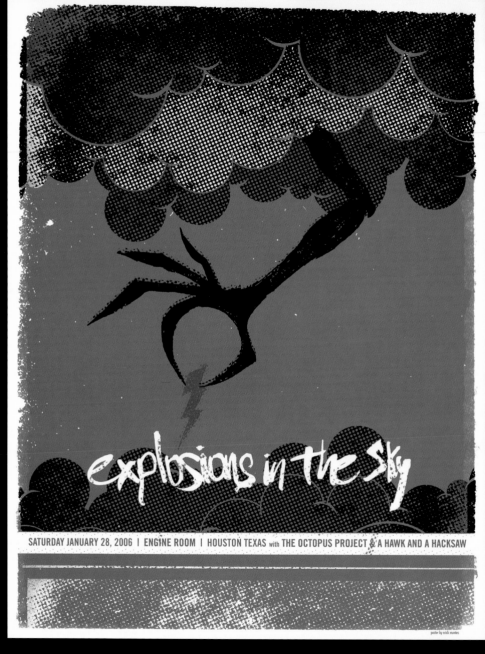

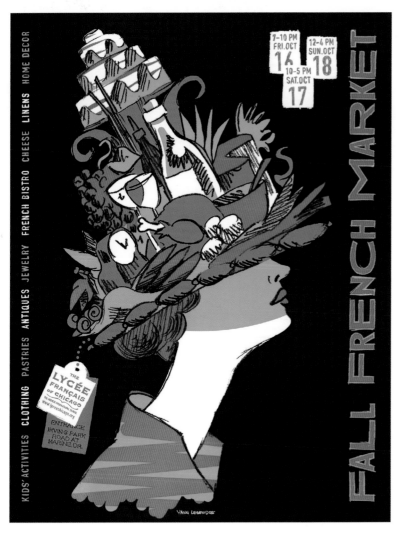

bottom left 0127 > YANN LEGENDRE

upper left 0128 > YANN LEGENDRE

botom right 0129 > POST TYPOGRAPHY

bottom center 0130 > POST TYPOGRAPHY

0131—0134 > BAD PEOPLE GOOD THINGS

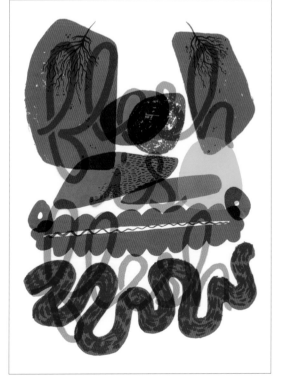

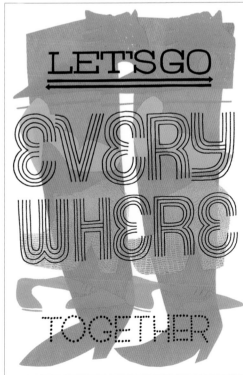

0135–0138 > JEN MUSSARI

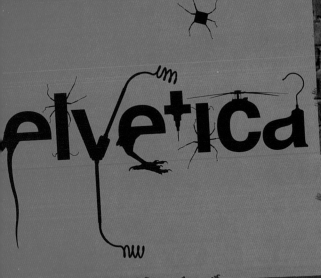

elvetica

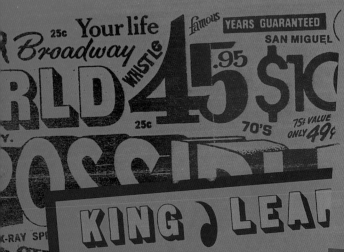

25c Your life
Broadway
famous
YEARS GUARANTEED
SAN MIGUEL
RLD WHISTLE 45.95 $10
25c 70'S 75¢ VALUE ONLY 49¢

KING ♪ LEAR

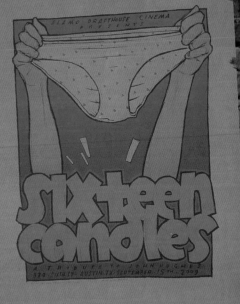

ALAMO DRAFTHOUSE CINEMA
PRESENTS

sixteen
candles

A TRIBUTE TO JOHN HUGHES
$20 JUNE ST. AUSTIN TX SEPTEMBER 15th 2009

SKULL
SALE
KING

WHAT'S OLD IS NEW AGAIN

ZAPRASZAMY DO KIN

reżyseria Steen Agro

ZAMKNIJ SIĘ

I ZASTRZEL

MNIE

Czym grozi wycieczka do Pragi?

WWW.VIVAGRO.PL

ROCK 'N' ROLL
HIGH SCHOOL

with Clint Howard Live! MAY 4, 2009
ALAMO RITZ 320 E. 6TH ST. AUSTIN, TX
originalalamo.com POSTER BY PRINT MAFIA WWW.PRINTMAFIA.NET

1000

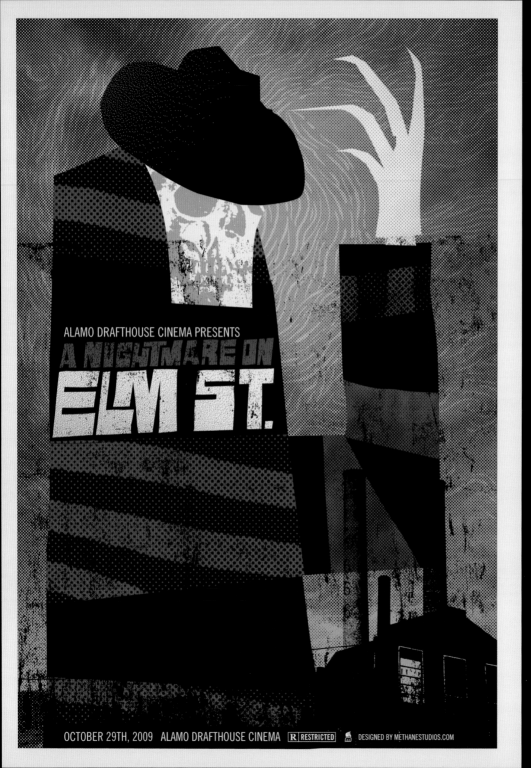

ALAMO DRAFTHOUSE CINEMA PRESENTS

A NIGHTMARE ON ELM ST.

OCTOBER 29TH, 2009 ALAMO DRAFTHOUSE CINEMA R RESTRICTED DESIGNED BY METHANESTUDIOS.COM

The Art Directors Club of Metropolitan Washington presents

The Principal Navigations, Voyages & Discoveries of the 344 Empire
an evening with Mr. Stefan G. Bucher

Thursday, 19 Feb 2009 at 6:30pm United States Navy Memorial Washington, D.C.

CRUIS ING

AL PACINO IS CRUISING. BY WILLIAM FRIED
AT THE ALAMO DRAFTHOUSE CINEMA AT THE R
MARCH 27, 2009 8:30 PM HEY HOMO! PRESEN
TICKE NFO ORIGINALALAMO.C
 0 E 6TH ST AUSTIN

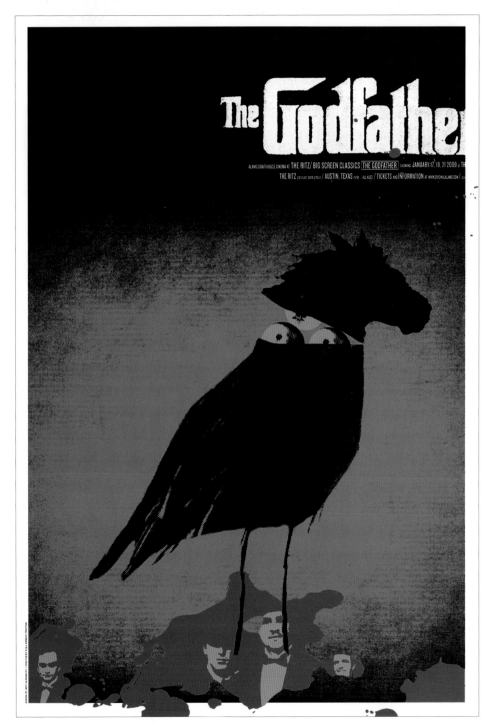

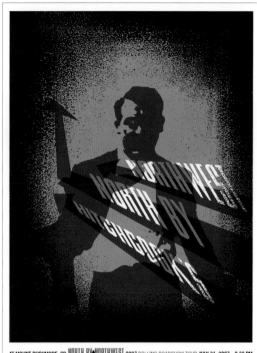

0141–0143 > **PATENT PENDING DESIGN**

REŻYSERIA ARTHUR PENN

BONNIE I CLYDE

TYLKO W KINACH STUDYJNYCH

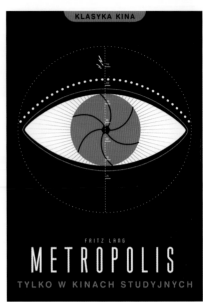

KLASYKA KINA

FRITZ LANG

METROPOLIS

TYLKO W KINACH STUDYJNYCH

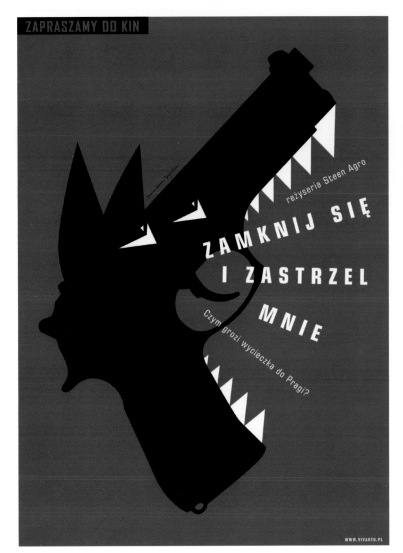

0144–0147 > HOMEWORK

0148–0149 > JONAS BERGSTRAND

Astrid Lindgrens Barnsjukhus 9 år 2007. Fira Pippidagen på Astrid Lindgrens Barnsjukhus torsdagen den 14 juni. Festligheter från 13.00, Bullkalas, överraskningståg och barnföreställning. Välkomna! www.astrid-barn.nu

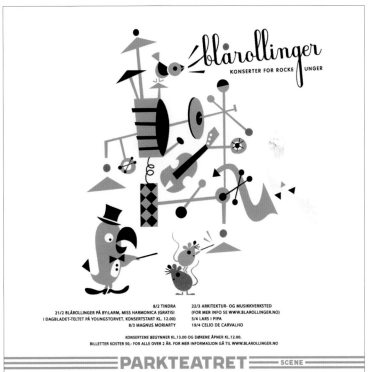

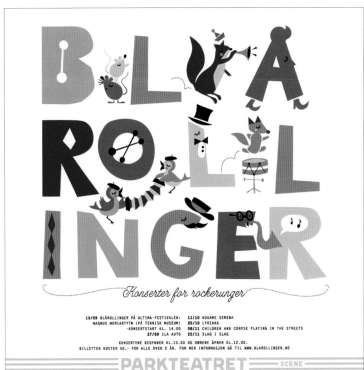

upper left ○150 **>** JONAS BERGSTRAND

upper right ○151 **>** DARLING CLEMENTINE

bottom right ○152 **>** DARLING CLEMENTINE

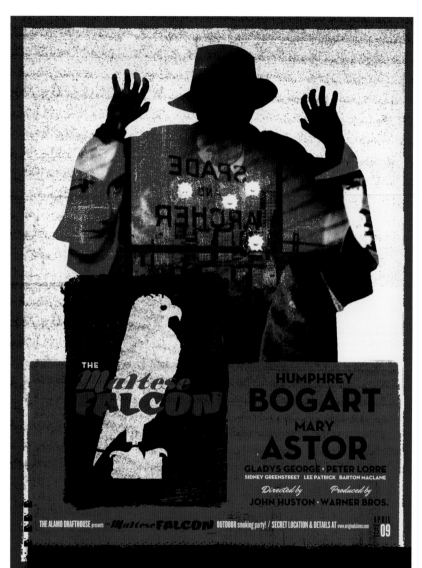

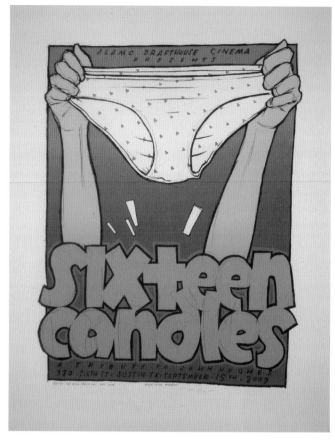

upper left 0153 > **THE SILENT GIANTS**

upper right 0154 > **JAY RYAN**

0155—0158 > TOOTH

CHINATI FOUNDATION, BALLROOM MARFA, JUDD FOUNDATION, AND CHARLES ATTAL PRESENT A FREE SHOW 9PM SATURDAY OCTOBER 6, 2007 AT THE THUNDERBIRD HOTEL MARFA, TEXAS WITH BLACK LEATHER JESUS

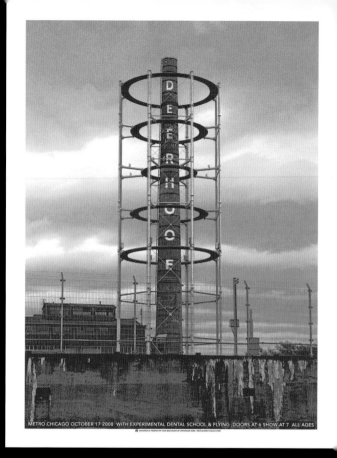

METRO CHICAGO OCTOBER 17 2008 WITH EXPERIMENTAL DENTAL SCHOOL & FLYING DOORS AT 6 SHOW AT 7 ALL AGES

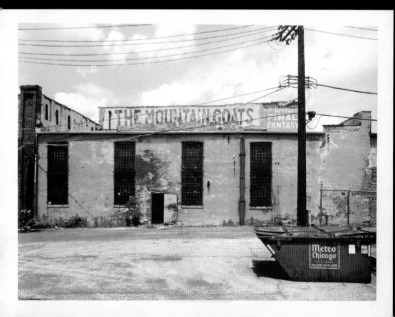

0159—0161 > CROSSHAIR

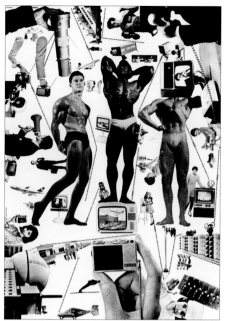

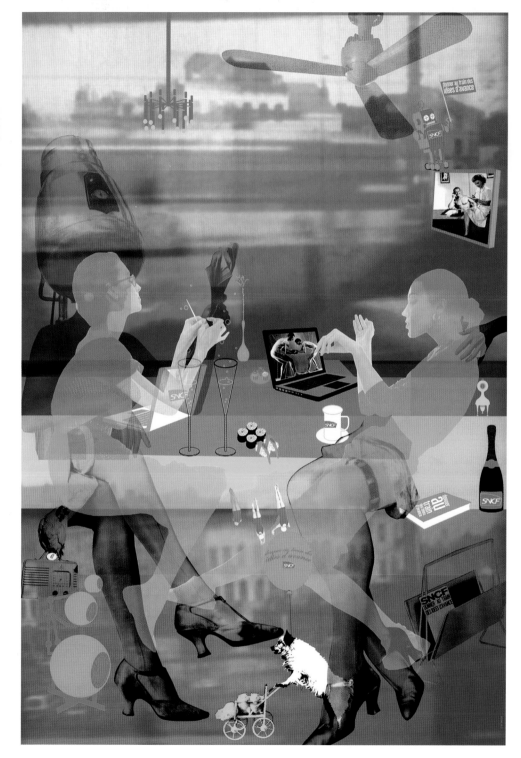

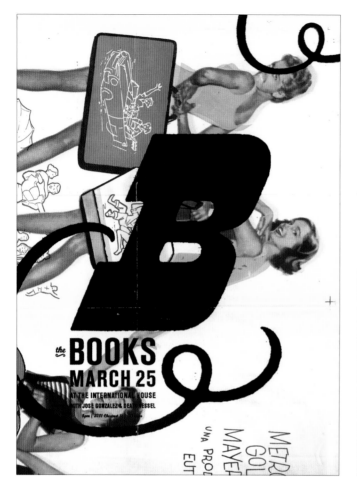

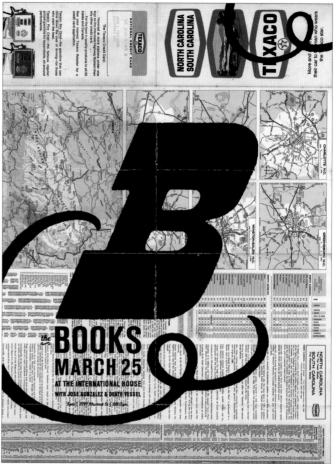

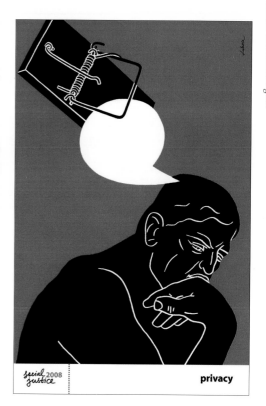

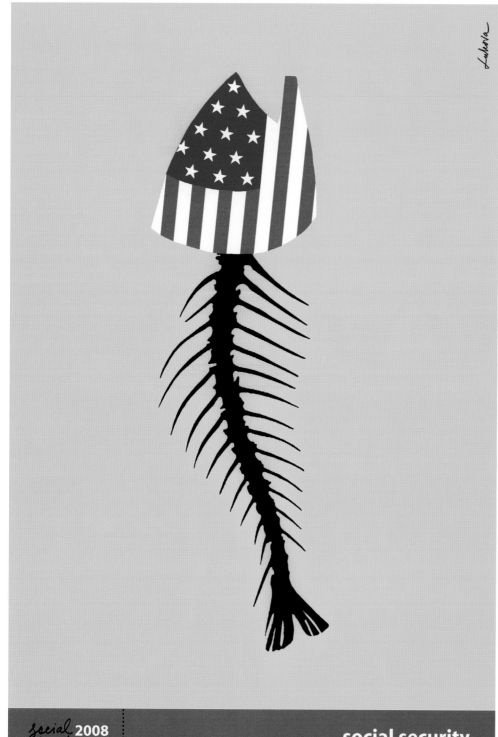

0170—0171 > LUBA LUKOVA

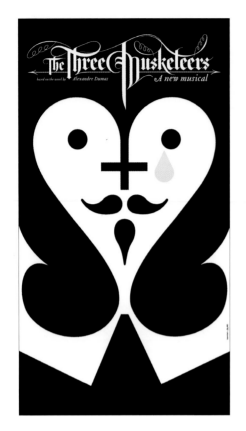

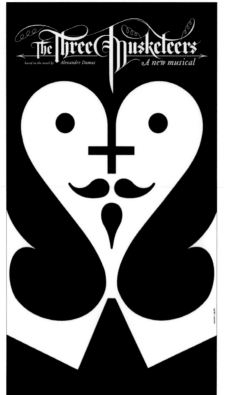

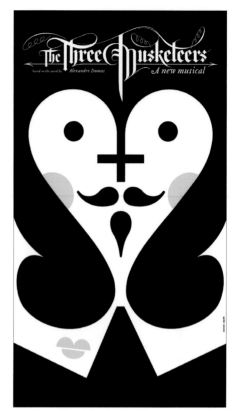

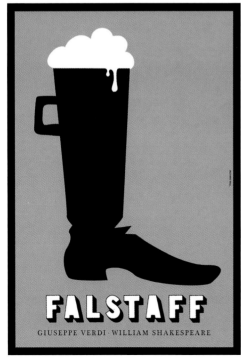

0172–0183 > YANN LEGENDRE

THE NATIONAL

21 MAY: TORONTO - KOOL HAUS W/ COLIN STETSON // 22 MAY: MONTREAL - METROPOLIS W/ COLIN STETSON //
23 MAY: BOSTON - HOUSE OF BLUES W/ COLIN STETSON // 24 MAY: WASHINGTON DC - 9:30 CLUB W/ COLIN STETSON //
25 MAY: WASHINGTON DC - 9:30 CLUB W/ COLIN STETSON // 27 MAY: ATLANTA GA - TABERNACLE W/ COLIN STETSON //
28 MAY: RALEIGH NC - LINCOLN THEATER W/ COLIN STETSON // 29 MAY: PHILADELPHIA PA - ELECTRIC FACTORY W/ COLIN STETSON //

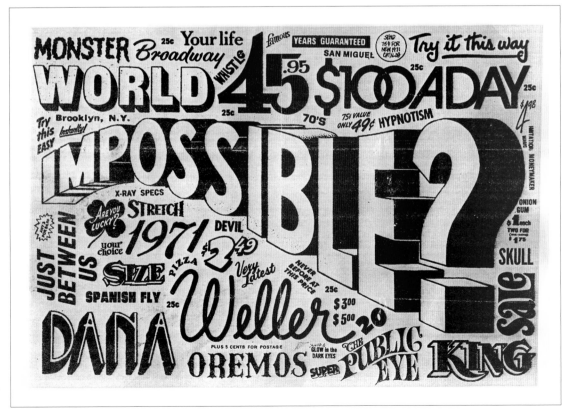

0185–0188 > **MORNING BREATH INC.**

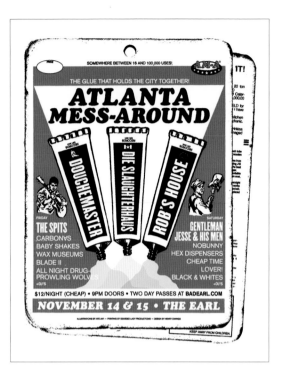

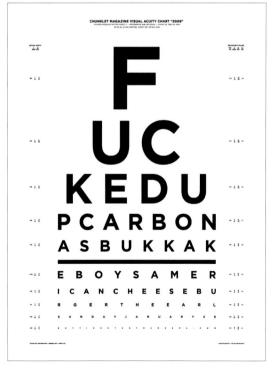

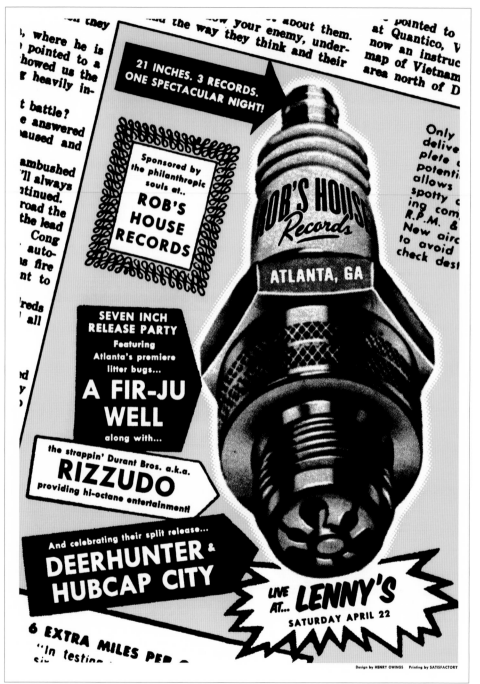

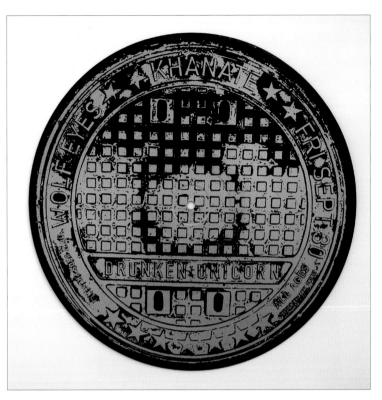

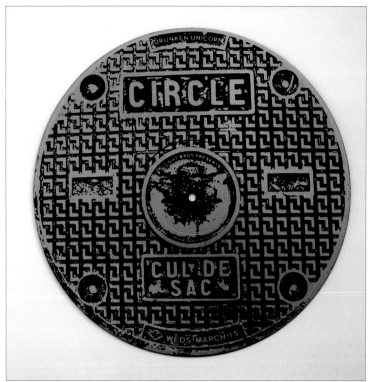

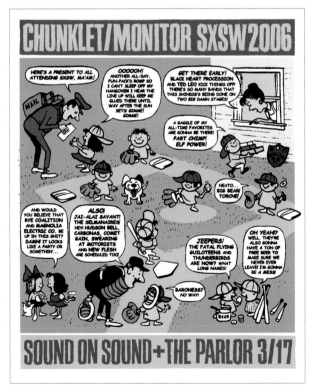

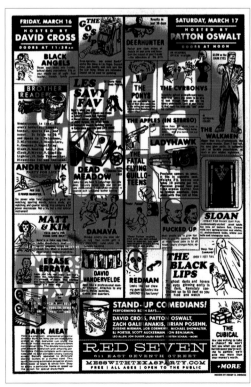

THE MARKED MEN

BIRTHDAY SUITS
MUTE ERA
AWESOME SNAKES

SATURDAY MAY 27, 2006 • TRIPLE ROCK SOCIAL CLUB

the Black Keys
AND JAY REATARD

FIRST AVENUE • MINNEAPOLIS • FRIDAY APRIL 11 2008

★ SECOND ANNUAL ★
Deep Blues
FESTIVAL
JULY 18 - 20 2008
LAKE ELMO MINNESOTA • DEEPBLUESFESTIVAL.COM

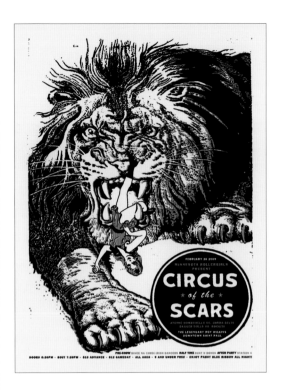

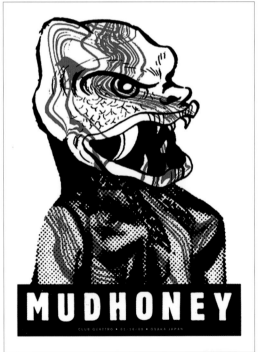

0196—0201 > MISS AMY JO

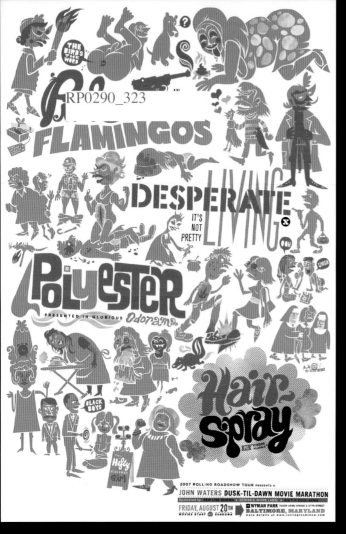

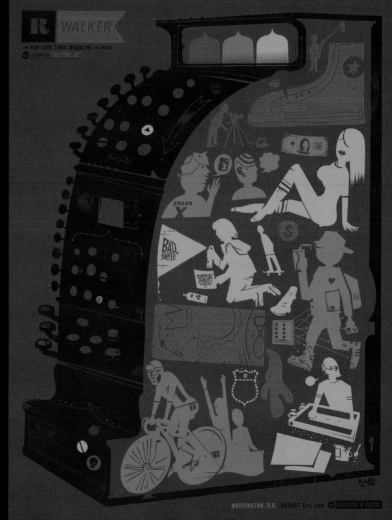

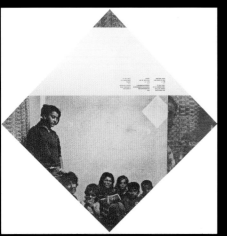

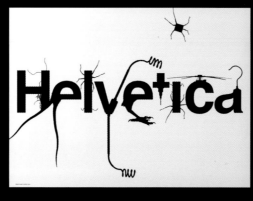

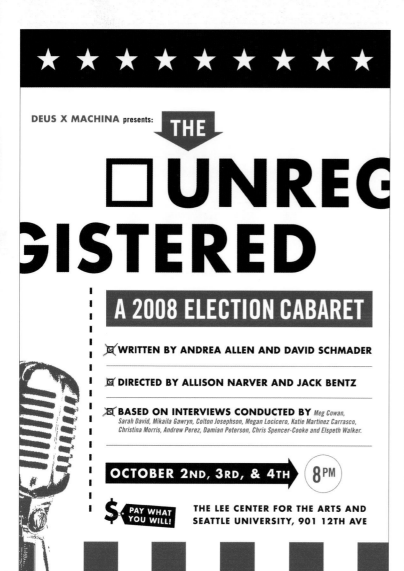

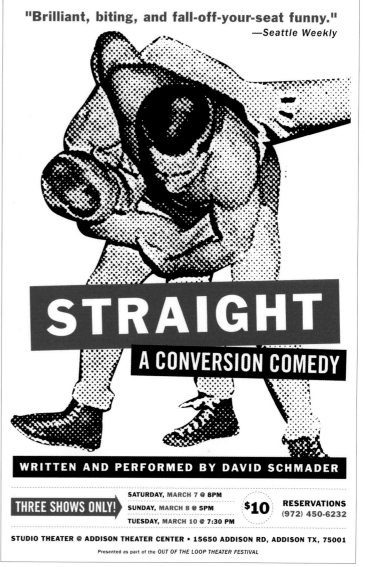

0206—0207 > SLEEP OP

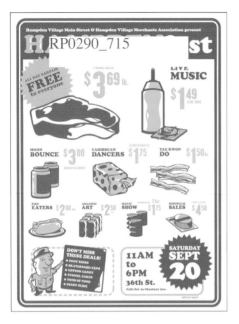

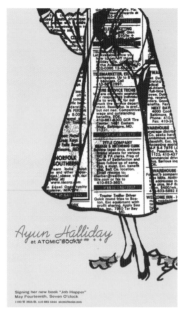

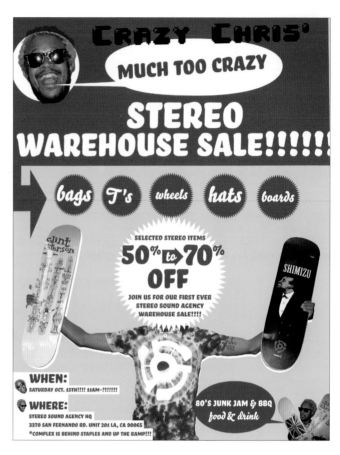

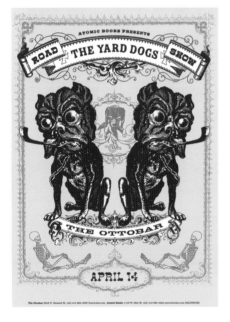

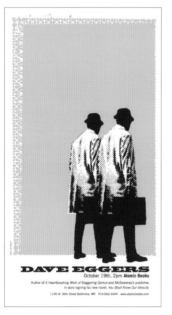

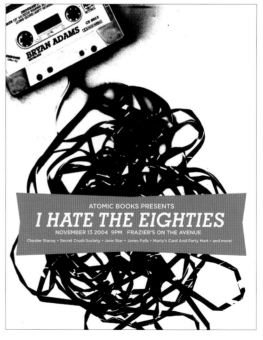

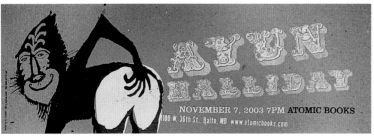

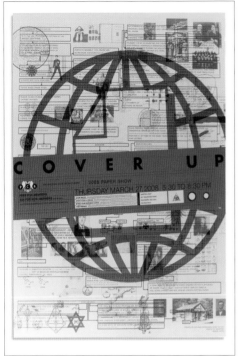

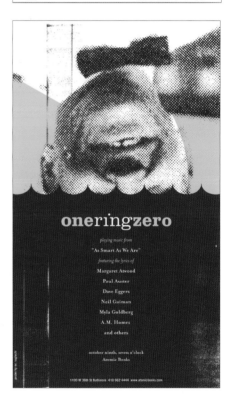

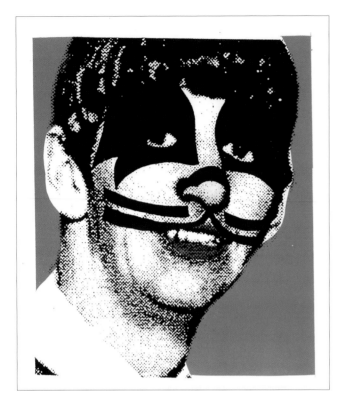
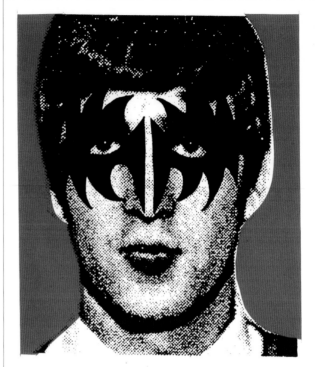

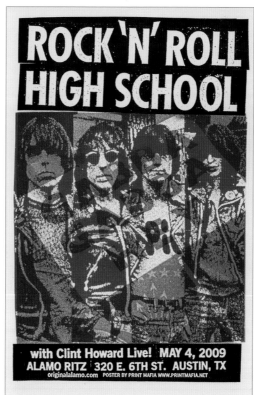

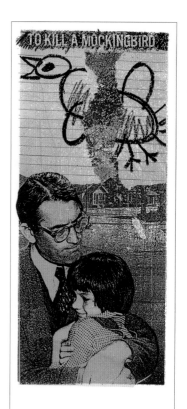

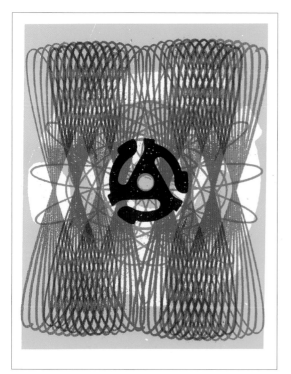

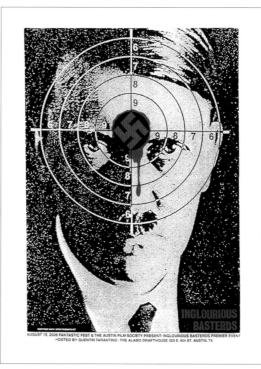

0221—0229 > PRINT MAFIA

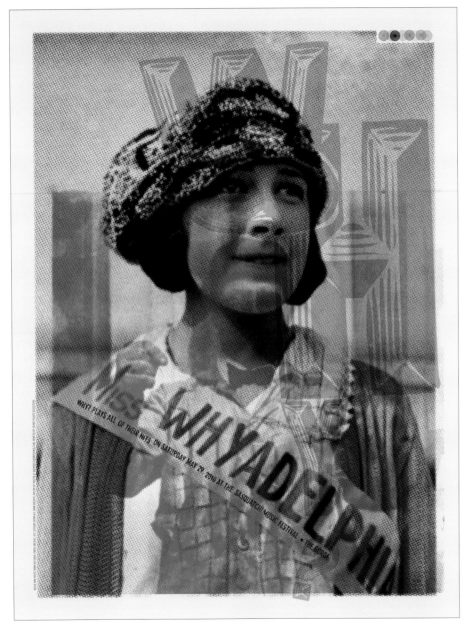

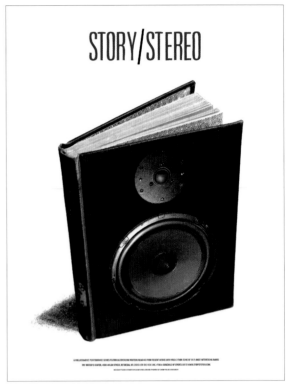

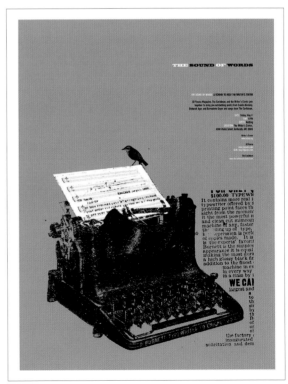

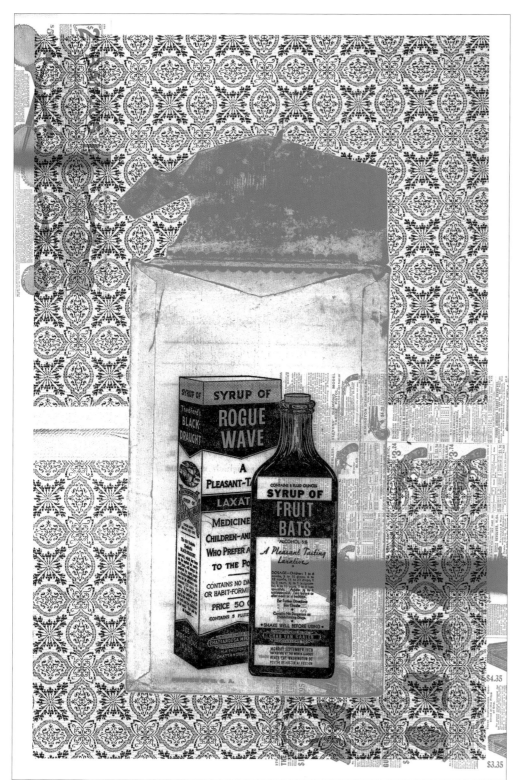

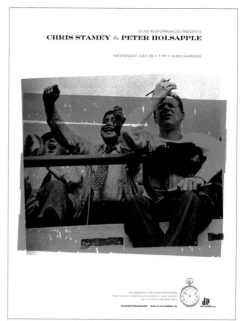

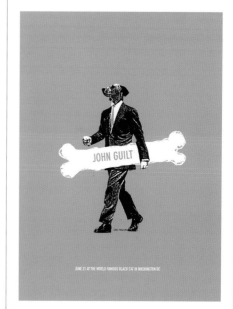

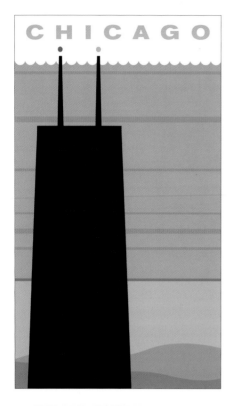

CHICAGO

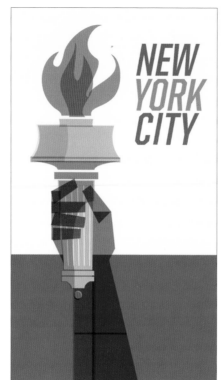

NEW YORK CITY

PHILADELPHIA

PHOENIX

SEATTLE

WASHINGTON

0236–0243 > THE HEADS OF STATE

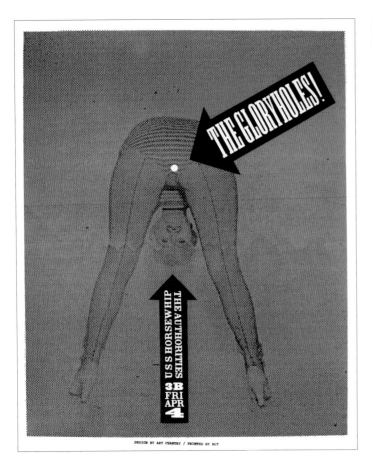

THE GLORYHOLES!

THE AUTHORITIES
U S S HORSEWHIP
3B
FRI
APR
4

DESIGN BY ART CHANTRY / PRINTED BY BLT

DIED YOUNG STAYED PRETTY

A MOVIE ABOUT
ROCK POSTERS

DIRECTED BY
EILEEN YAGHOOBIAN

CIRCA
SURVIVE

DESIGN BY ART CHANTRY & BRIAN ELLIS

SPOOKY DANCE BAND
3B
TAVERN
MARCH
22
SIX FOOT SLOTH

DESIGN BY ART CHANTRY / PRINTED BY BLT

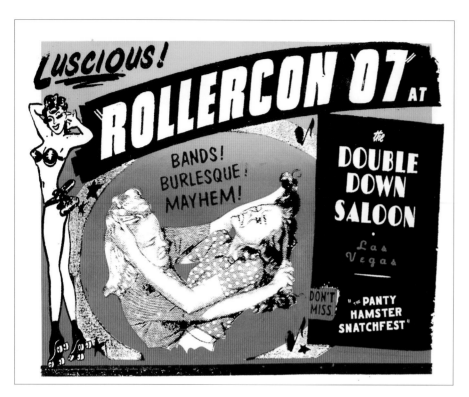

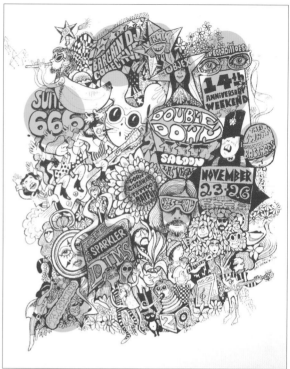

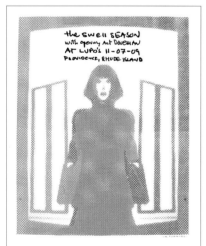

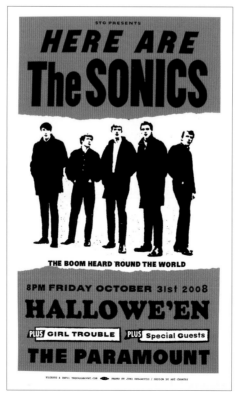

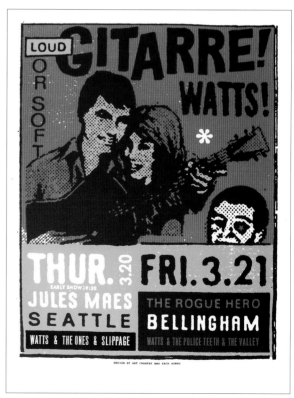

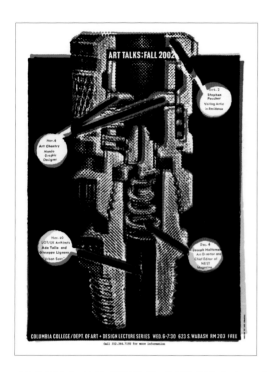

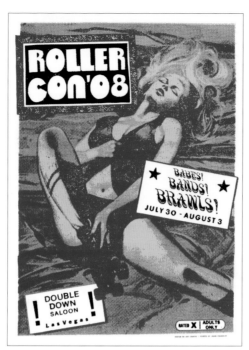

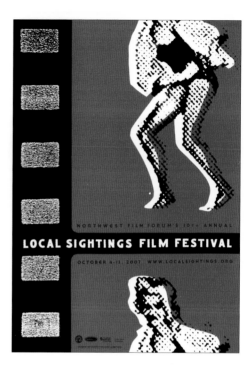

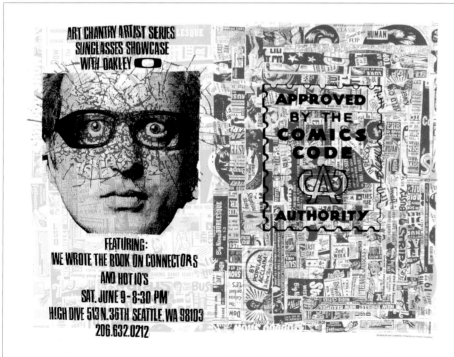

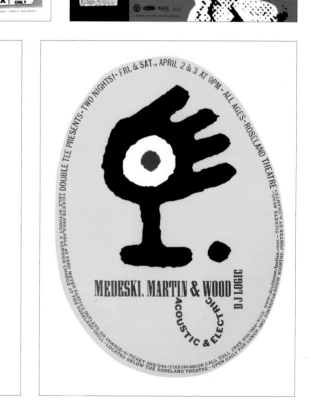

0254–0263 > ART CHANTRY DESIGN CO.

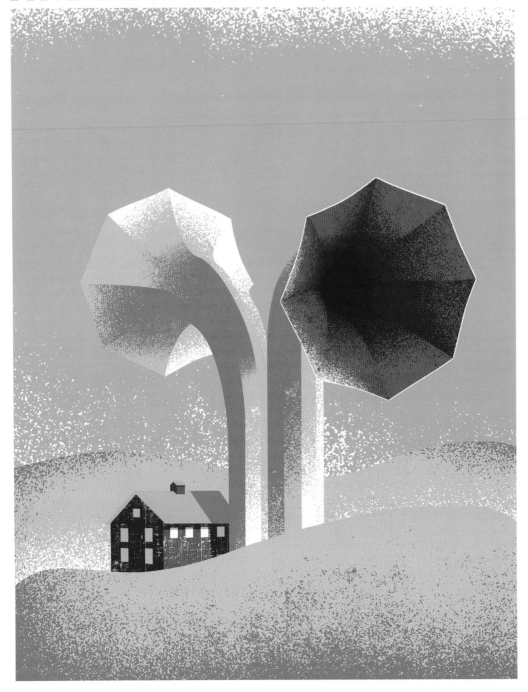

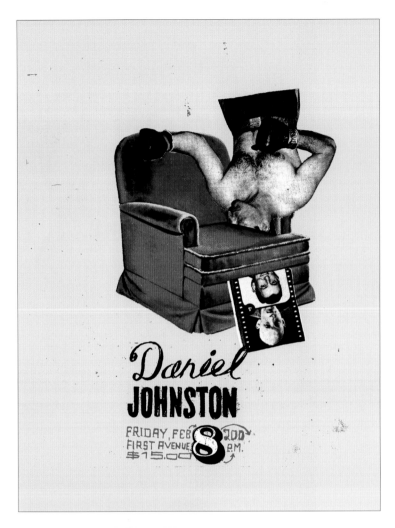

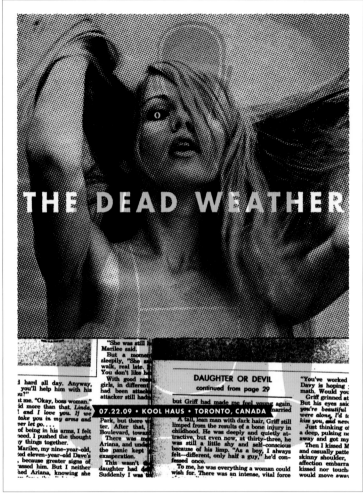

0264–0267 > AESTHETIC APPARATUS

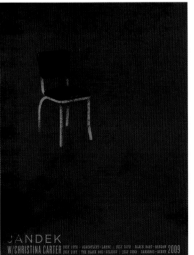

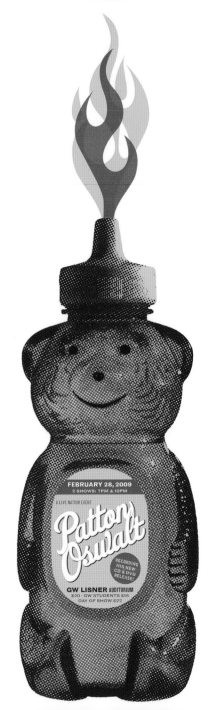

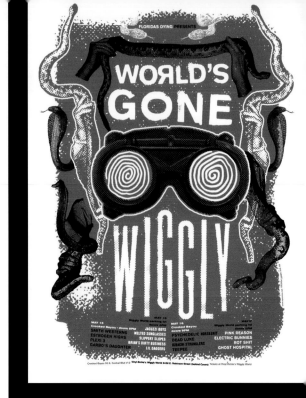

upper left 0270 > LUCKY BUNNY COMMUNICATIONS
upper right 0271 > BENNETT HOLZWORTH
bottom 0272 > LUCKY BUNNY COMMUNICATIONS

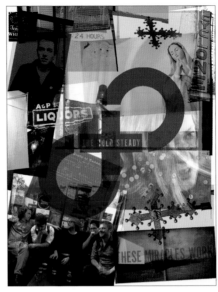

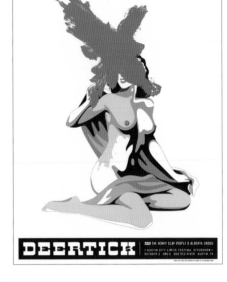

0282—0287 > DECODER RING DESIGN CONCERN

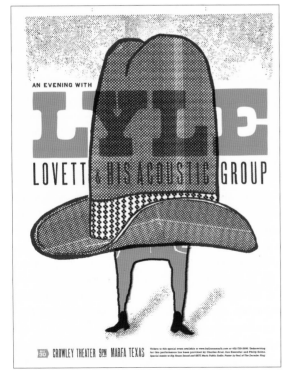

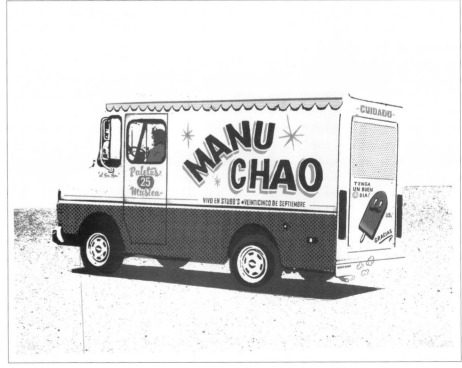

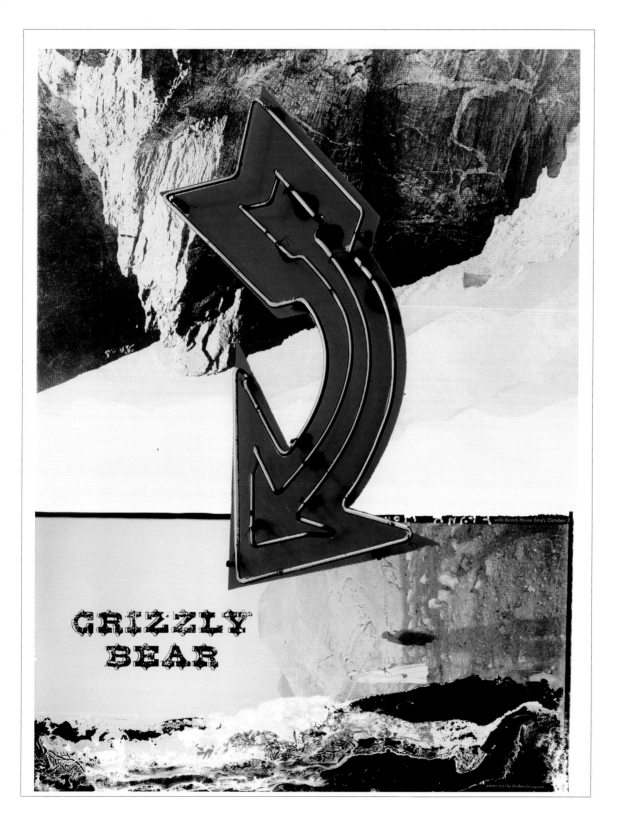

BETTER STILL... SEE THEM LIVE IN PERSON

July 23 - Toronto, ONT - Opera House
July 24 - Northampton, MA - Academy of Music
July 25 - Philadelphia, PA - Trocadero
July 26 - New York, NY - Terminal 5
July 28 - Carrboro, NC - Cats Cradle
July 29 - Atlanta, GA - Variety Playhouse
July 30 - Nashville, TN - Mercy Lounge

July 31 - Asheville, NC - Orange Peel
August 2 - Newport, RI - Newport Folk Festival
August 4 - Columbus, OH - Wexner Center for the Arts
August 5 - Chicago, IL - Park West
August 7 - Minneapolis, MN - First Avenue
August 8 - Madison, WI - Barrymore
August 10 - Washington, DC - V Fest

DESIGNED AND HANDPRINTED BY HERO DESIGN STUDIO HEROAIRFOUND.COM

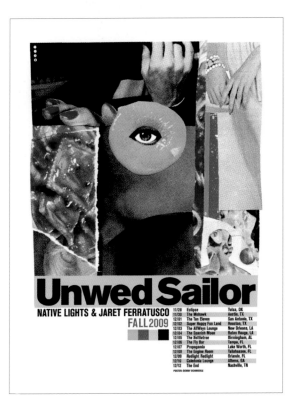

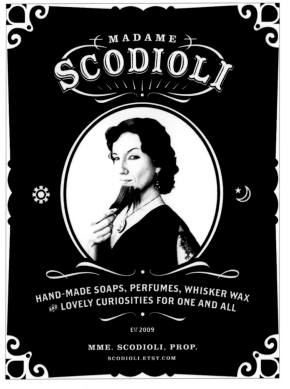

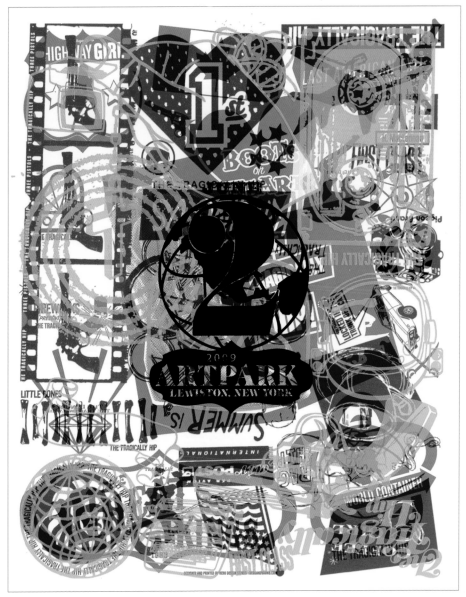

bottom left 0289 > **SCODIOLI CREATIVE**

upper left 0290 > **DENNY SCHMICKLE**

upper right 0291 > **HERO DESIGN**

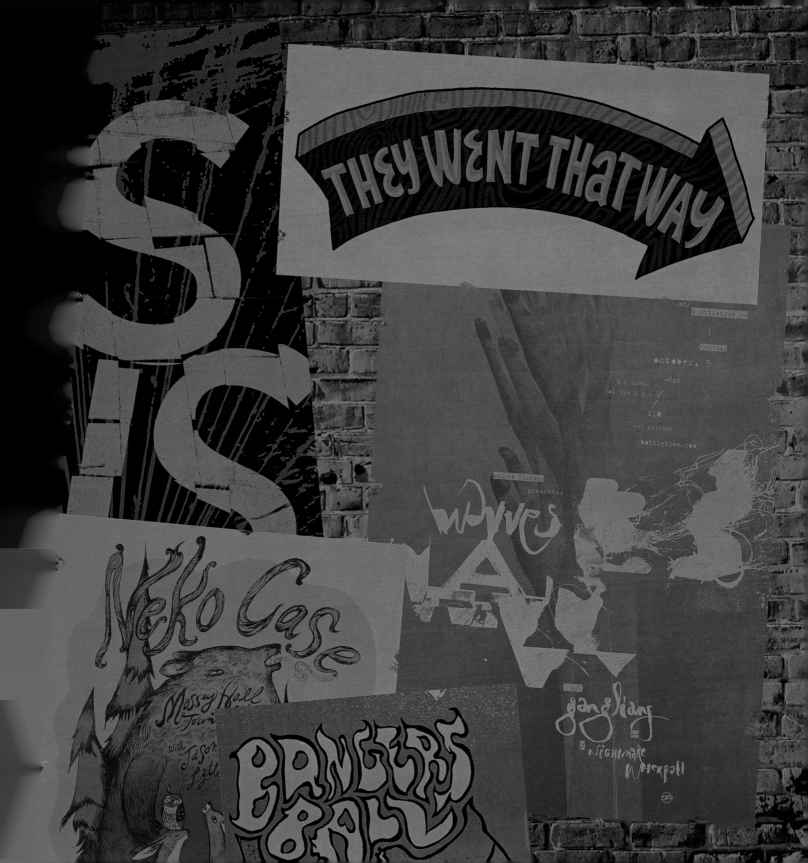

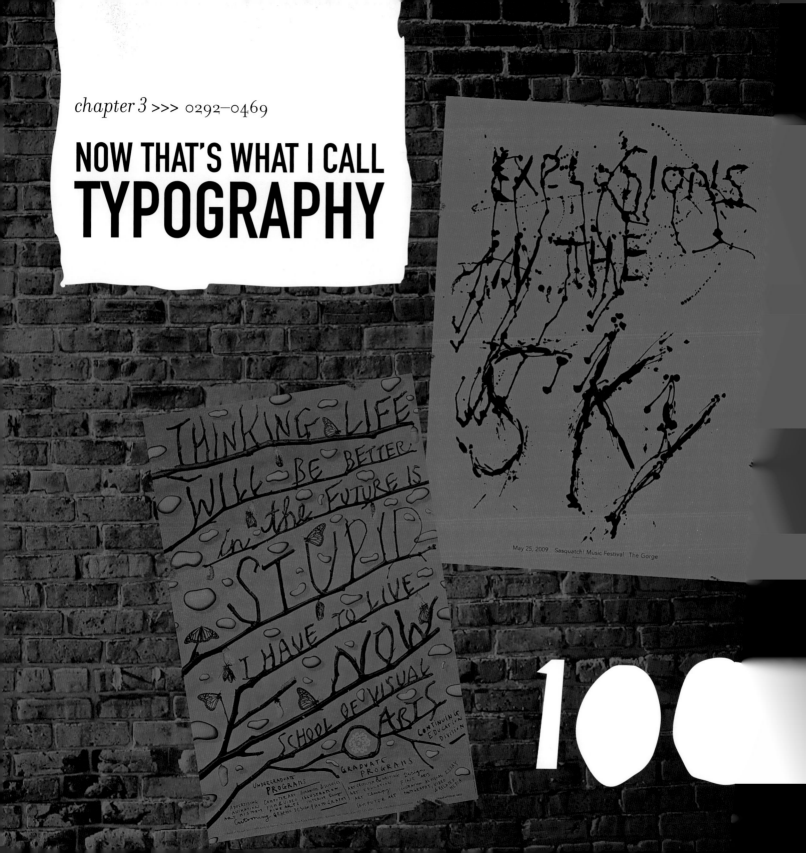

NOW THAT'S WHAT I CALL
TYPOGRAPHY

EXPLOSIONS IN THE SKY

May 25, 2009 Sasquatch! Music Festival The Gorge

THINKING LIFE WILL BE BETTER in the FUTURE IS STUPID I HAVE TO LIVE NOW SCHOOL OF VISUAL ARTS

CONTINUING EDUCATION DIVISION

UNDERGRADUATE PROGRAMS

GRADUATE PROGRAMS

100

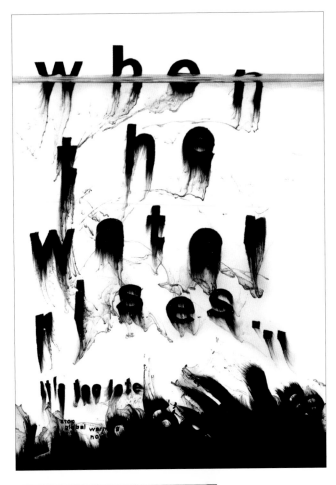

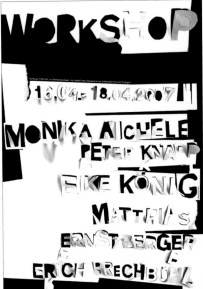

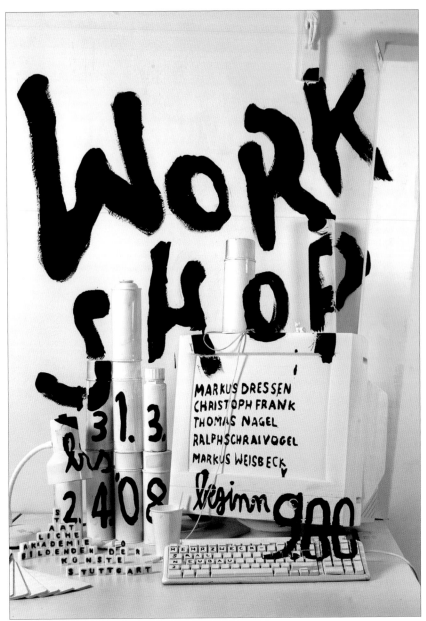

0292—0294 > KATJA SCHLOZ

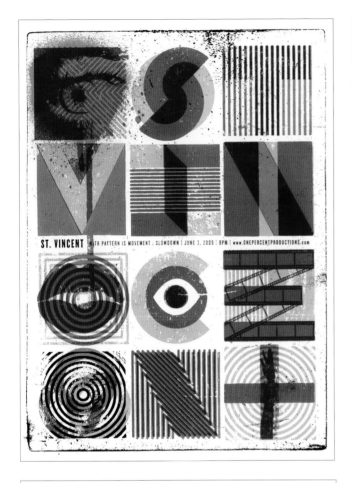

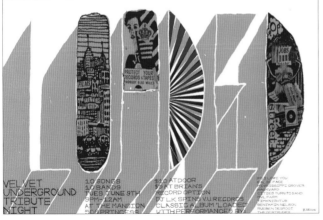

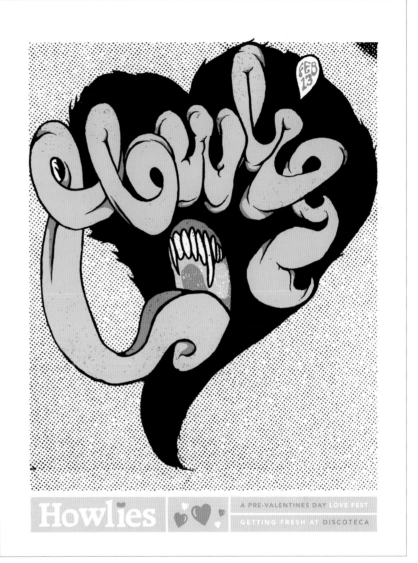

bottom left 0295 > BENJAMIN NELSON

upper left 0296 > DOE EYED DESIGN

upper right 0297 > NICK DUPEY

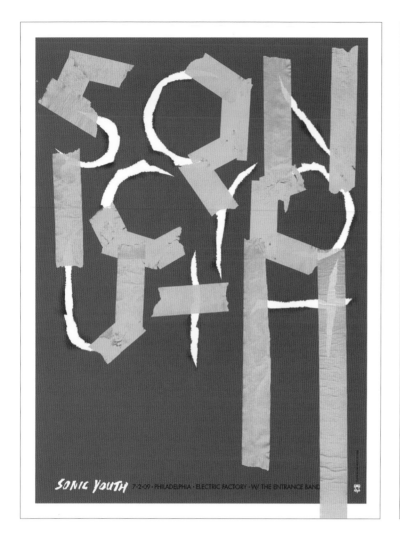

SONIC YOUTH · 7-2-09 · PHILADELPHIA · ELECTRIC FACTORY · W/ THE ENTRANCE BAND

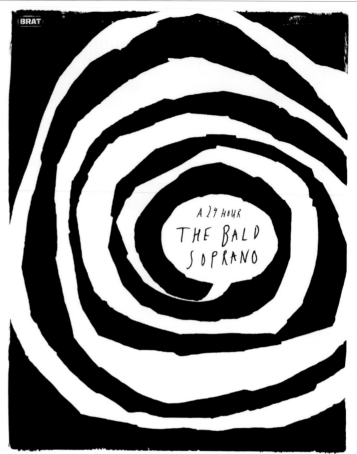

A 24 HOUR
THE BALD
SOPRANO

EUGÈNE IONESCO'S 60 MINUTE ABSURDIST MASTERPIECE · JANUARY 22-23, 2010
PERFORMED EVERY HOUR FOR 24 HOURS · DIRECTED BY MADI DISTEFANO · ANNENBERG CENTER FOR THE PERFORMING ARTS

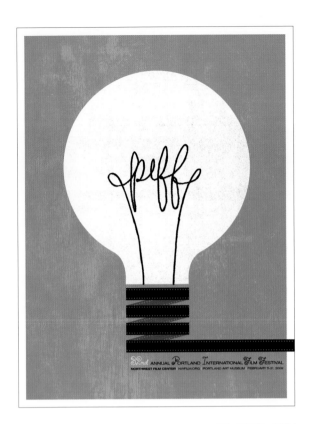

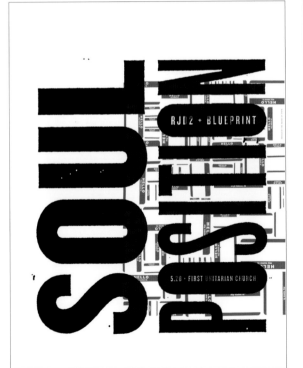

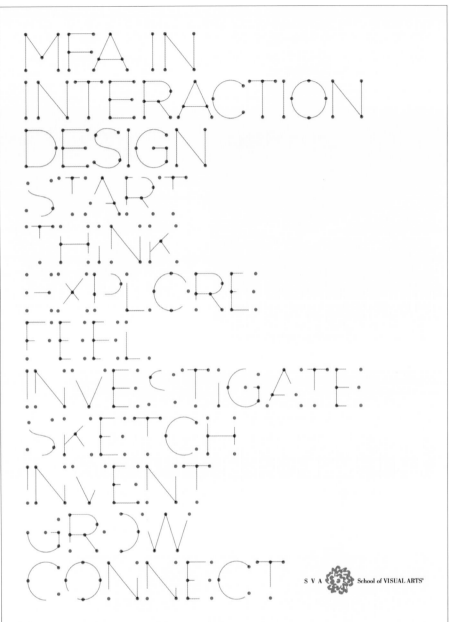

0298–0302 > **THE HEADS OF STATE**

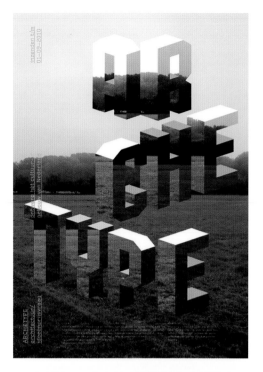

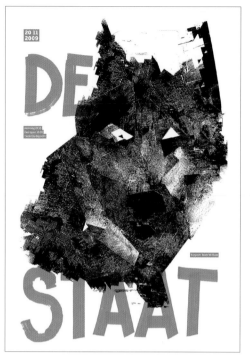

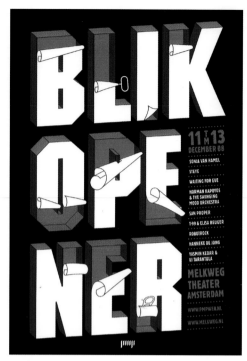

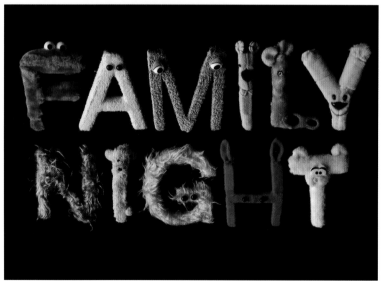

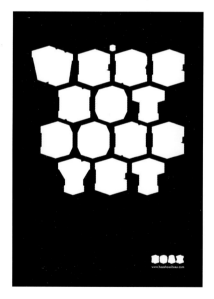

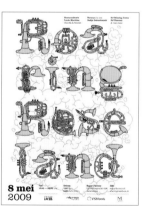

o3o3—o3o8 > HOAX

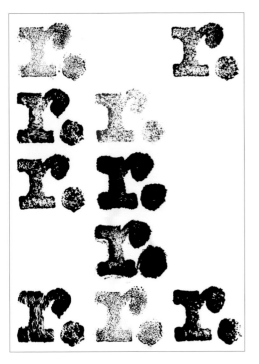

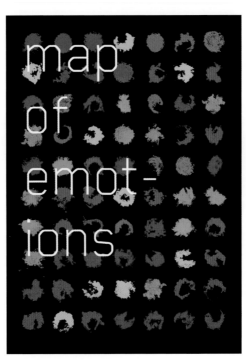

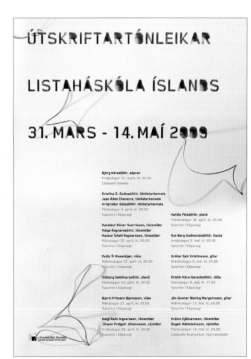

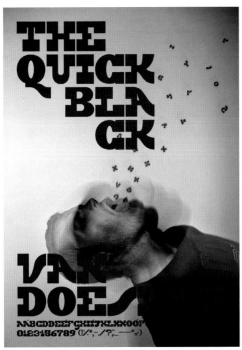

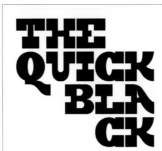

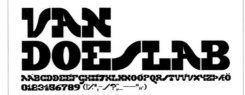

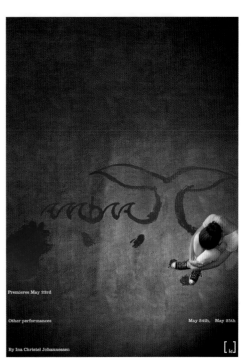

0309–0314 > RAGNAR MÁR NIKULÁSSON

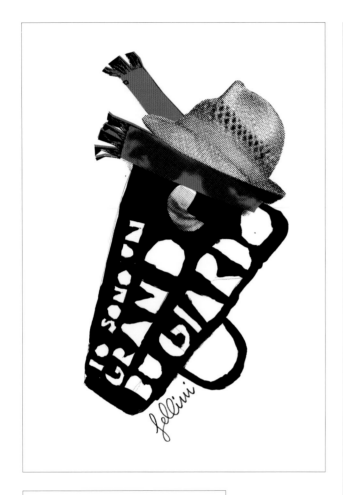

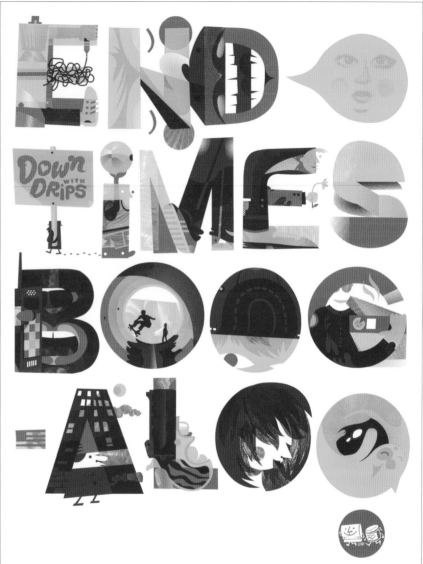

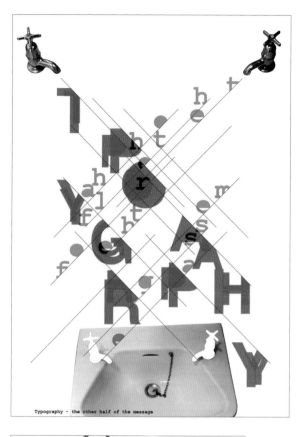

Typography - the other half of the message

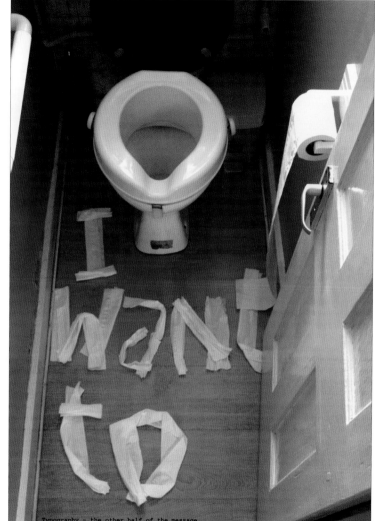

Typography - the other half of the message

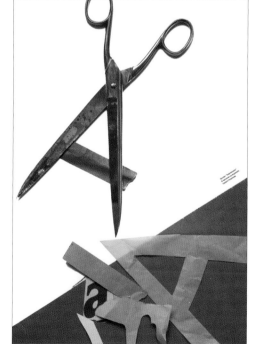

0318—0321 > GEORGI GEORGIEV

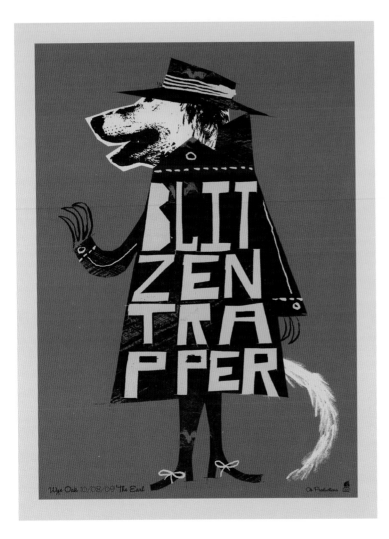

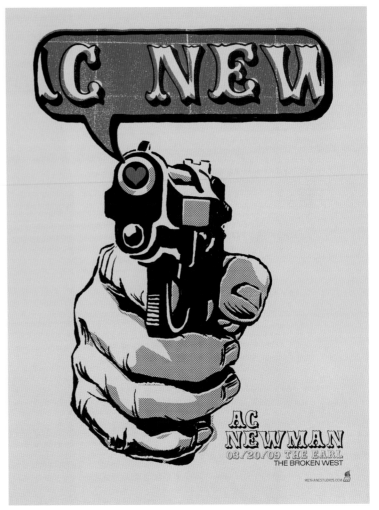

upper left 0322 > **METHANE STUDIOS**

upper right 0323 > **METHANE STUDIOS**

bottom right 0324 > **FRIDA CLEMENTS DESIGN**

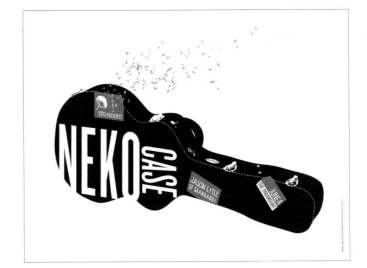

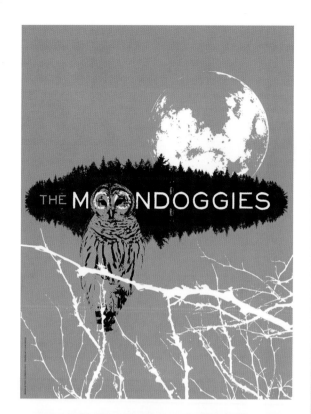

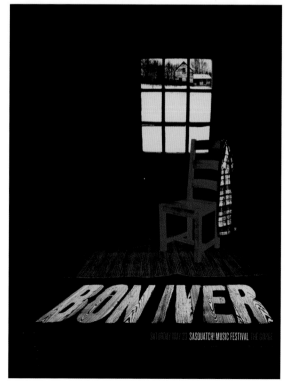

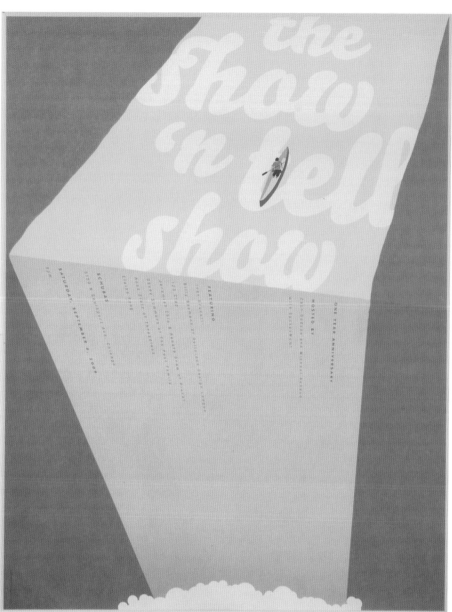

bottom left 0325 > FRIDA CLEMENTS DESIGN
upper left 0326 > FRIDA CLEMENTS DESIGN
upper right 0327 > SONNENZIMMER

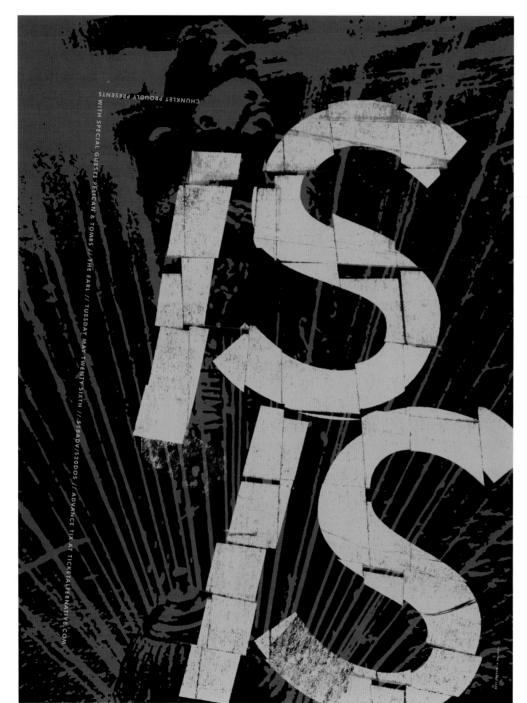

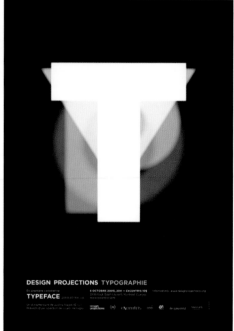

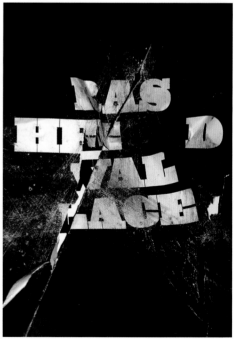

upper left 0328 > CHUNKLET GRAPHIC CONTROL
upper right 0329 > BALISTIQUE
bottom right 0330 > HORT

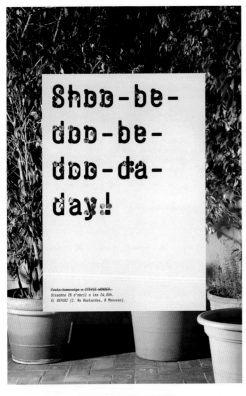

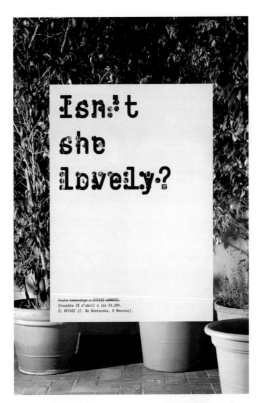

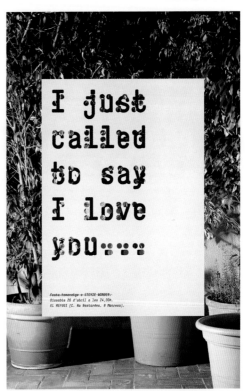

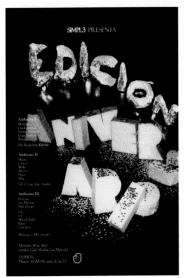

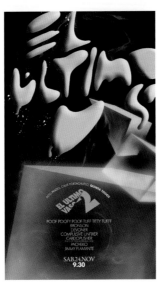

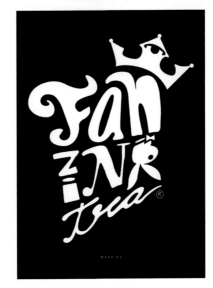

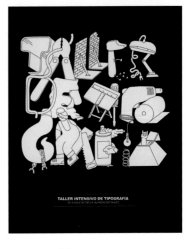

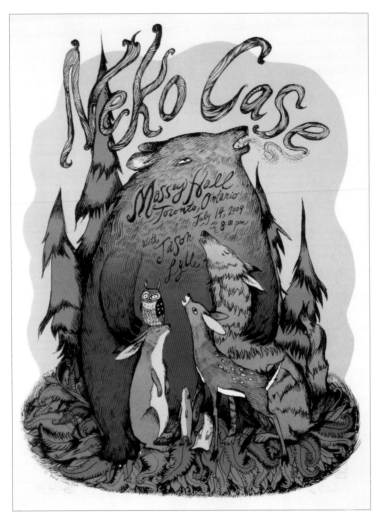

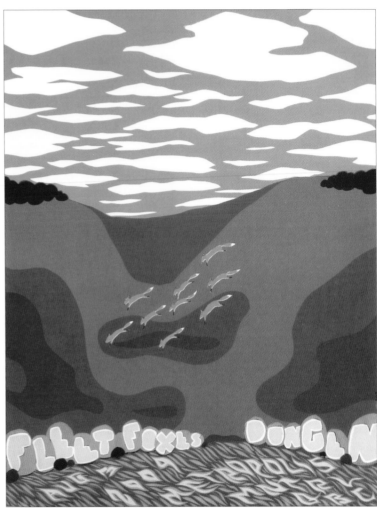

upper left ○338 > DIANA SUDYKA

upper right ○339 > MAT DALY

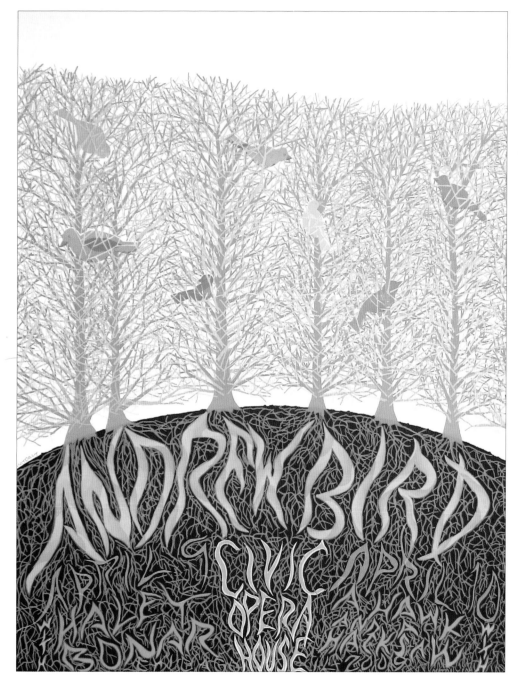

0340–0342 > **MAT DALY**

MAY 11 & 12, 2008 ★ STUBB'S ★ AUSTIN, TEXAS

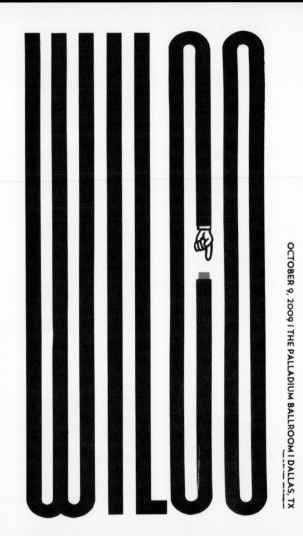

OCTOBER 9, 2009 | THE PALLADIUM BALLROOM | DALLAS, TX

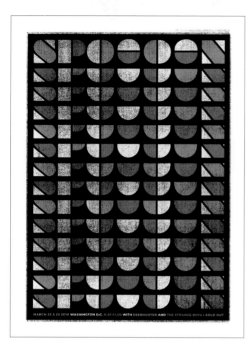

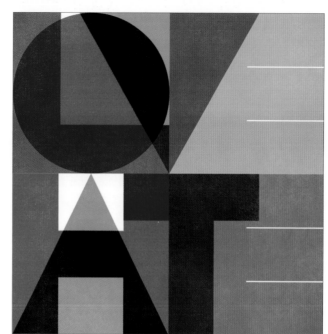

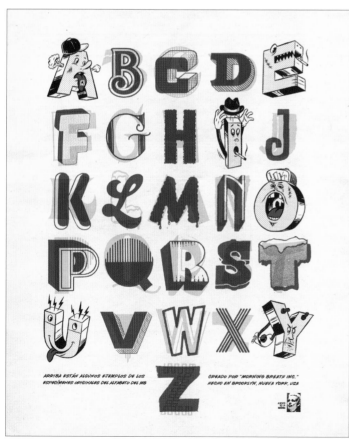

bottom left 0346 > MORNING BREATH INC.

upper left 0347 > NATE DUVAL

upper right 0348 > BLANCA GÓMEZ

bottom right 0349 > WERNER DESIGN WERKS

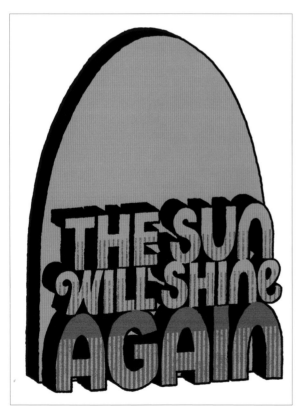

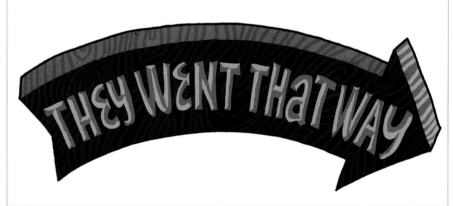

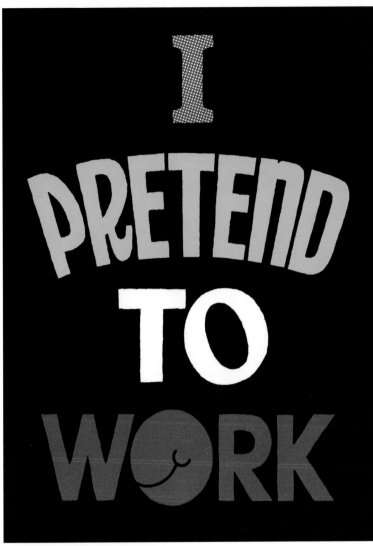

0350—0358 > ANDY SMITH ILLUSTRATION

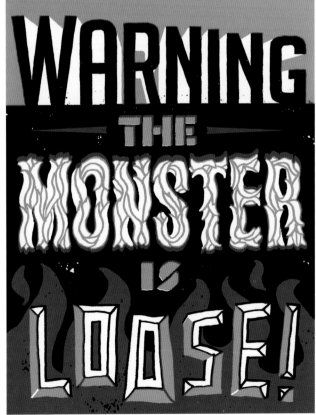

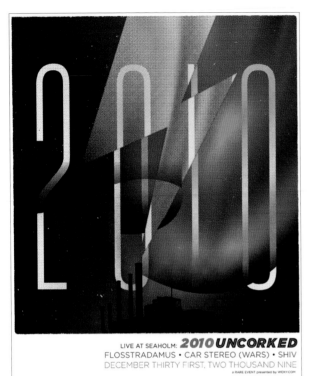

LIVE AT SEAHOLM: **2010 UNCORKED**
FLOSSTRADAMUS • CAR STEREO (WARS) • SHIV
DECEMBER THIRTY FIRST, TWO THOUSAND NINE

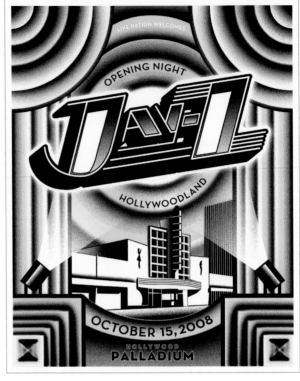

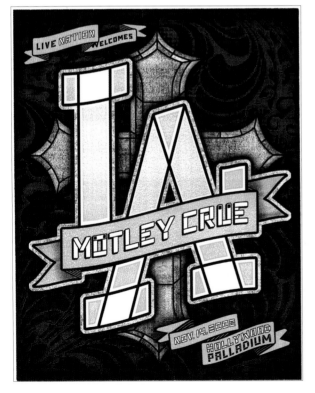

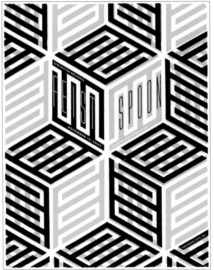

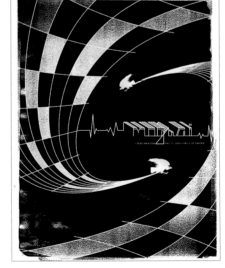

0359–0363 > BOSS CONSTRUCTION

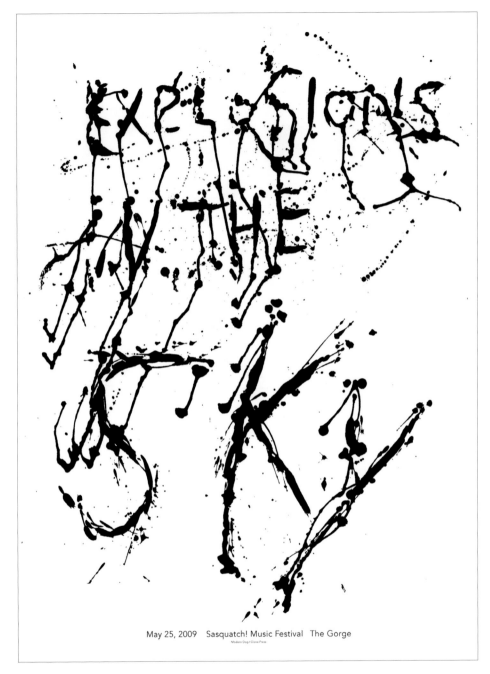

May 25, 2009 Sasquatch! Music Festival The Gorge
Modern Dog / Clone Press

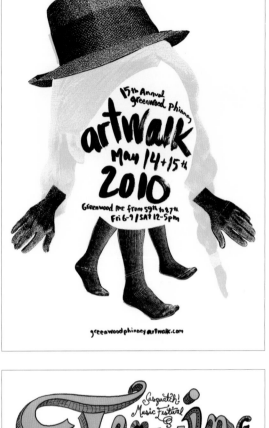

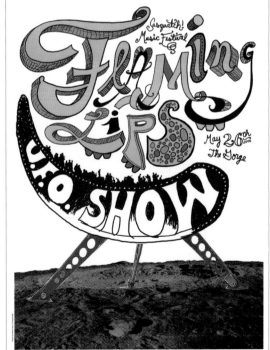

0364–0366 > **MODERN DOG DESIGN CO.**

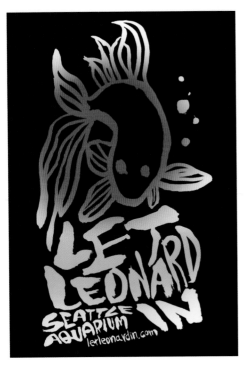

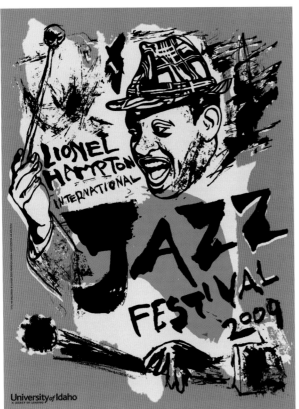

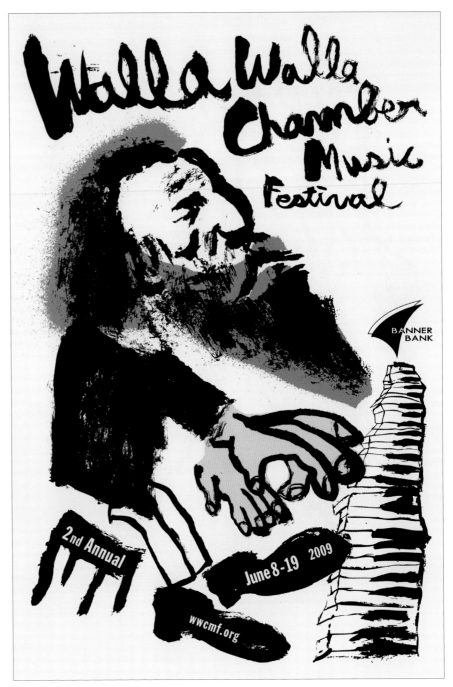

0367–0369 > MODERN DOG DESIGN CO.

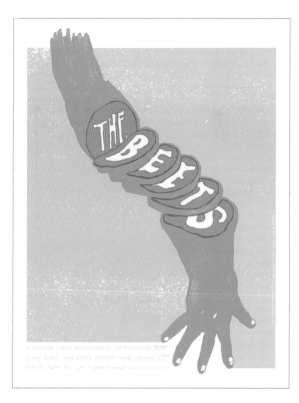

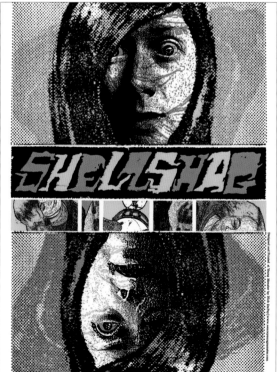

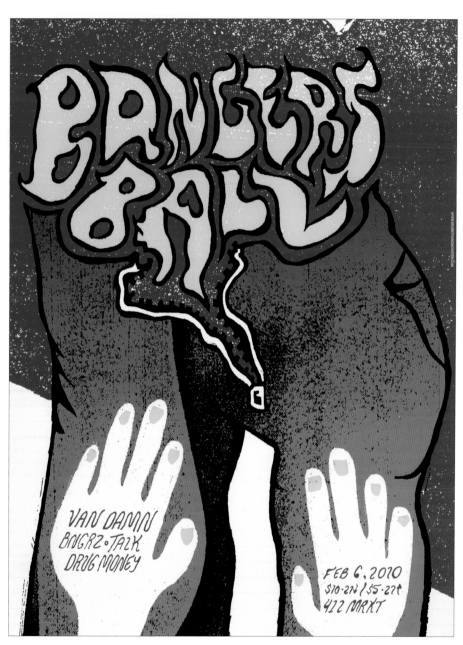

0370—0372 > NICK DUPEY

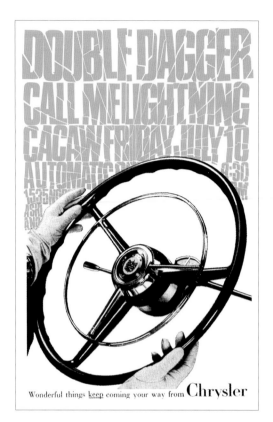

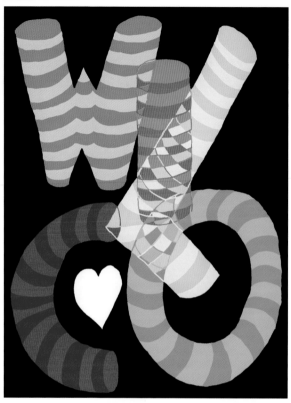

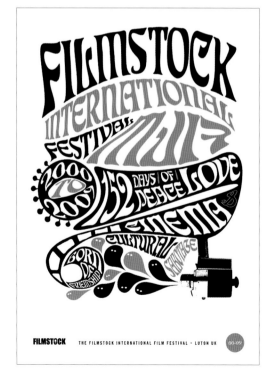

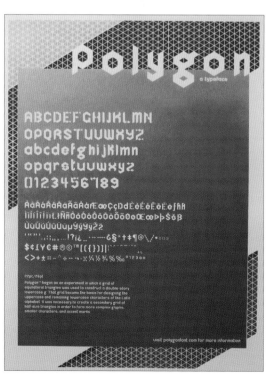

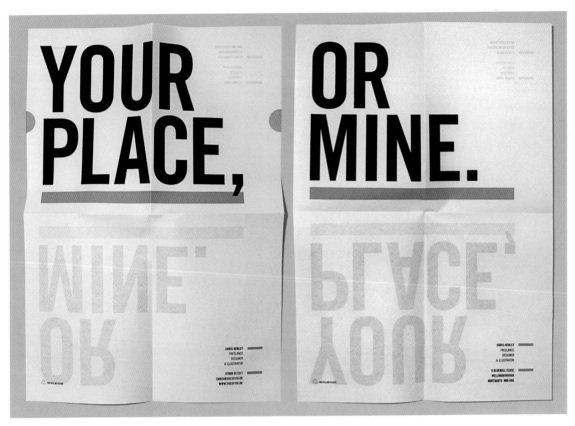

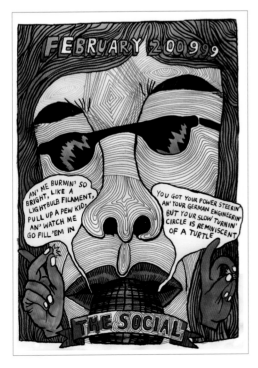

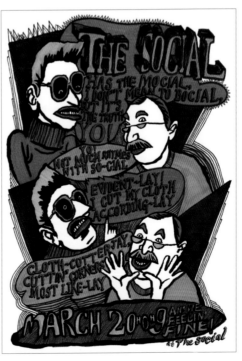

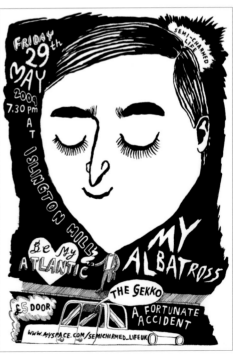

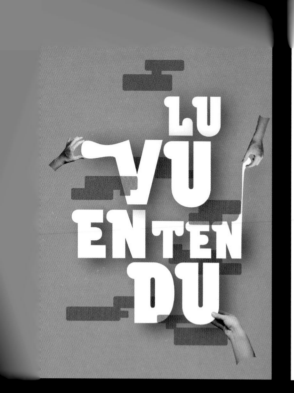

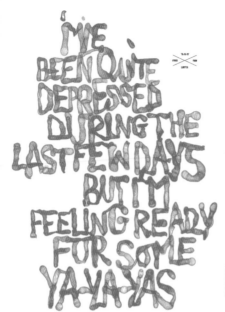

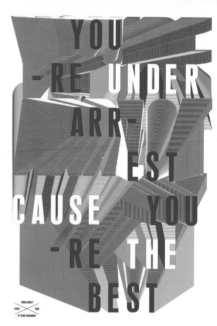

0387—0388 > **TIMOTHY O'DONNELL**

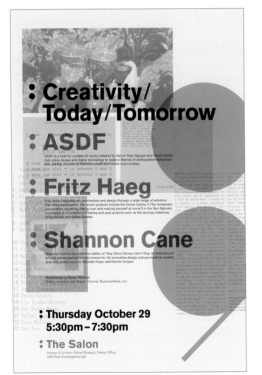

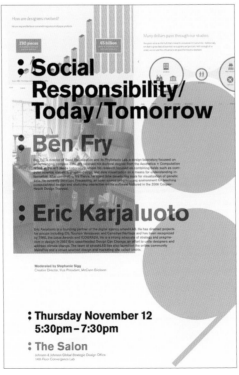

0389–0393 > TIMOTHY O'DONNELL

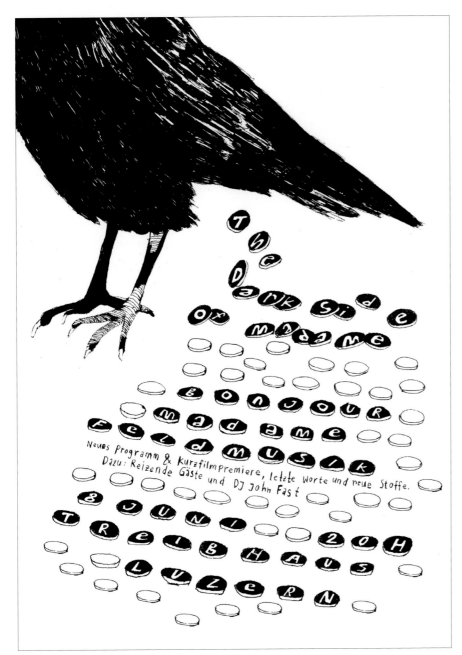

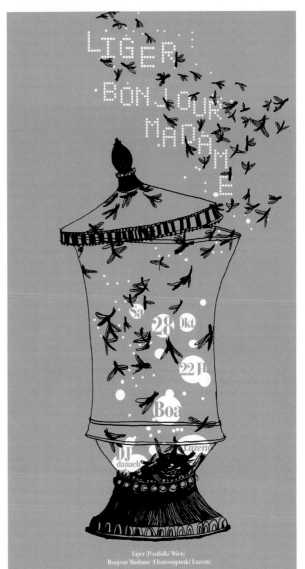

Liger (Postfolk/ Wien)
Bonjour Madame (Chansonpunk/ Luzern)

0394—0395 > PAULA TROXLER

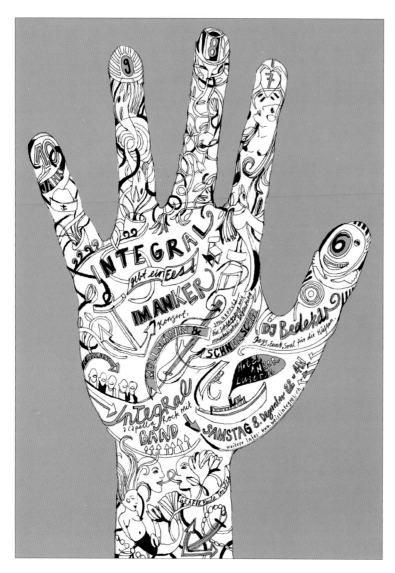

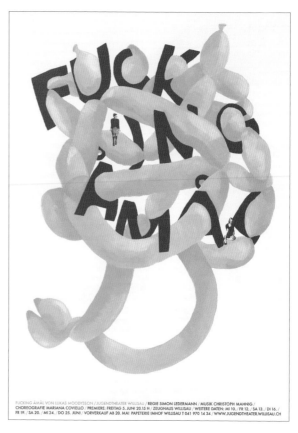

FUCKING ÄMÄL VON LUKAS MOODYSSON / JUGENDTHEATER WILLISAU / REGIE SIMON LEDERMANN / MUSIK CHRISTOPH MAHNIG / CHOREOGRAFIE MARIANA COVIELLO / PREMIERE: FREITAG 5. JUNI 20.15 H / ZEUGHAUS WILLISAU / WEITERE DATEN: MI 10. / FR 12. / SA 13. / DI 16. / FR 19. / SA 20. / MI 24. / DO 25. JUNI / VORVERKAUF AB 20. MAI PAPETERIE IMHOF WILLISAU T 041 970 14 34 / WWW.JUGENDTHEATER.WILLISAU.CH

0396–0398 > PAULA TROXLER

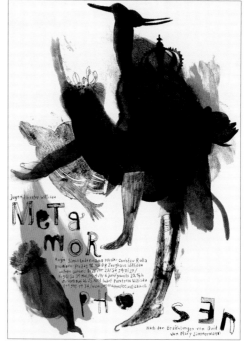

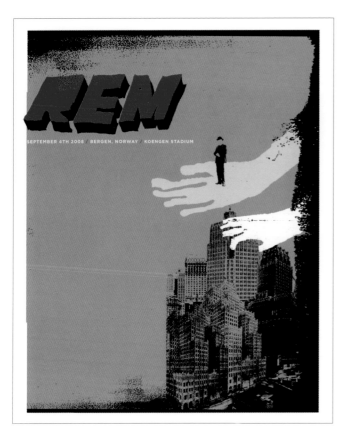

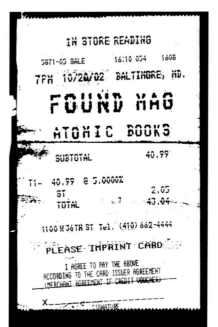

bottom left 0399 > **EXIT10**

upper left 0400 > **PATENT PENDING DESIGN**

upper right 0401 > **EXIT10**

bottom right 0402 > **EXIT10**

bottom center 0403 > **EXIT10**

upper left 0404 > **GREG PIZZOLI**

upper right 0405 > **EYE NOISE**

0406–0407 > EYE NOISE

M. WARD

WITH THE WATSON TWINS | SATURDAY, APRIL 25, 2009 | FIRST AVENUE | 6PM

THE NATIONAL

WITH MY BRIGHTEST DIAMOND
FEBRUARY 22 & 23
BAM OPERA HOUSE, BROOKLYN NY

left 0408 > **AESTHETIC APPARATUS**
right 0409 > **SPIKE PRESS**

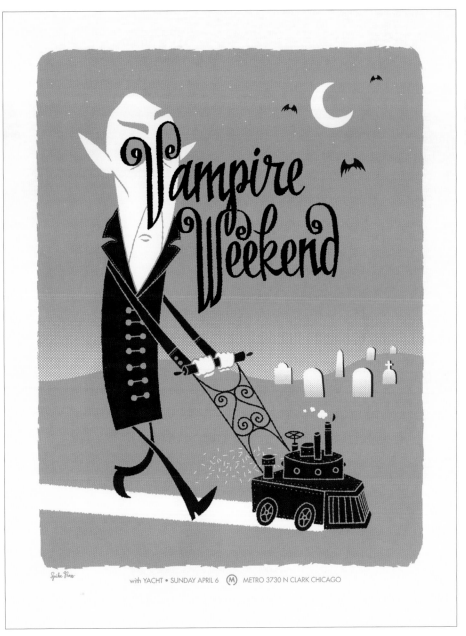

0410—0412 > **SPIKE PRESS**

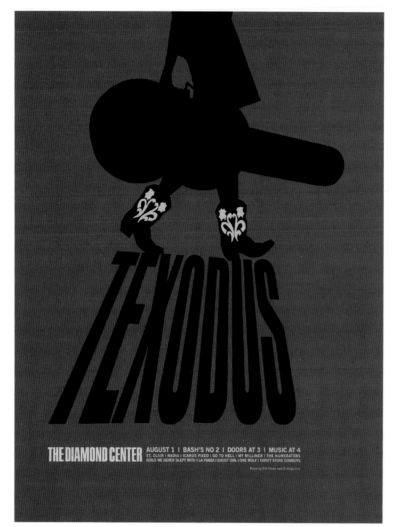

THE DIAMOND CENTER
AUGUST 1 | BASH'S NO 2 | DOORS AT 3 | MUSIC AT 4
ST. CLAIR | NADIA | ICARUS FIXED | GO TO HELL | MY MILLINER | THE NUMERATORS
GIRLS WE NEVER SLEPT WITH | LA PANZA | GHOST OWL | ONE WOLF | THRIFT STORE COWBOYS

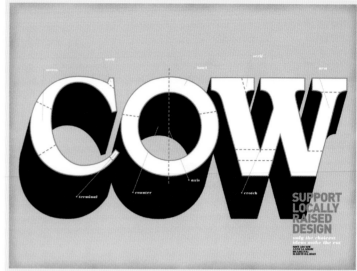

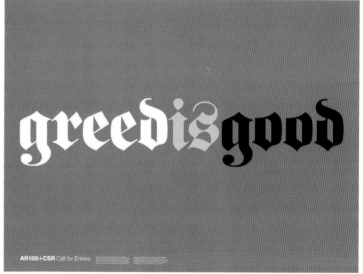

0418—0419 > FRANÇOIS CASPAR

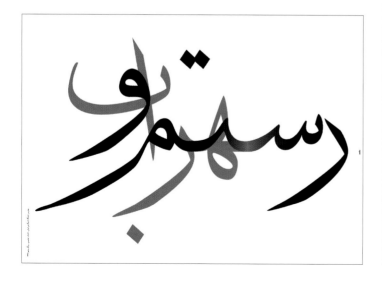

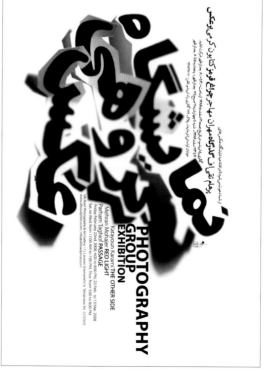

Those who bring sunshine to the lives of others cannot keep it from themselves.
In the memory of Khorramshahr freedom.

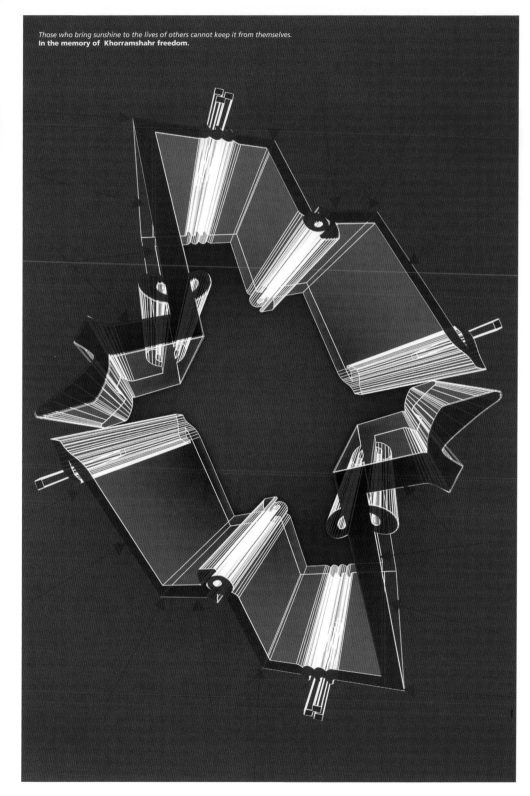

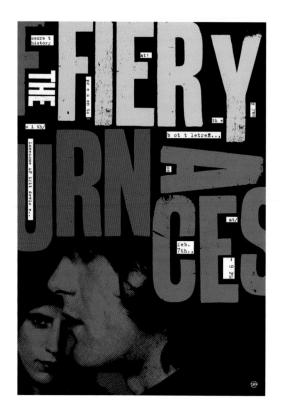

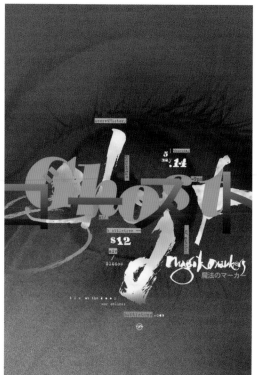

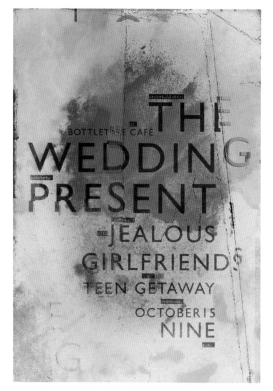

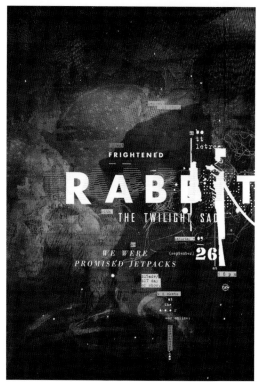

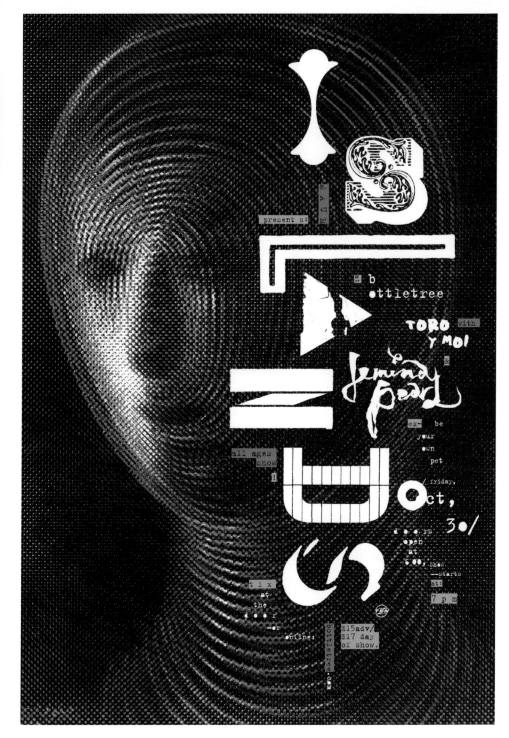

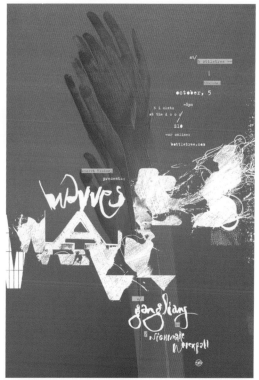

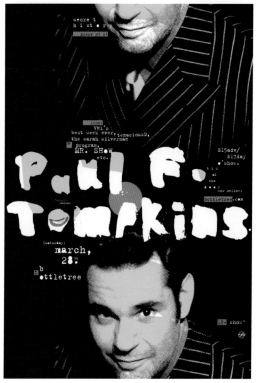

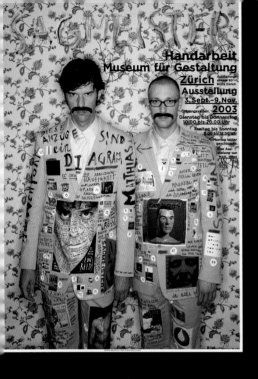
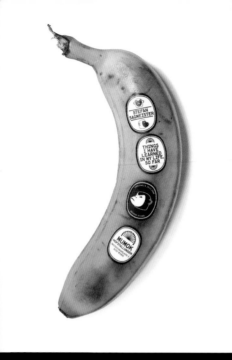
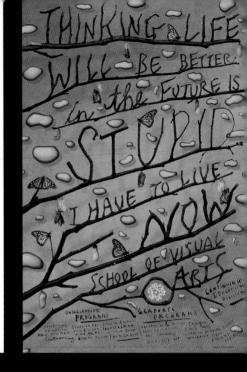

0432–0436 > SAGMEISTER INC.

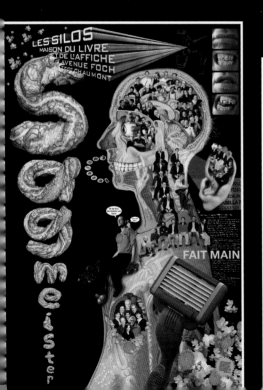
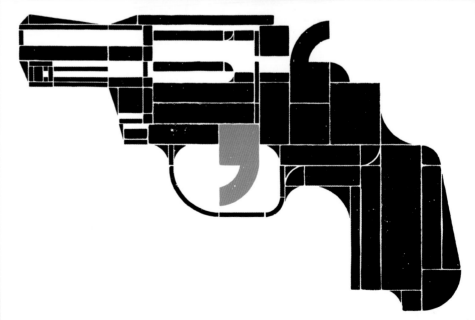

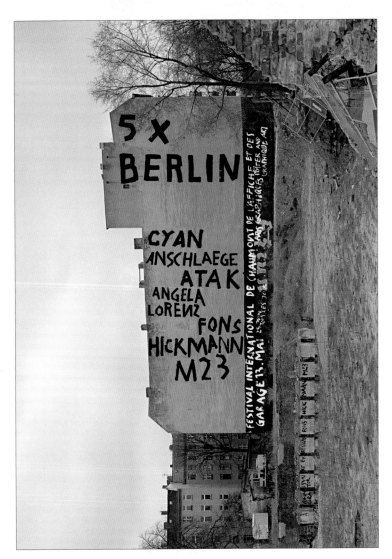

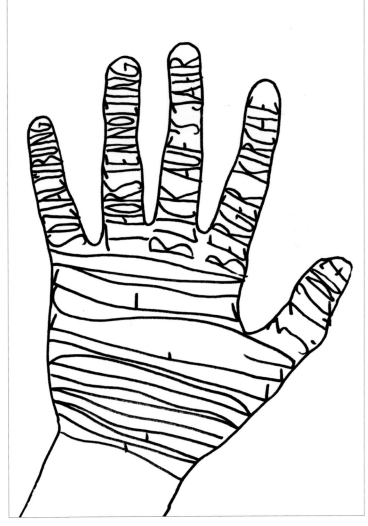

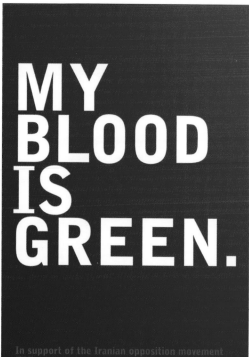

MY
BLOOD
IS
GREEN.

In support of the Iranian opposition movement

S-god figurine (Detail) Pe-god figurine

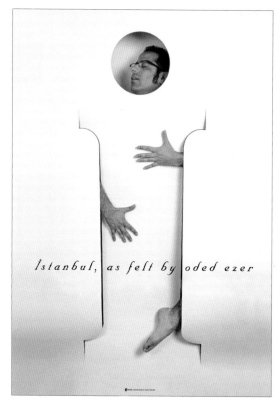

İstanbul, as felt by oded ezer

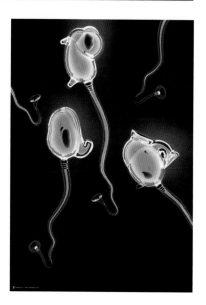

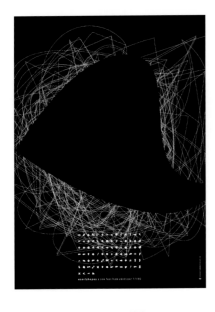

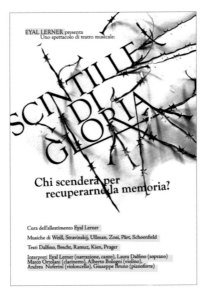

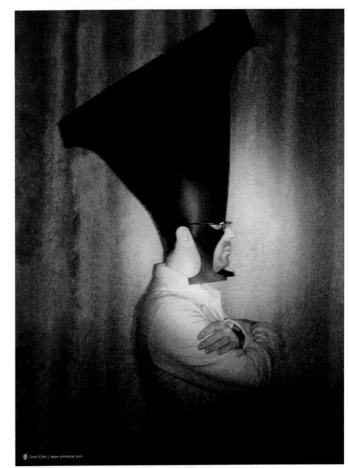

0441–0451 > **ODED EZER**

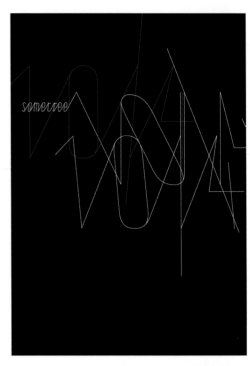

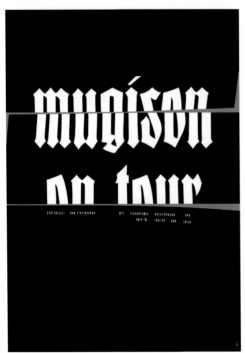

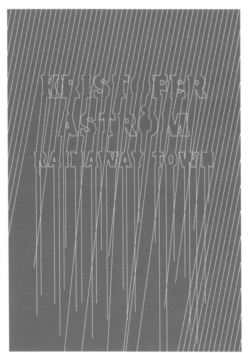

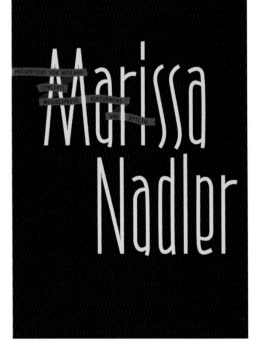

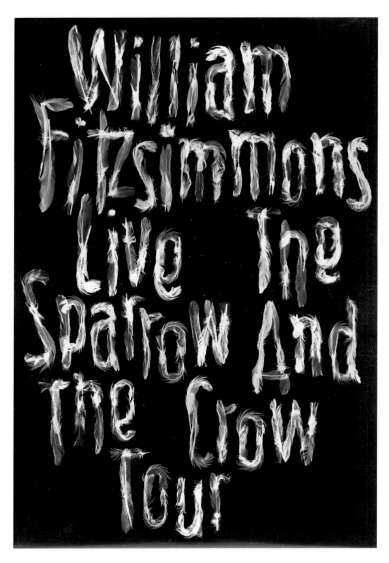

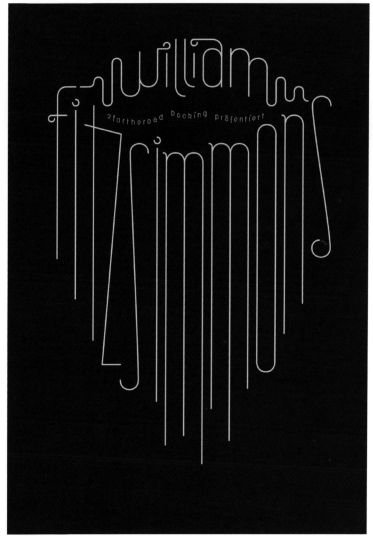

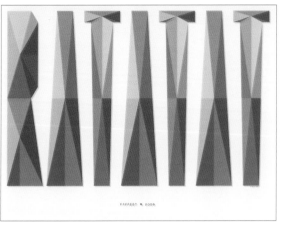

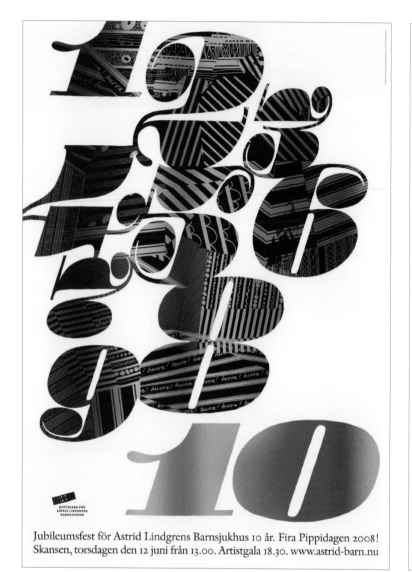

Jubileumsfest för Astrid Lindgrens Barnsjukhus 10 år. Fira Pippidagen 2008!
Skansen, torsdagen den 12 juni från 13.00. Artistgala 18.30. www.astrid-barn.nu

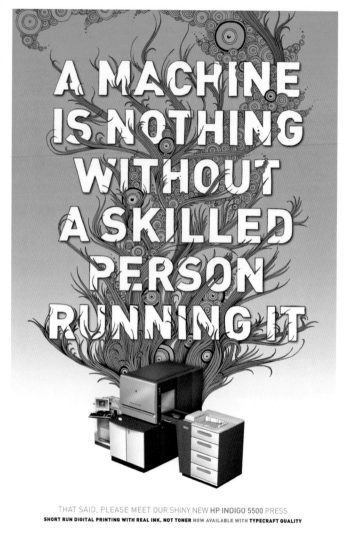

THAT SAID, PLEASE MEET OUR SHINY NEW HP INDIGO 5500 PRESS
SHORT RUN DIGITAL PRINTING WITH REAL INK, NOT TONER NOW AVAILABLE WITH TYPECRAFT QUALITY

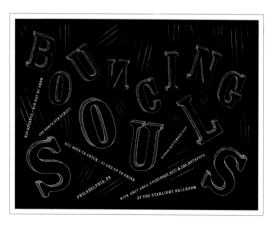

bottom left 0461 > RONALD J. CALLA II
upper left 0462 > JONAS BERGSTRAND
upper right 0463 > 344 DESIGN

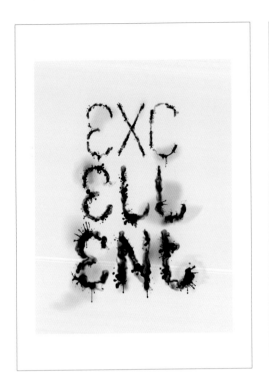

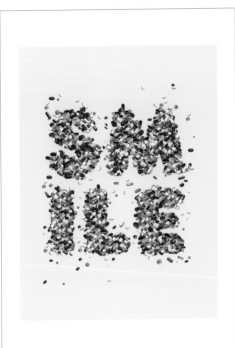

0464–0469 > **STAYNICE**

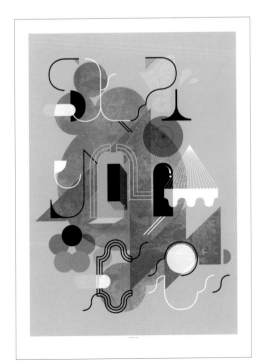

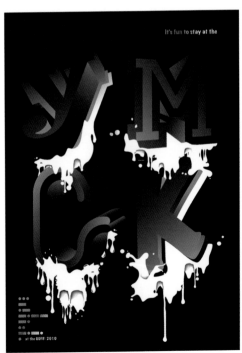

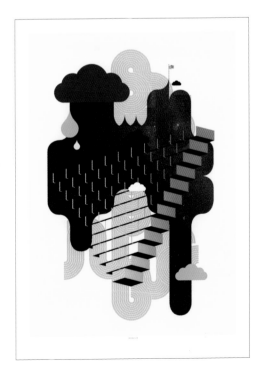

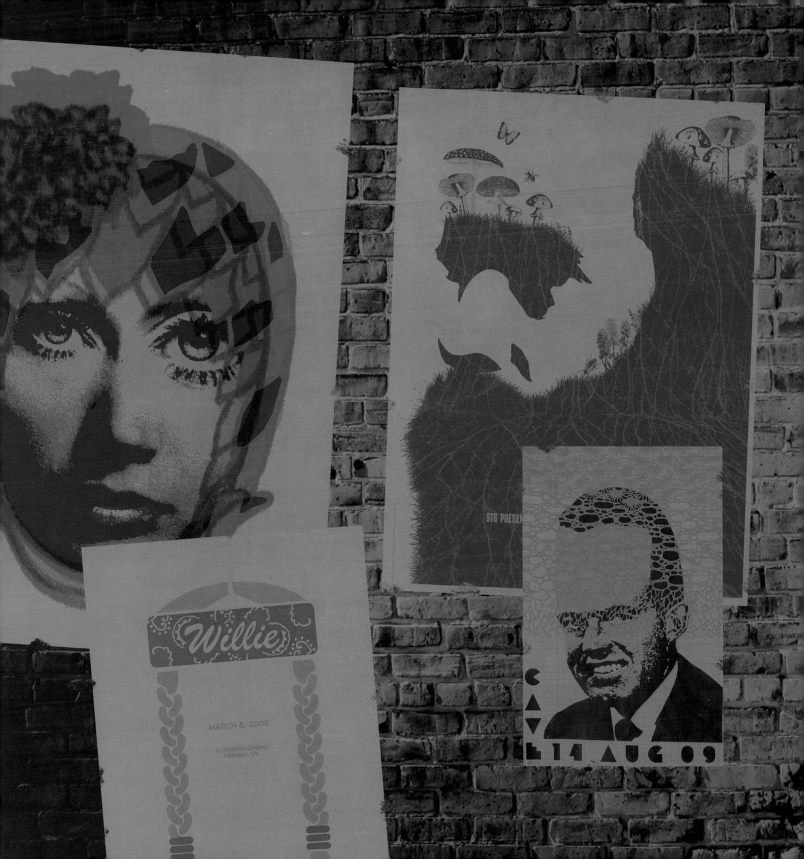

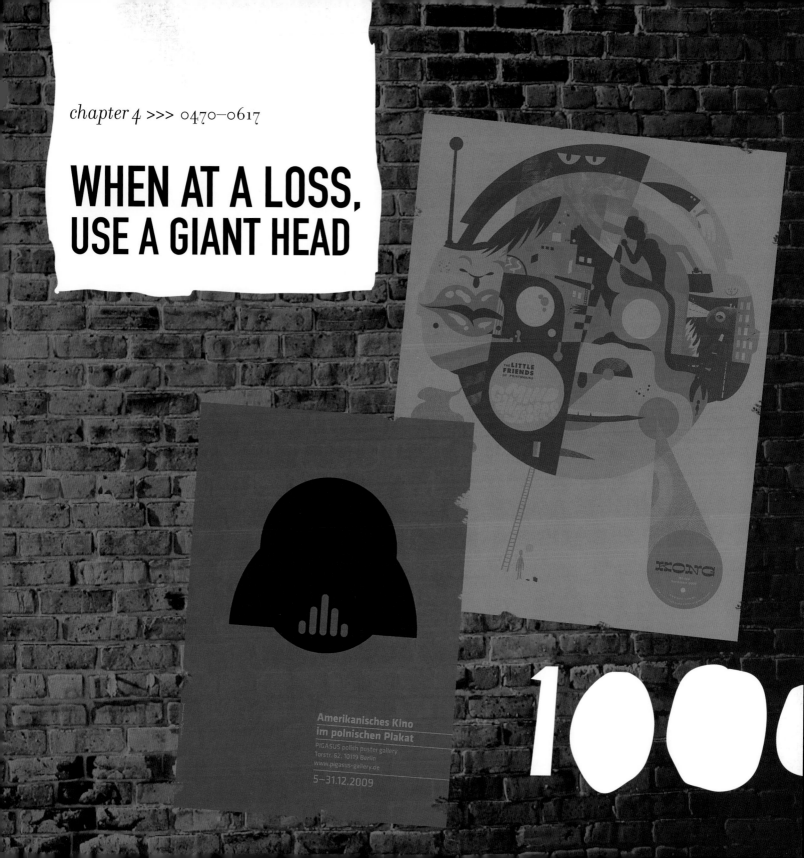

WHEN AT A LOSS,
USE A GIANT HEAD

Amerikanisches Kino
im polnischen Plakat

PIGASUS polish poster gallery
Torstr. 62, 10119 Berlin
www.pigasus-gallery.de

5–31.12.2009

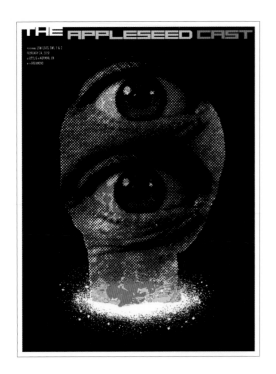

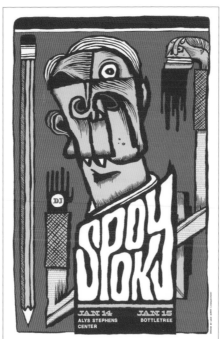

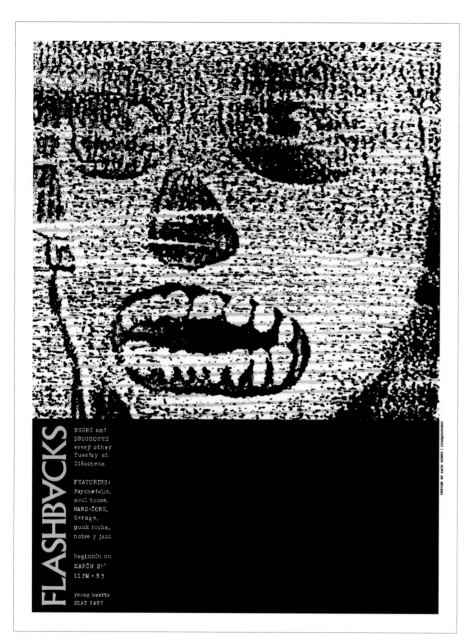

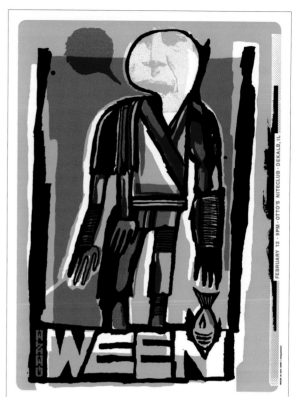

0470—0477 > ZACH HOBBS

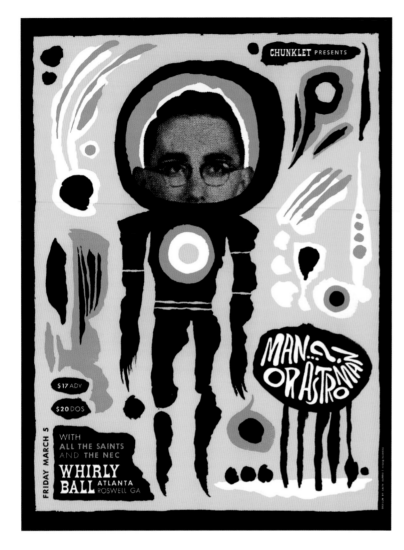

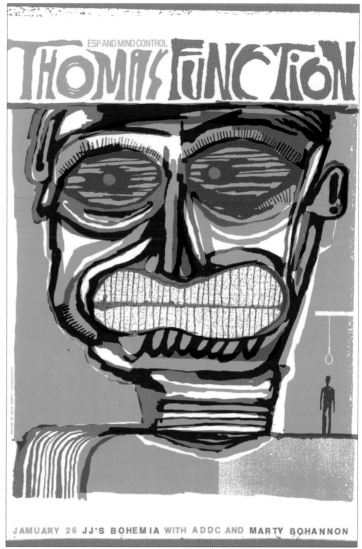

0478–0479 > ZACH HOBBS

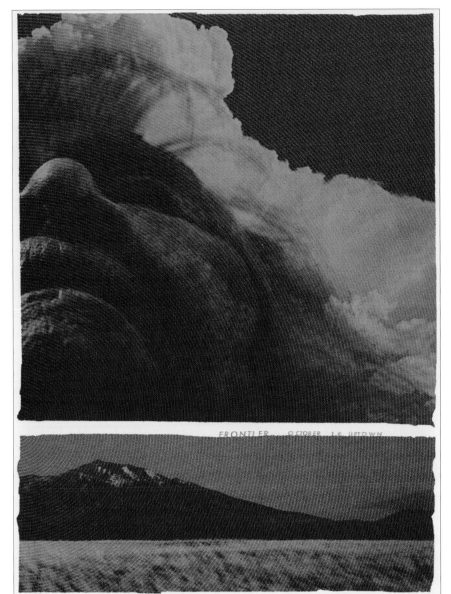

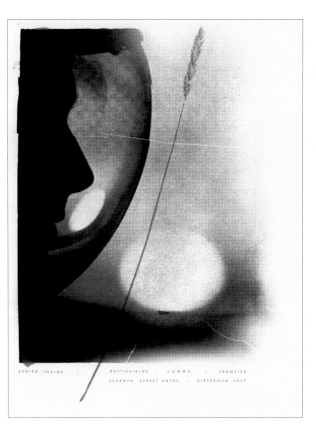

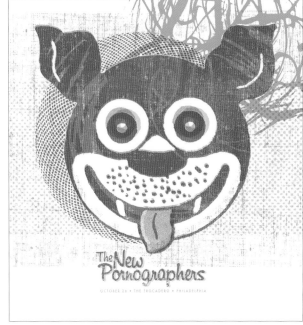

upper left 0480 > STEADY PRINT SHOP CO.

upper right 0481 > STEADY PRINT SHOP CO.

bottom right 0482 > LARGEMAMMAL

The SADiES

3B TAVern Sat. MAY 3
Fist CITY AlaMO SociAL CluB

MONSTERS ARE WAITING

11·13·06 CLUB AT FIRESTONE
DOORS OPEN 7PM
$17 ADVANCE · $19 DAY OF SHOW

ON STAGE

HEY, MAN! DIG THIS CRAZY SHOW for a REAL GONE THRILLER!

DO NOT JUDGE BY ANYTHING SEEN BEFORE!

NOT JUST ANOTHER SPOOK SHOW!

EXCLUSIVE

YOU SEE IT UNCENSORED!

SPOOKTACULAR!

FRIDAY 13

You'll Gasp
You'll Wince
You'll Shudder

LAS VEGAS

YOU'VE NEVER SEEN ANYTHING LIKE IT BEFORE!

DOUBLE DOWN SALOON

IN PERSON...
SUITE 666
THE DOLLYROTS
the MISSION CREEPS
the RESISTORS

ESTRUS WRECKERS PRESENTS
GARAGE ROCK ASS MASTERS

mono MEN

FIRST SHOW IN A DECADE

WITH
STAR SPANGLED BASTARDS
THE BRYAN ELLIOT BAND

SAT.
**APRIL 8.
2006**
3B TAVRN

THE **SUPERVILLIANS!**

NOVEMBER 14

AT THE SOCIAL PAVILLION

18 AND UP DOORS AT 8PM, $15
TICKETS AT THE SOCIAL
BOX OFFICE AND AT THE
DOOR AND TICKETMASTER

ANTIPOP

0483—0491 > ART CHANTRY DESIGN CO.

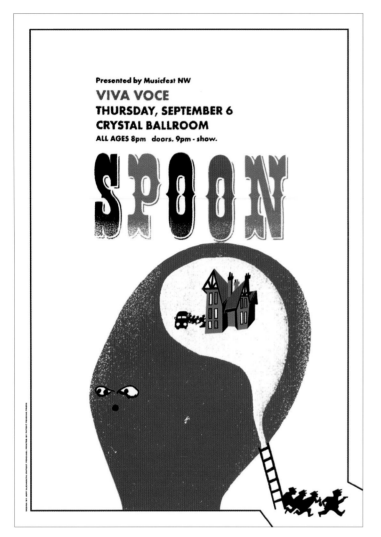

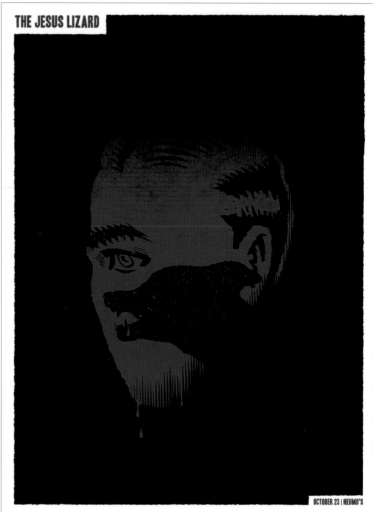

0492–0493 > PATENT PENDING DESIGN

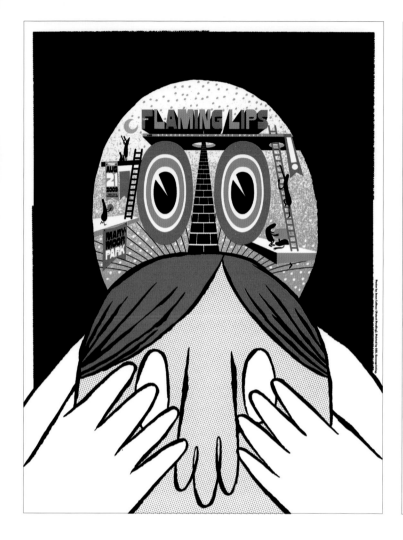

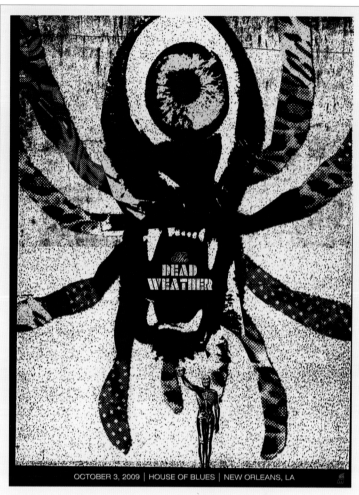

upper left ○494 > **PATENT PENDING DESIGN**
upper right ○495 > **METHANE STUDIOS**

Call + Response

Hamiltonian Gallery Washington DC January 23 – February 13 2010

left 0496 > **DIRTY PICTURES**

upper right 0497 > **ZELOOT**

bottom right 0498 > **ZELOOT**

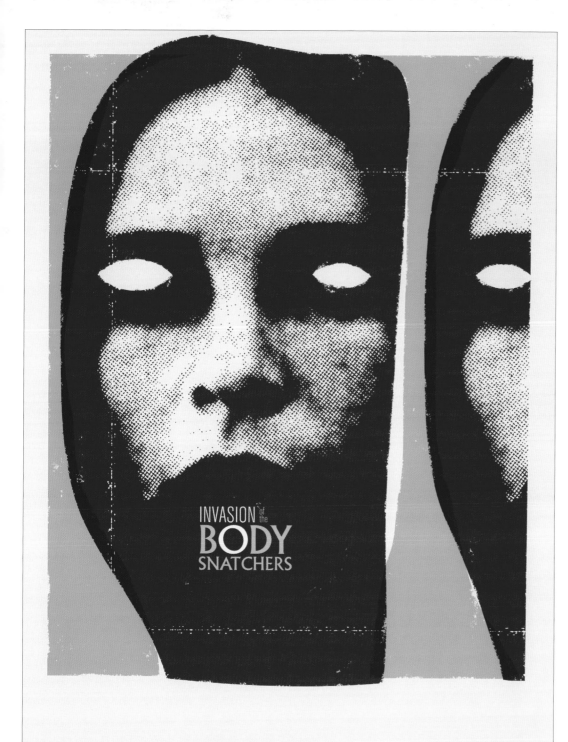

INVASION of the
BODY
SNATCHERS

TERROR THURSDAY PRESENTS Invasion of the Bodysnatchers FREE • NOVEMBER 20TH, 2008
ALAMO DRAFTHOUSE CINEMA AT THE RITZ • 1120 S. LAMAR BLVD • AUSTIN TX 78701 INFO AT WWW.ORIGINALALAMO.COM • POSTER BY THE HEADS OF STATE

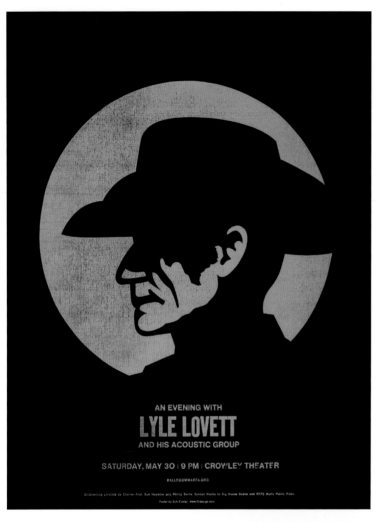

AN EVENING WITH

LYLE LOVETT
AND HIS ACOUSTIC GROUP

SATURDAY, MAY 30 | 9 PM | CROWLEY THEATER

BALLROOMMARFA.ORG

Underwriting provided by Charles Attal, Eve Hostetter and Phillip Soine. Special thanks to Big House Sound and KRTS Marfa Public Radio.

Poster by Dirk Fowler, www.f2-design.com

MARCH 8, 2008

RIVERWIND CASINO
NORMAN, OK

Poster By Dirk Fowler f2-design.com

0500—0502 > **F2 DESIGN**

WILCO
APRIL 20, 2009 • ATHENS, GA
CLASSIC CENTER

WILCO
TEMPLETON • BLACKBURN ALUMNI MEMORIAL AUDITORIUM
APRIL 17, 2009 • ATHENS, OH

Poster by Dirk Fowler f2-design.com

0503–504 > **NATE DUVAL**

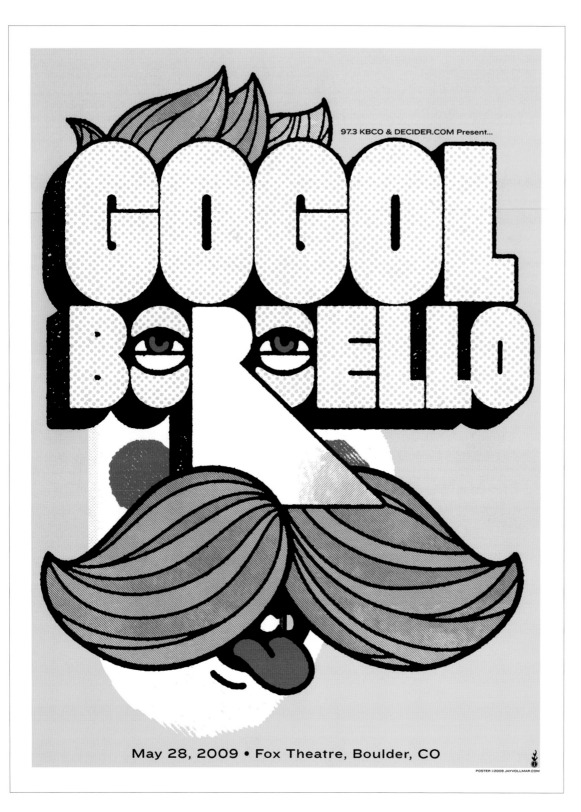

97.3 KBCO & DECIDER.COM Present...

GOGOL BORDELLO

May 28, 2009 • Fox Theatre, Boulder, CO

POSTER ©2009 JAYVOLLMAR.COM

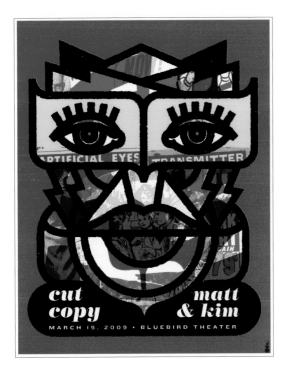

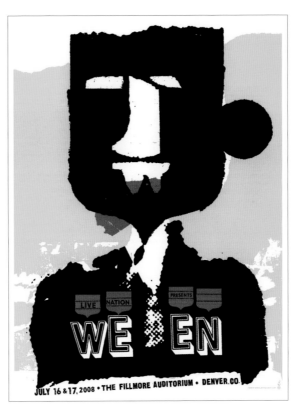

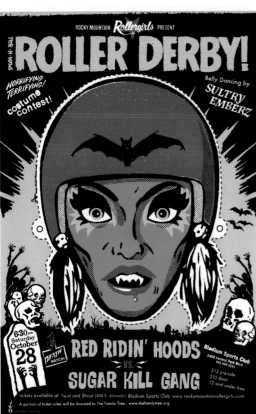

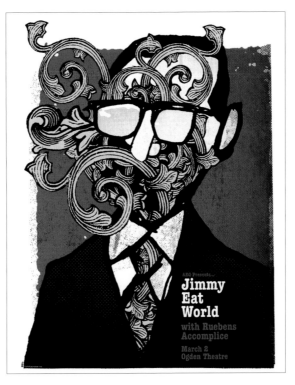

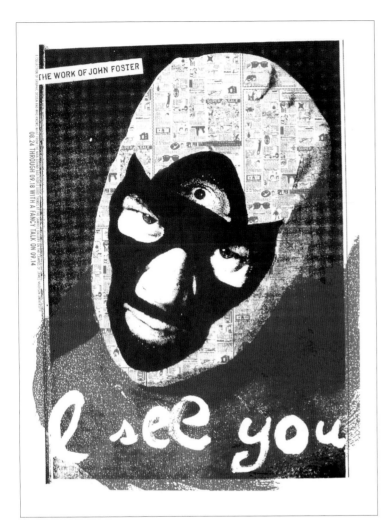

THE WORK OF JOHN FOSTER

08.24 THROUGH 09.18 WITH A FANCY TALK ON 09.14

I see you

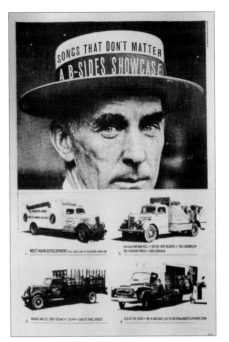

SONGS THAT DON'T MATTER
A B-SIDES SHOWCASE

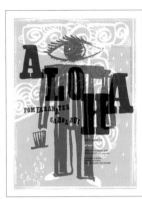

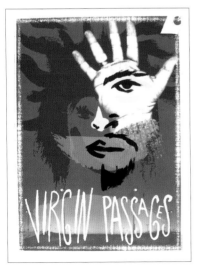

VIRGIN PASSAGES

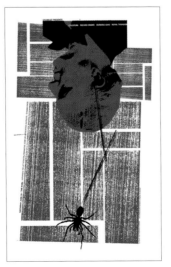

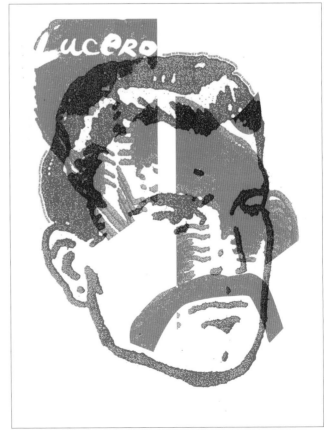

Lucero

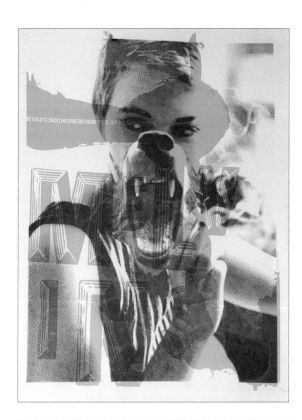

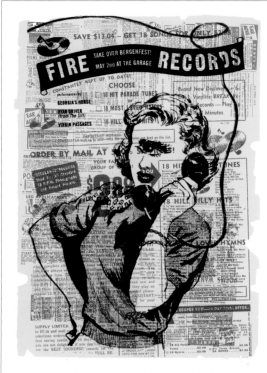

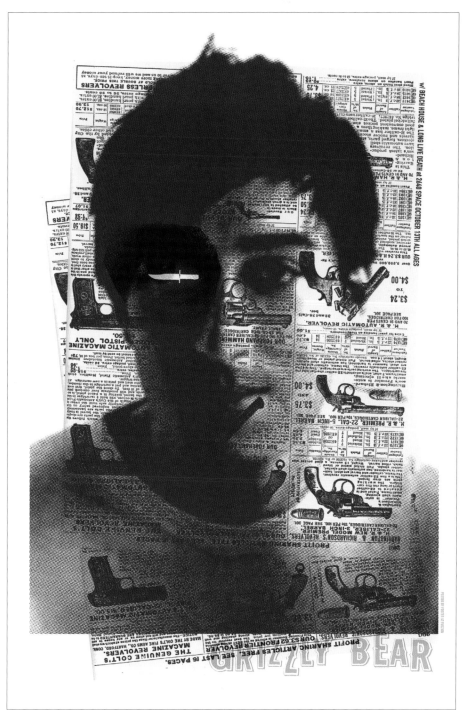

0510—518 > BAD PEOPLE GOOD THINGS

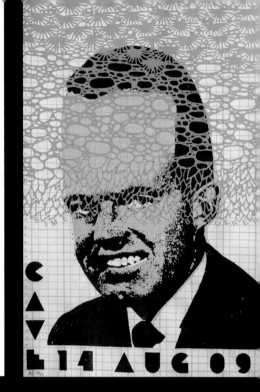

melvins

Playing 2 Sets at The Conservatory
Aug 25 2009

POSTER: DENNYSCHMICKLE.COM

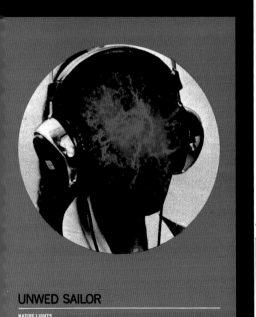

UNWED SAILOR

NATIVE LIGHTS
MAN PLUS BUILDING
FRI DEC 4TH
SPANISH MOON BULLHORN BANDITS PRESENT

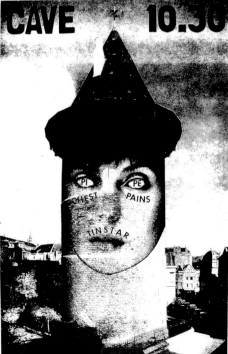

CAVE 10.30

ALBERTA CROSS + THE HENRY CLAY PEOPLE

0524–526 > PAULA TROXLER

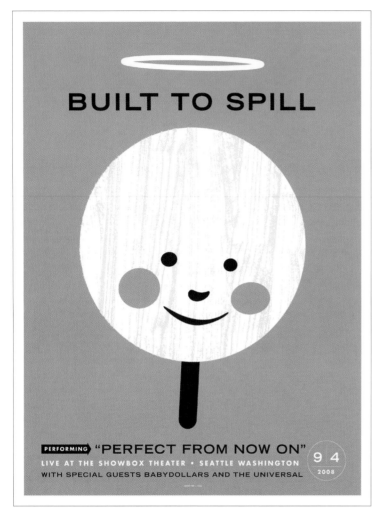

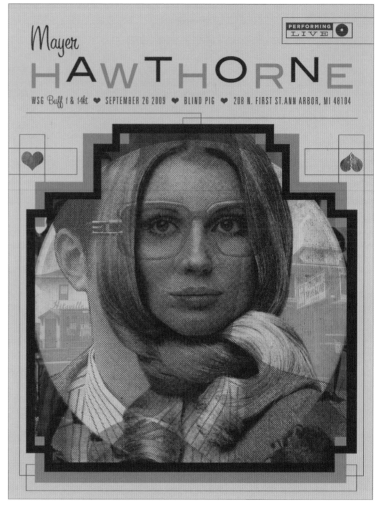

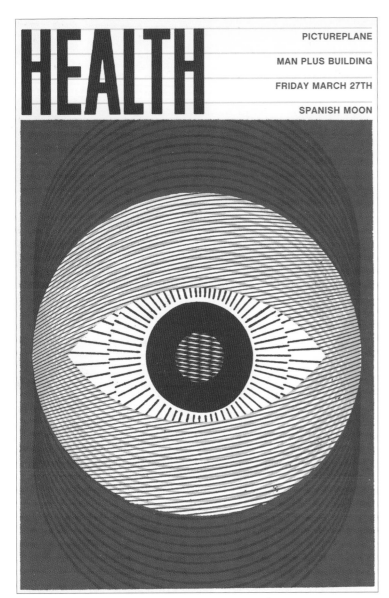

HEALTH

PICTUREPLANE

MAN PLUS BUILDING

FRIDAY MARCH 27TH

SPANISH MOON

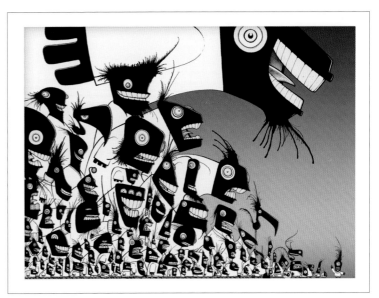

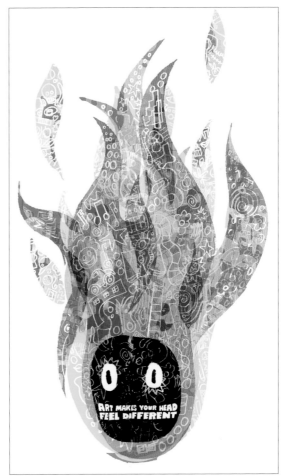

ART MAKES YOUR HEAD FEEL DIFFERENT

upper left 0531 > **SCOTT CAMPBELL**
upper right 0532 > **344 DESIGN**
bottom right 0533 > **HENDERSONBROMSTEADART**

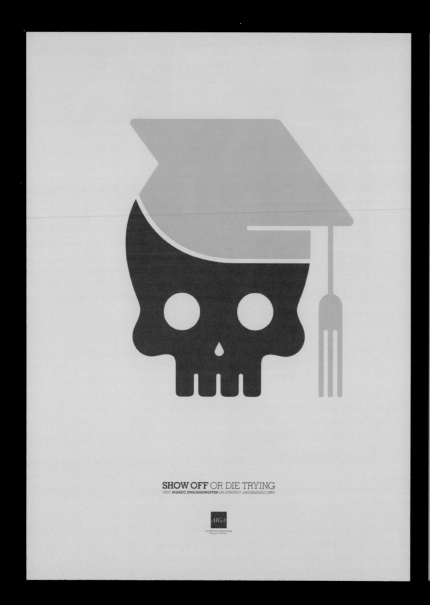

SHOW OFF OR DIE TRYING
VISIT **AIGADC.ORG/SHOWOFF09** OR CONTACT JAKE@AIGADC.ORG

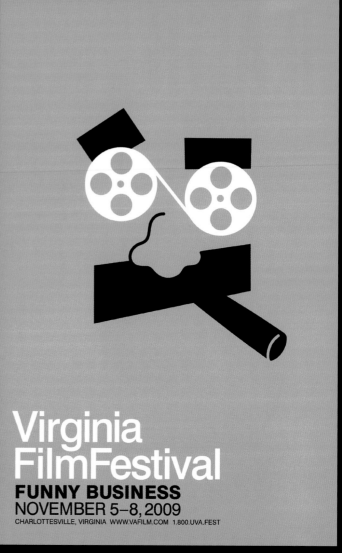

Virginia
FilmFestival
FUNNY BUSINESS
NOVEMBER 5–8, 2009
CHARLOTTESVILLE, VIRGINIA WWW.VAFILM.COM 1.800.UVA.FEST

0534–0535 > DESIGN ARMY

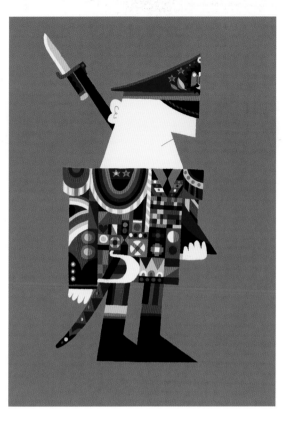

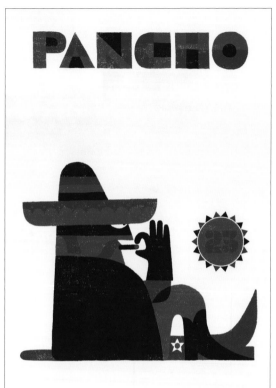

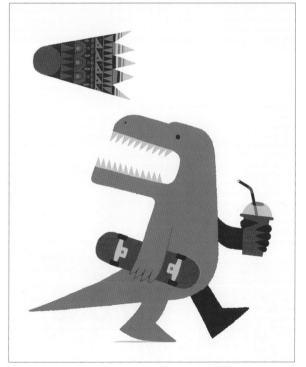

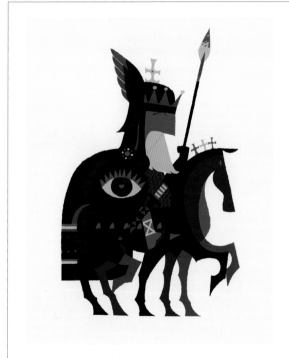

0536–0539 > ADRIAN JOHNSON

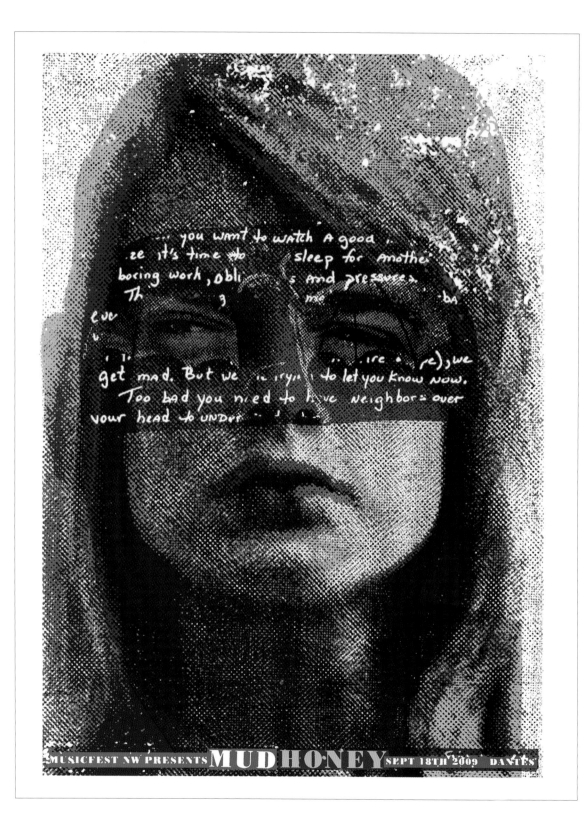

0540—0541 > JOANNA WECHT

upper left ○542 > JOANNA WECHT

upper right ○543 > BOSS CONSTRUCTION

bottom right ○544 > BOSS CONSTRUCTION

bottom center ○545 > JOANNA WECHT

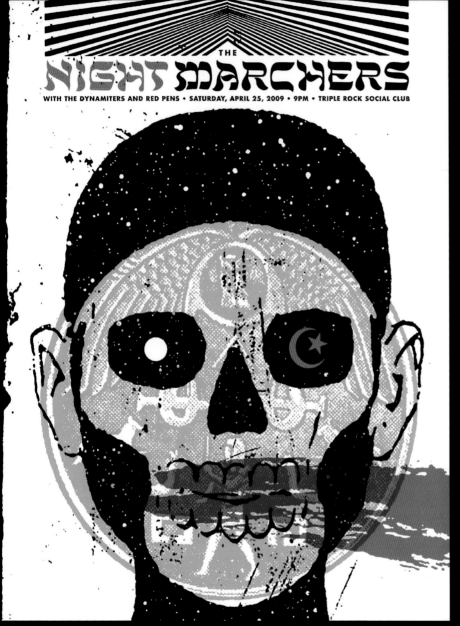

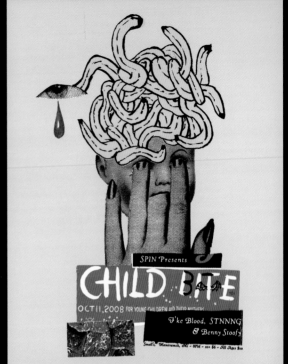

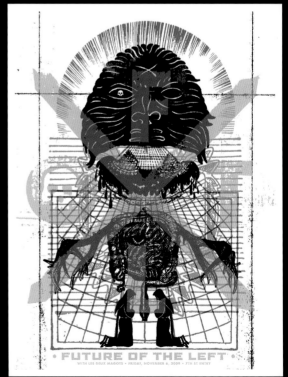

0546—0548 > AESTHETIC APPARATUS

upper left 0551 > HATCH

upper right 0552 > MY ASSOCIATE CORNELIUS

0553–0555 > MY ASSOCIATE CORNELIUS

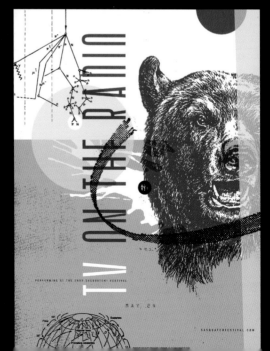

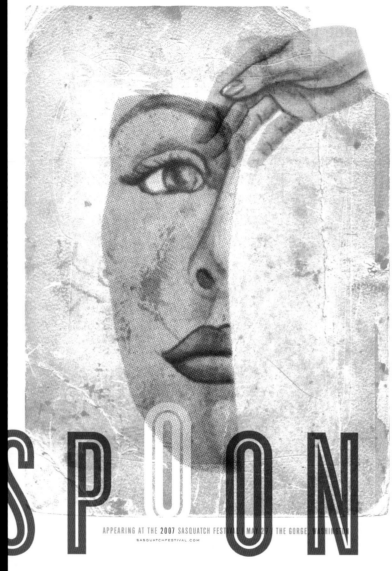

0556—0558 > INVISIBLE CREATURE

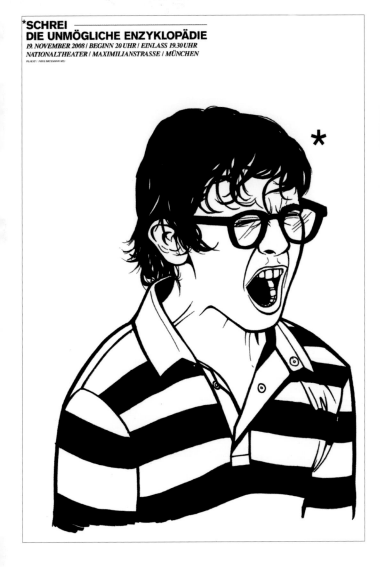

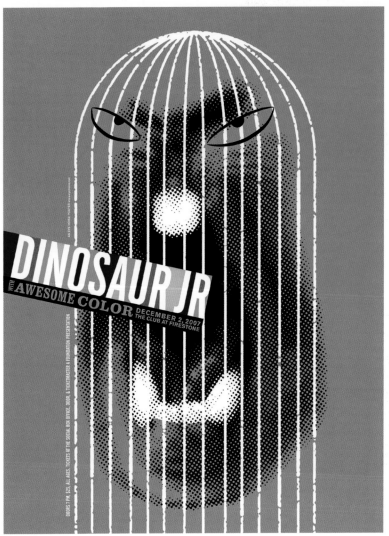

oct 25-nov 4

THEATRE
PROJECT

2007/08 Season 45 West Preston Street Baltimore (410) 752-8558 www.theatreproject.org

AN ANTIDOTE FILMS PRODUCTION OF A KEVEN McALESTER FILM "THE DUNGEON MASTERS" EXECUTIVE PRODUCERS MATT MANFREDI / PHIL HAY PRODUCERS JEFFREY LEVY-HINTE / BRIAN GERBER & KIL SEMORS SUPERVISING EDITOR VICTOR LIVINGSTON EDITOR CHRISTINE KHALAFIAN ORIGINAL SCORE BLONDE REDHEAD CINEMATOGRAPHER LEE DANIEL DIRECTOR KEVEN McALESTER

BEING THE ADVENTURES OF 3 AMERICANS WHO PLAY DUNGEONS & DRAGONS

THE DUNGEON MASTERS

THIS IS HOW THEY ROLL

Baltimore: The Opera nov 29-dec 9

THEATRE
BALTIMORE IN AMERICA
PROJECT

2007/08 Season 45 West Preston Street Baltimore (410) 752-8558 www.theatreproject.org

0569—0571 > TIM GOUGH

04.24.2008 VALARIUM
KNOXVILLE, TENNESSEE **BLACK REBEL MOTORCYCLE CLUB**

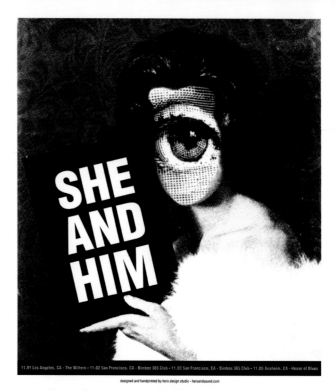

SHE AND HIM

11.01 Los Angeles, CA · The Wiltern · 11.02 San Francisco, CA · Bimbos 365 Club · 11.03 San Francisco, CA · Bimbos 365 Club · 11.05 Anaheim, CA · House of Blues

designed and handprinted by hero design studio · heroandsound.com

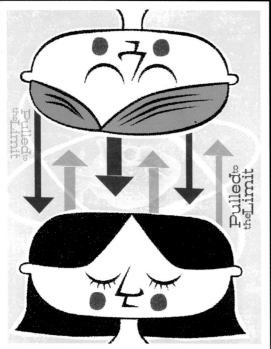

Pulled to the Limit

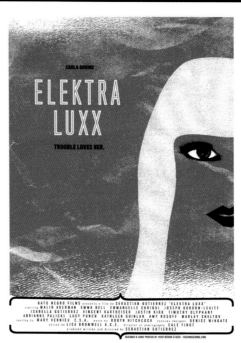

CARLA GUGINO

ELEKTRA LUXX

TROUBLE LOVES HER.

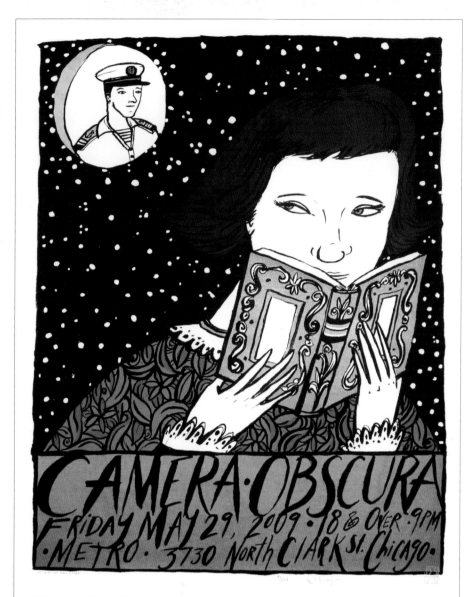

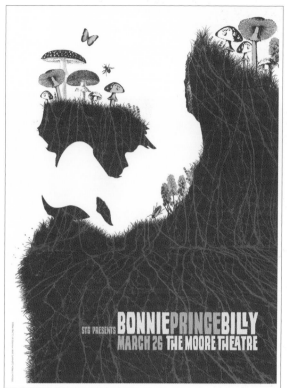

upper left 0576 > DIANA SUDYKA
upper right 0577 > FRIDA CLEMENTS DESIGN

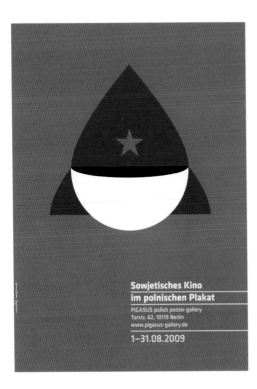

Sowjetisches Kino
im polnischen Plakat
PIGASUS polish poster gallery
Torstr. 62, 10119 Berlin
www.pigasus-gallery.de
1–31.08.2009

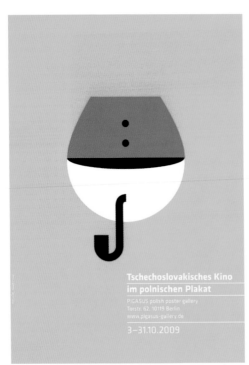

Tschechoslovakisches Kino
im polnischen Plakat
PIGASUS polish poster gallery
Torstr. 62, 10119 Berlin
www.pigasus-gallery.de
3–31.10.2009

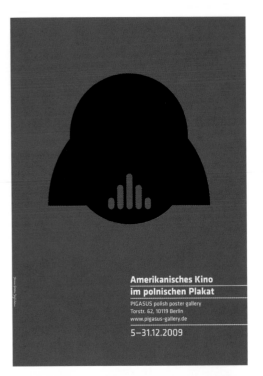

Amerikanisches Kino
im polnischen Plakat
PIGASUS polish poster gallery
Torstr. 62, 10119 Berlin
www.pigasus-gallery.de
5–31.12.2009

0578–0583 > HOMEWORK

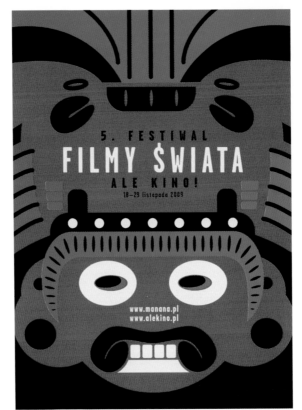

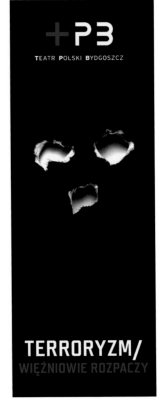

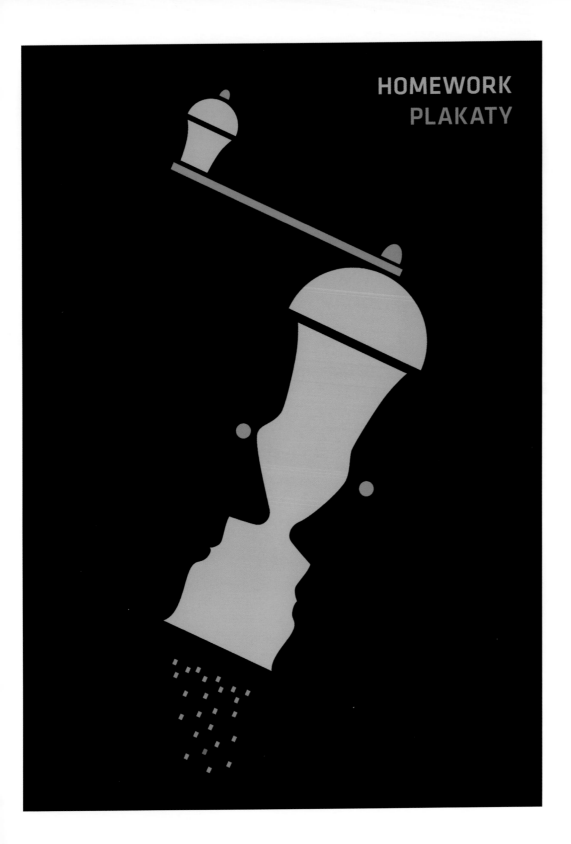

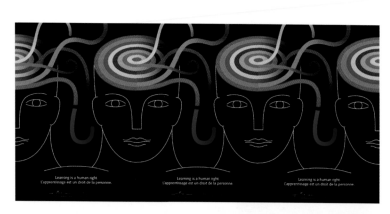

Learning is a human right.
L'apprentissage est un droit de la personne.

Learning is a human right.

2010
INTERNATIONAL YEAR
FOF THE RAPPROCHEMENT OF CULTURES

THEATRE DE LA TETE NOIRE

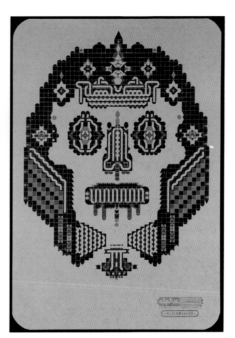

bottom left 0588 > **BENDITA GLORIA**
upper left 0589 > **WERNER DESIGN WERKS**
upper center 0590 > **YEE-HAW INDUSTRIES**
bottom right 0591 > **BENDITA GLORIA**
bottom center 0592 > **BENDITA GLORIA**

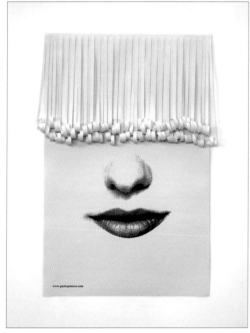

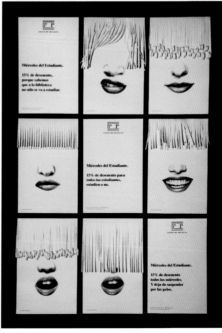

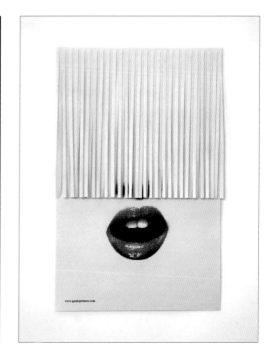

0593–0596 > THE LITTLE FRIENDS OF PRINTMAKING

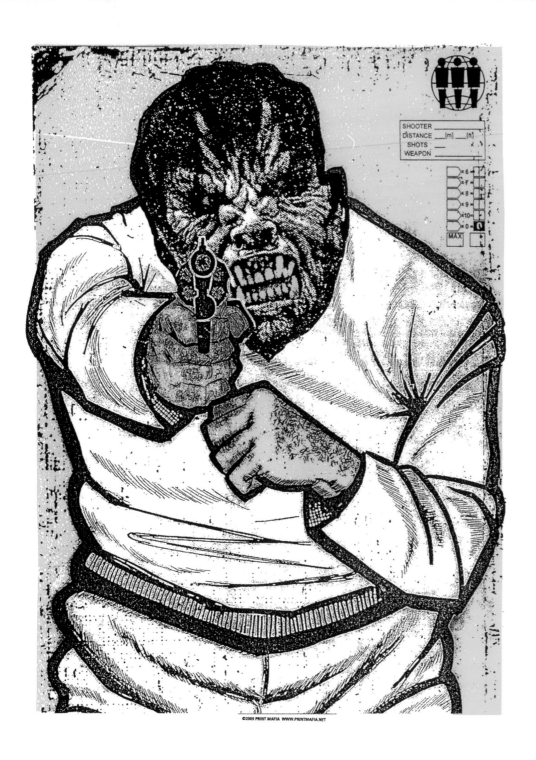

0598–0602 > SUSSNER DESIGN CO.

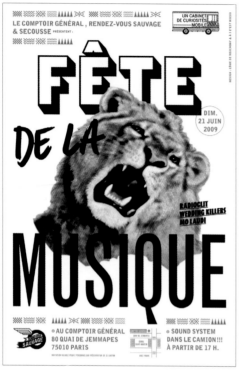

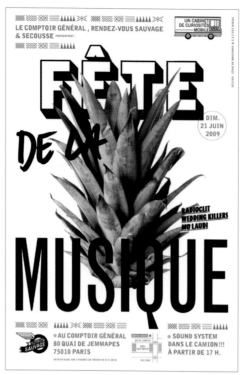

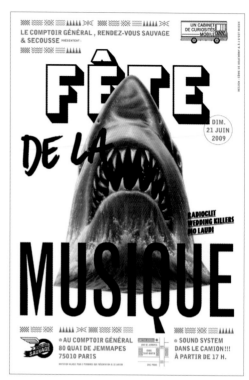

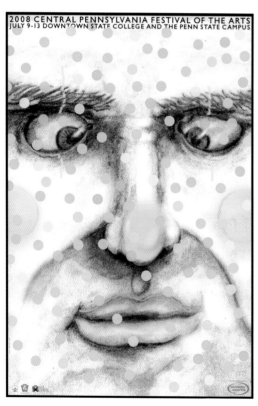

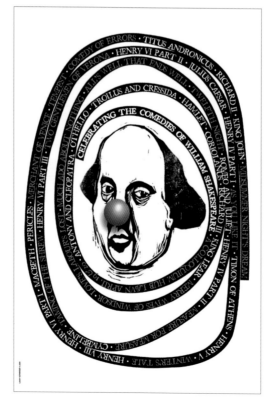

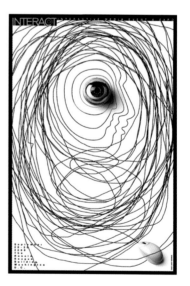

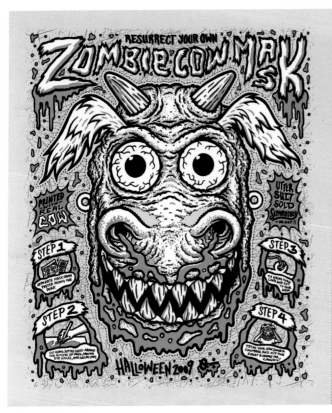

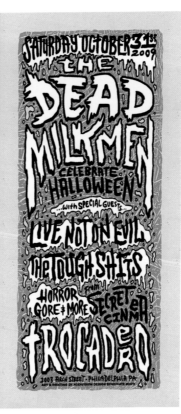

bottom left 0609 > **LANNY SOMMESE**

upper left 0610 > **NODIVISION**

bottom right 0611 > **GREG BENNETT**

bottom center 0612 > **GREG BENNETT**

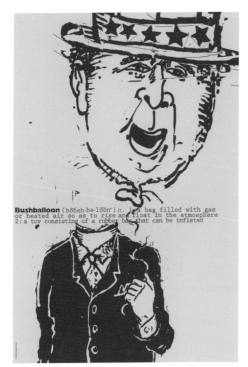

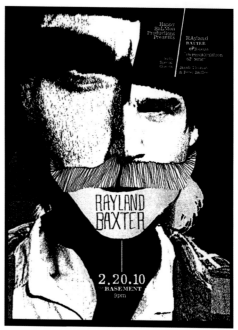

left 0613 > TODD SLATER

upper right 0614 > NICK DUPEY

bottom right 0615 > NICK DUPEY

0616—0617 > **HORT**

love
modernism.
hate
mods.

reading

a limnaic

VOTE!

ATELIER HSL PARIS

20

HIGH-SPEED

TRAIN

EUROPE

NETWORK

EBERSWALDER STR. 10 - 11
10437 BERLIN
EINTRITT 14 / ERM. 10 EURO
TICKET@HALLE-TANZ-BERLIN.DE
WWW.HALLE-TANZ-BERLIN.DE

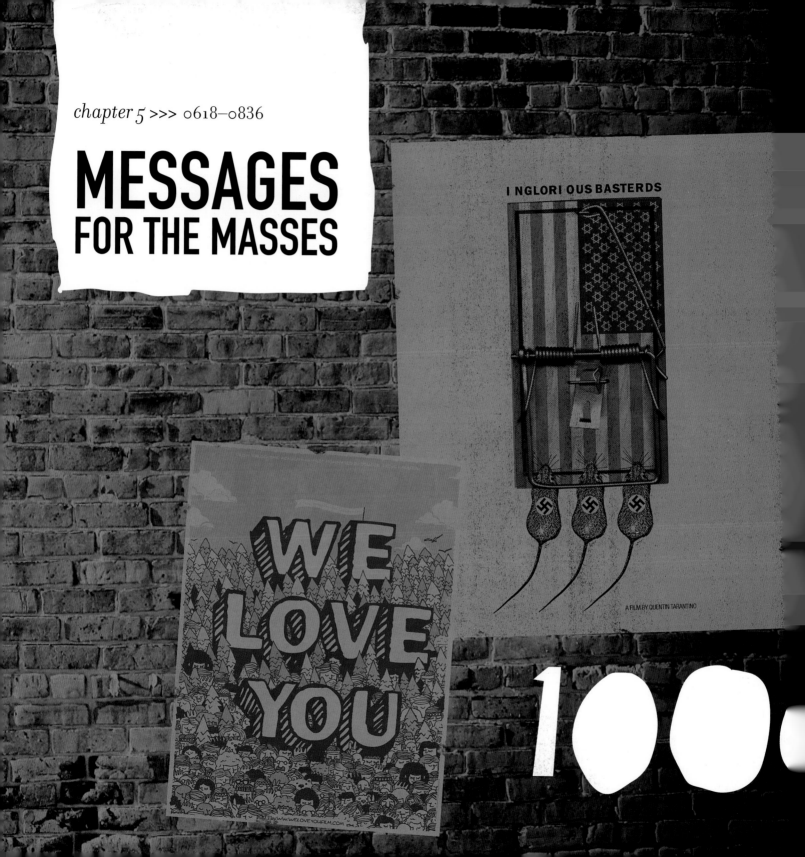

MESSAGES
FOR THE MASSES

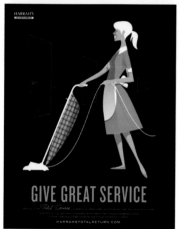
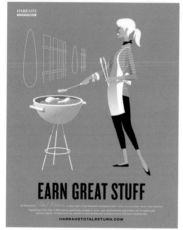
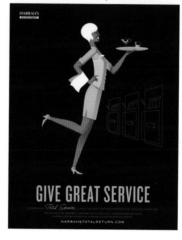
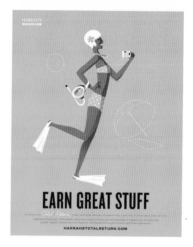

top 0622–0629 **>** HATCH
bottom right 0630 **>** LANNY SOMMESE

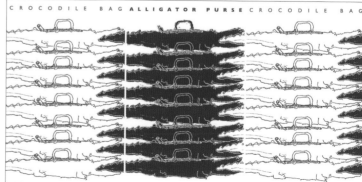

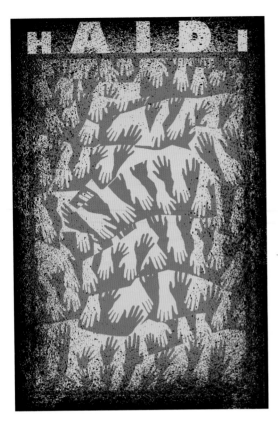

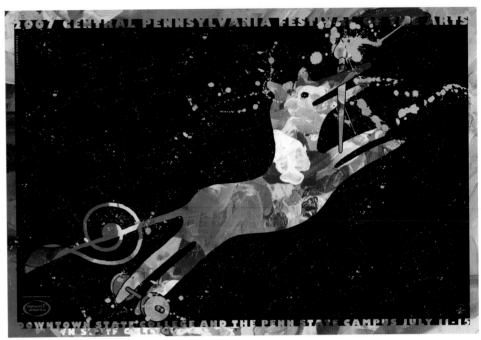

0631—0635 > LANNY SOMMESE

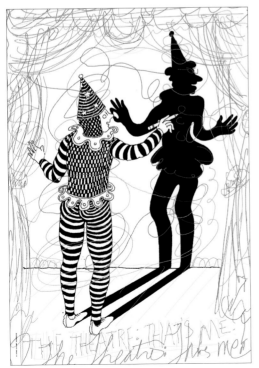

après nous le déluge

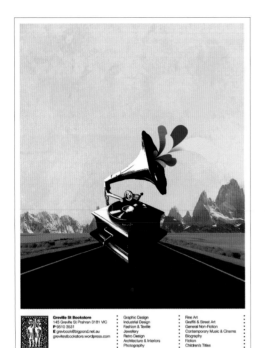

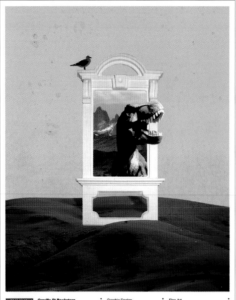

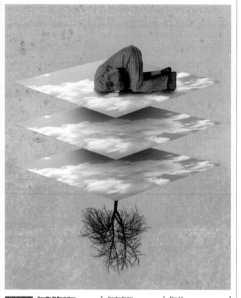

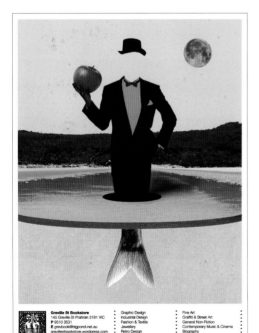

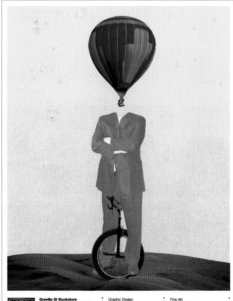

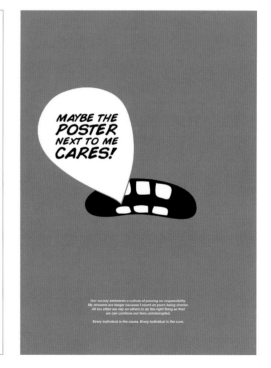

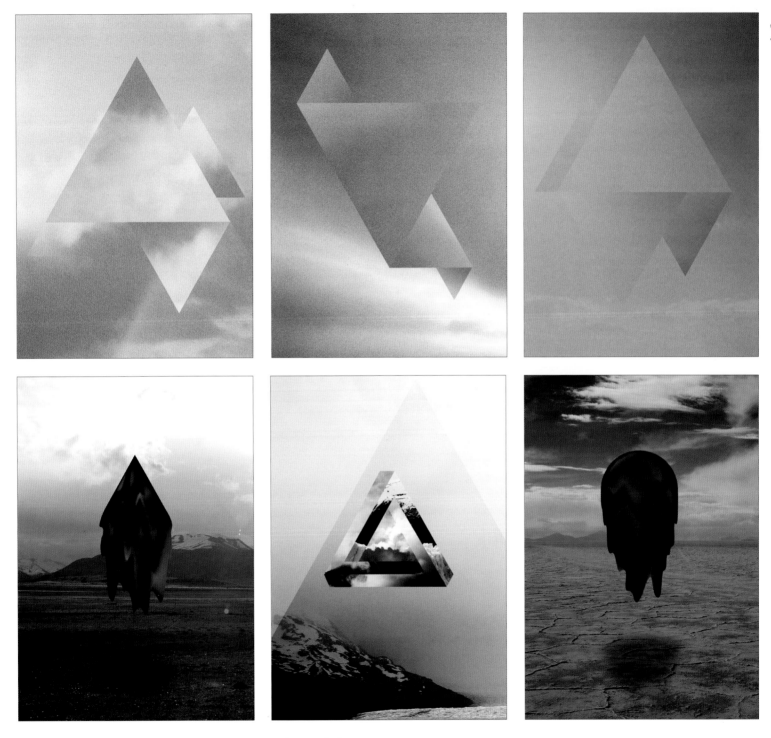

0642–0653 > MOTHERBIRD

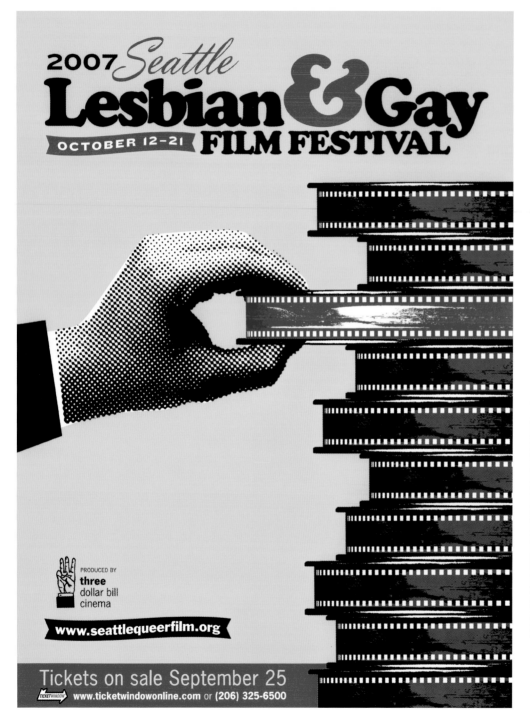

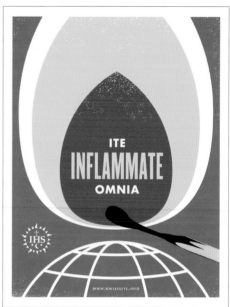

left 0654 > SLEEP OP

upper right 0655 > SLEEP OP

bottom right 0656 > DECODER RING DESIGN CONCERN

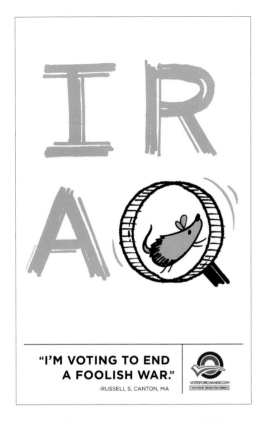

"I'M VOTING TO END
A FOOLISH WAR."

-RUSSELL S, CANTON, MA

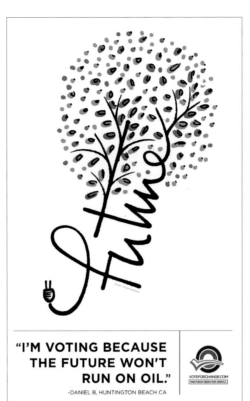

"I'M VOTING BECAUSE
THE FUTURE WON'T
RUN ON OIL."

-DANIEL B, HUNTINGTON BEACH CA

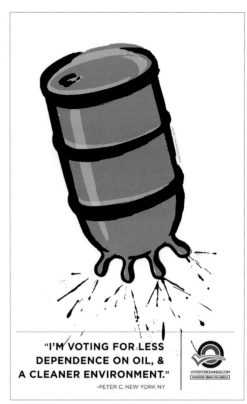

"I'M VOTING FOR LESS
DEPENDENCE ON OIL, &
A CLEANER ENVIRONMENT."

-PETER C, NEW YORK NY

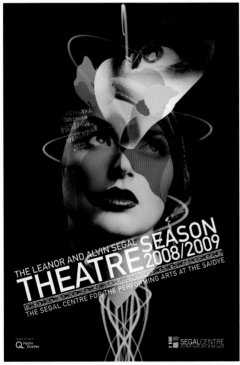

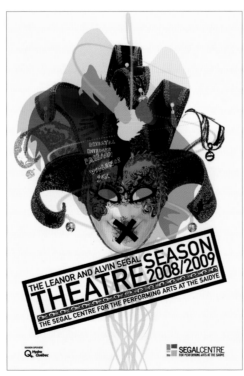

bottom left 0657 > DEPARTEMENT

upper left 0658 > DECODER RING DESIGN CONCERN

upper center 0659 > DECODER RING DESIGN CONCERN

upper right 0660 > DECODER RING DESIGN CONCERN

bottom center 0661 > DEPARTEMENT

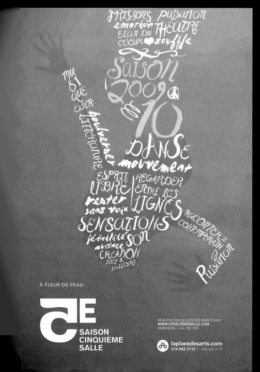
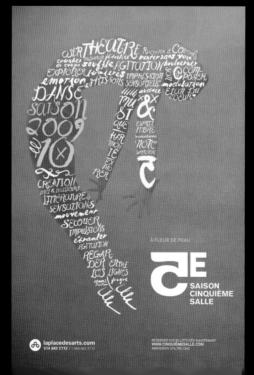
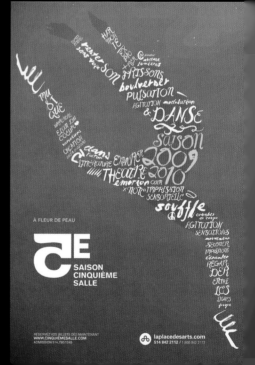

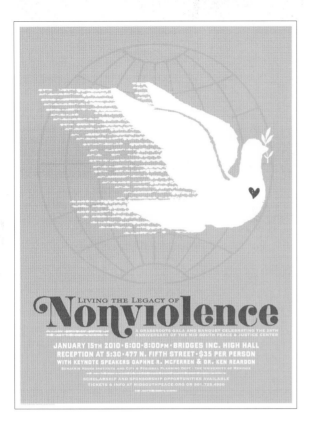

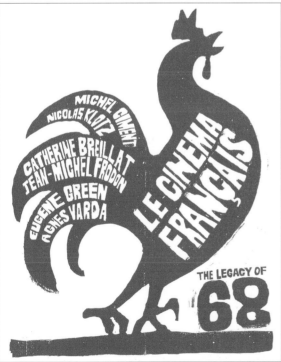

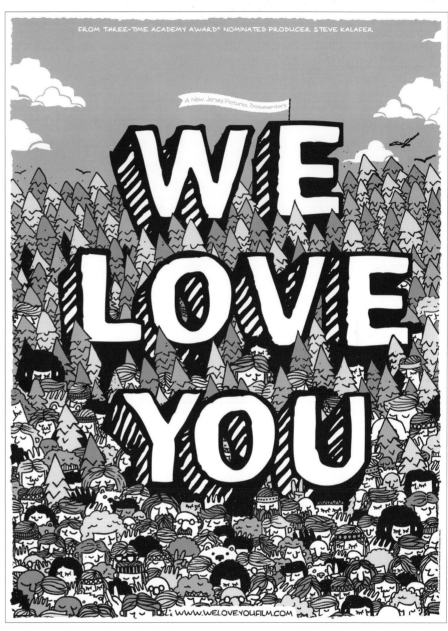

bottom left 0668 > ANDY SMITH ILLUSTRATION

upper left 0669 > THE NEW YEAR

right 0670 > THE NEW YEAR

BROUGHT TO YOU BY THE HOT SNOT PRINT SHOP

Work Hard For Satan

SAINT PAUL, MINNESOTA

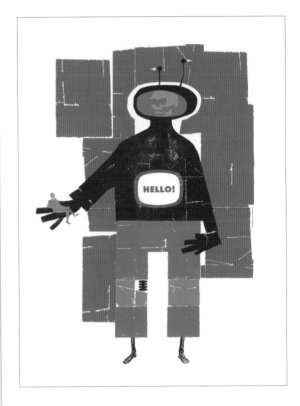

left 0671 > STEADY PRINT SHOP CO.
upper right 0672 > JEFF KLEINSMITH DESIGN

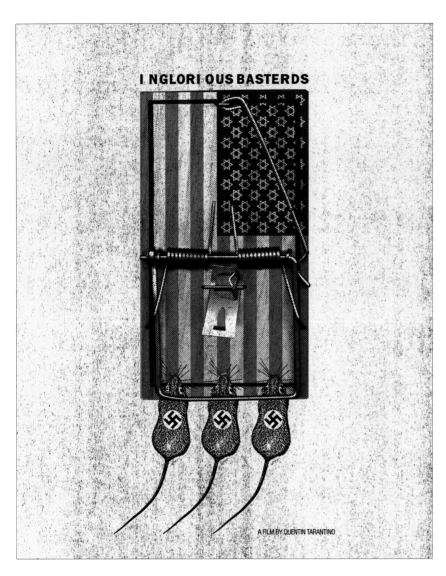

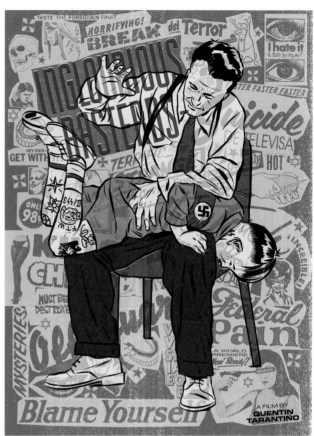

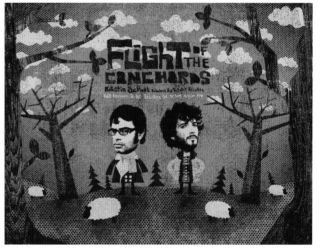

upper left 0673 > **MORNING BREATH INC.**
upper right 0674 > **MORNING BREATH INC.**
bottom right 0675 > **THE SILENT GIANTS**

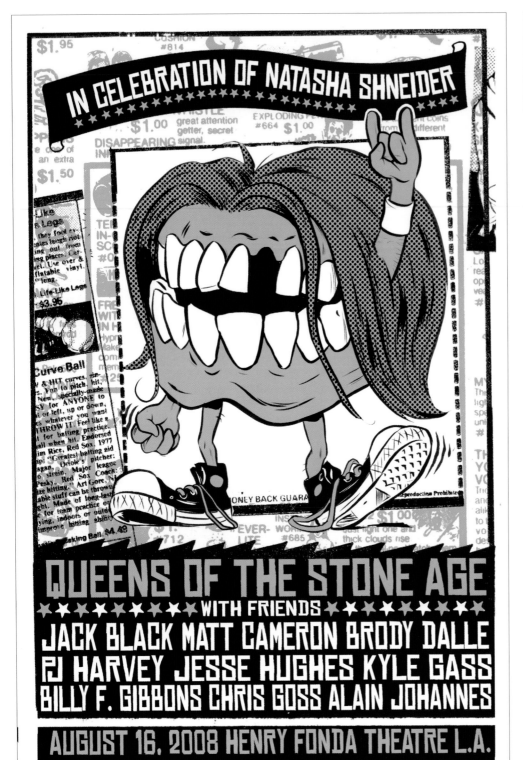

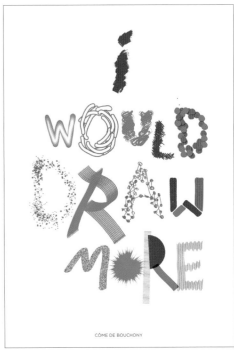

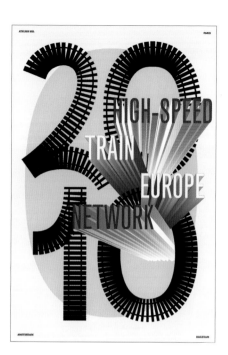

upper left 0679 > CÔME DE BOUCHONY
right 0680 > JONAS BERGSTRAND

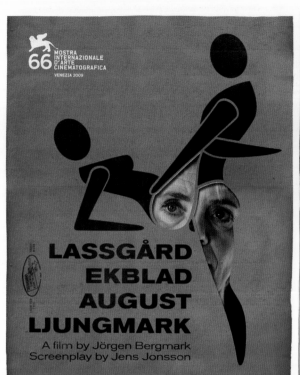

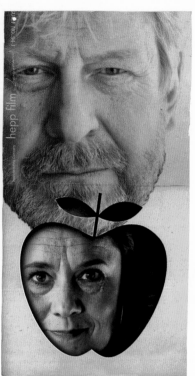

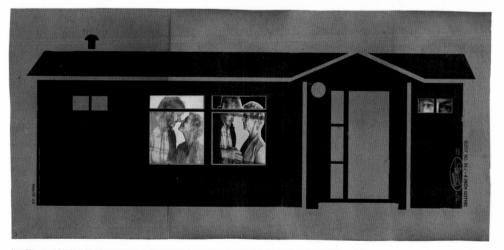

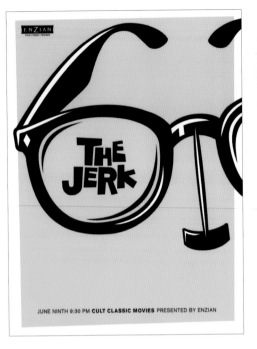

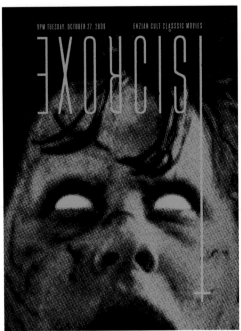

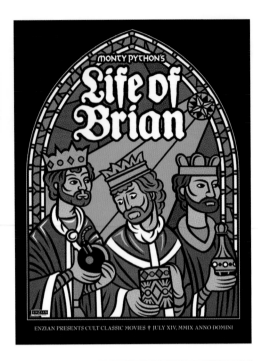

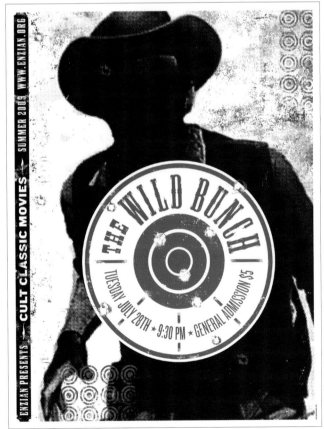

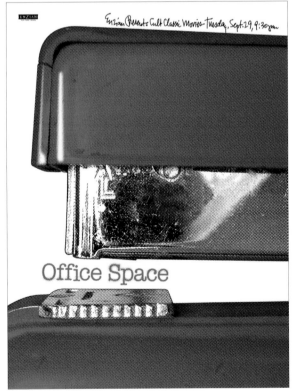

0681–0685 > LURE

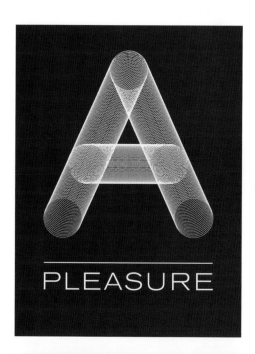

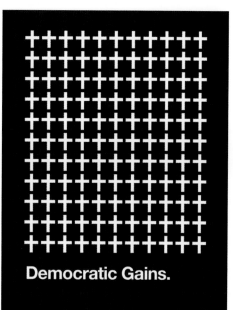

0686—0690 > GRIDULA

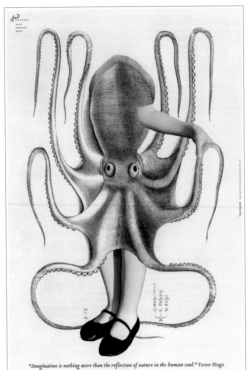

bottom left 0691 > DESIGN ARMY
upper left 0692 > YANN LEGENDRE
upper center 0693 > YANN LEGENDRE
bottom right 0694 > DESIGN ARMY
bottom center 0695 > DESIGN ARMY

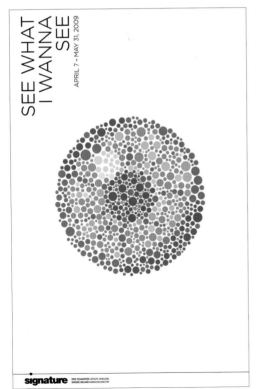

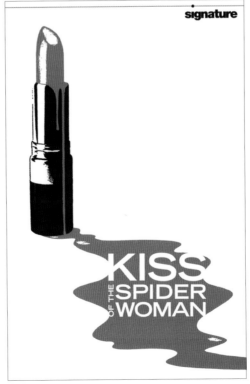

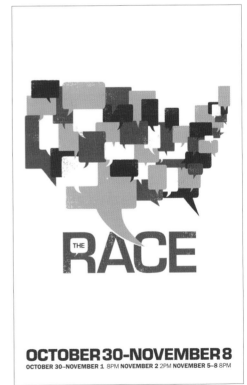

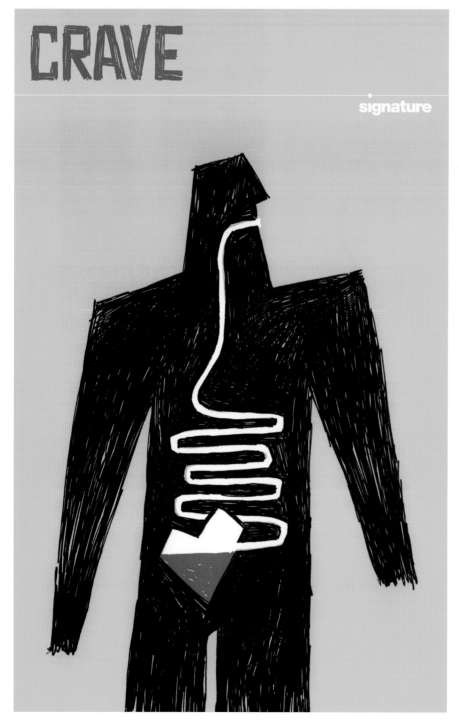

CRAVE

signature

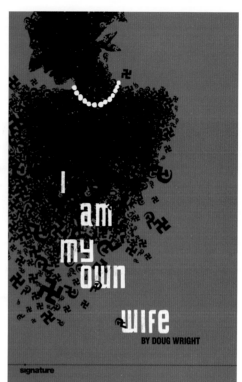

I am my own wife

BY DOUG WRIGHT

signature

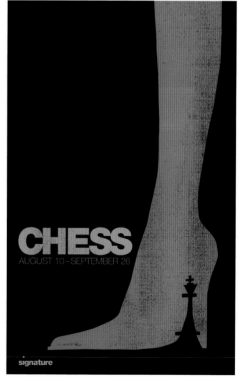

CHESS

AUGUST 10–SEPTEMBER 26

signature

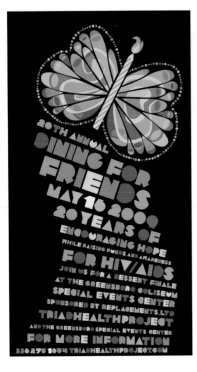

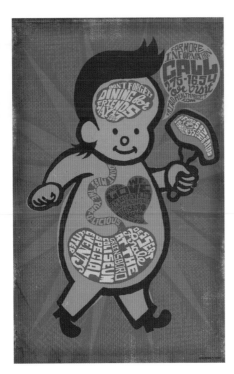

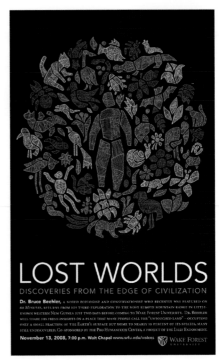

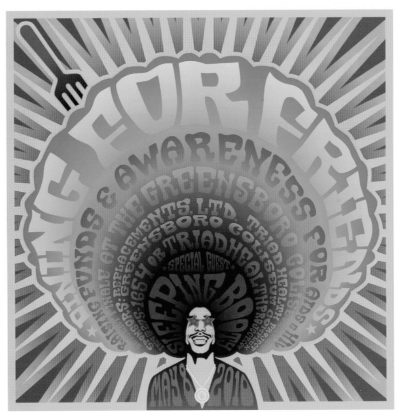

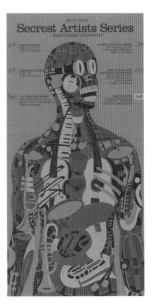

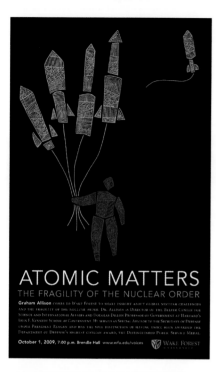

0699–0710 > HENDERSONBROMSTEADART

0711—0714 > HUIZAR 1984

bottom left 0715 > **SUSSNER DESIGN CO.**
upper left 0716 > **SPIKE PRESS**
right 0717 > **SUSSNER DESIGN CO.**

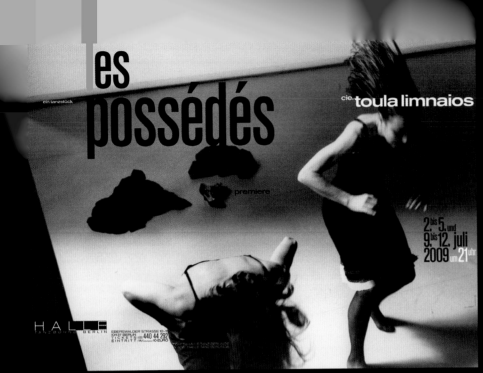

les
possédés

ein tanzstück

premiere

cie. toula limnaios

2 bis 5. und
9. bis 12. juli
2009 um 21 uhr

HALLE
TANZBÜHNE BERLIN
EBERSWALDER STRASSE 10–11
10437 BERLIN
TICKETS 030 440 44 292
EINTRITT 14/erm 10 EURO

man and nature

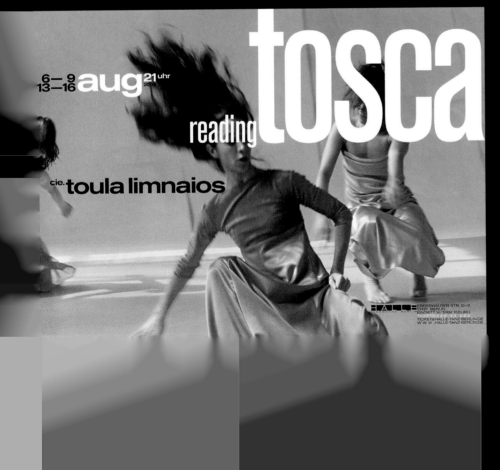

reading tosca

6— 9 aug 21 uhr
13—16

cie. toula limnaios

HALLE
TANZBÜHNE BERLIN
EBERSWALDER STR. 10–11
10437 BERLIN
EINTRITT 14/ ERM 10 EURO
TICKET@HALLE-TANZ-BERLIN.DE
WWW.HALLE-TANZ-BERLIN.DE

LIBERTAD®
1810

LIBERTAD®
2010

AKADEMIEKONZERT

LEOŠ JANÁČEK
Eifersucht

RICHARD STRAUSS
Don Juan op. 20
Burleske d-Moll

ALEXANDER SKRJABIN
Poème de l'extase op. 54

Leitung **Kirill Petrenko**
Klavier **Ewa Kupiec**

Nationaltheater
19. April, 10.10 Uhr
Veranstaltung für die Freunde des Nationaltheaters e.V.
20. und 21. April, 20.00 Uhr

Bayerisches
Staatsorchester

3. AKADEMIEKONZERT

LUDWIG VAN BEETHOVEN
»Der General« für Orchester, mit Sopran, Chor und Erzähler
»Egmont« op. 84 Text Paul Griffiths
Symphonie Nr. 5 c-Moll op. 67

Leitung **Kent Nagano**
Sopran **Aga Mikolaj**
Erzähler **Nikolaus Bachler**
Chor der Bayerischen Staatsoper

Nationaltheater
26. und 27. Januar, 20.00 Uhr

Bayerisches
Staatsorchester

0722–0725 > **FONS HICKMANN M23**

1. AKADEMIEKONZERT

BÉLA BARTÓK
Klavierkonzert Nr. 3

ANTON BRUCKNER
Symphonie Nr. 8, c-Moll (Urfassung)

Leitung **Kent Nagano**
Klavier **Richard Goode**

Nationaltheater
17. und 18. November, 20.00 Uhr
Bayerisches
Staatsorchester

6. AKADEMIEKONZERT

JOHANNES BRAHMS
Variationen für Orchester B-Dur
über ein Thema von Joseph Haydn op. 56a

SAMUEL BARBER
Violinkonzert op. 14

SERGEJ RACHMANINOFF
Symphonische Tänze op. 45

Leitung **Marin Alsop**
Violine **James Ehnes**

Nationaltheater
18. und 19. Mai, 20.00 Uhr
Bayerisches
Staatsorchester

GISELLE

URAUFFÜHRUNG 19.06.2010
PRINZREGENTENTHEATER

BALLETT Mats Ek
BÜHNE UND KOSTÜME Marie-Louise Ekman
SOLISTEN UND ENSEMBLE
DES BAYERISCHEN STAATSBALLETTS

Information und Karten T 089 21 85 1920
www.staatsballett.de

Bayerisches
Staatsballett

MASURCA
FOGO

STADTTHEATER WUPPERTAL PINA BAUSCH
AM 28.06.2010
NATIONALTHEATER MÜNCHEN

INSZENIERUNG UND CHOREOGRAPHIE Pina Bausch
BALLETT Pina Bausch
BÜHNE Peter Pabst
KOSTÜME Marion Cito
MUSIKALISCHE MITARBEIT Matthias Burkert,
Andreas Eisenschneider

Information und Karten T 089 21 85 1920
www.staatsballett.de

Bayerisches
Staatsballett

2009
SPIELZEIT
2010

PREMIEREN

VIELFÄLTIGKEIT. FORMEN VON
STILLE UND LEERE Nacho Duato 23.12.2009
ARTIFACT William Forsythe 14.02.2010
THE SECRET AGENT Terence Kohler 18.03.2010
THE FORSYTHE COMPANY — YES WE CAN'T
William Forsythe 25.04.2010

REPERTOIRE

100 JAHRE BALLETS RUSSES
Mikhail Fokine, Bronislawa Nijinska, Terence Kohler
LE CORSAIRE Ivan Liška, Marius Petipa
GISELLE — MATS EK
DIE KAMELIENDAME John Neumeier
ONEGIN John Cranko
RAYMONDA Marius Petipa, Ray Barra
DER STURM John Neumeier
ZUGVÖGEL Jiří Kylián
TERPSICHORE GALA IX UND X
BALLETTFESTWOCHEN 2010, 25. April bis 9. Mai

Information und Karten: T 089 21 85 1920

www.staatsballett.de

Bayerisches
Staatsballett

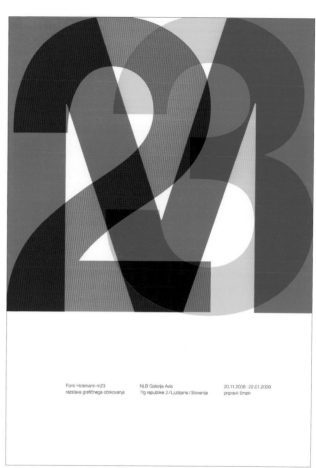

0726—0730 > FONS HICKMANN M23

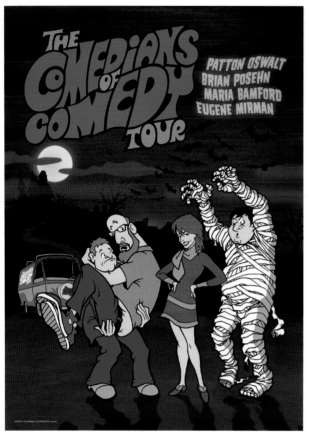

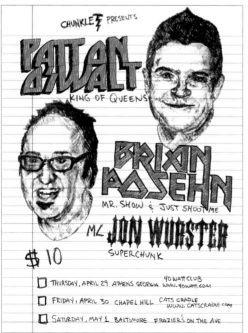

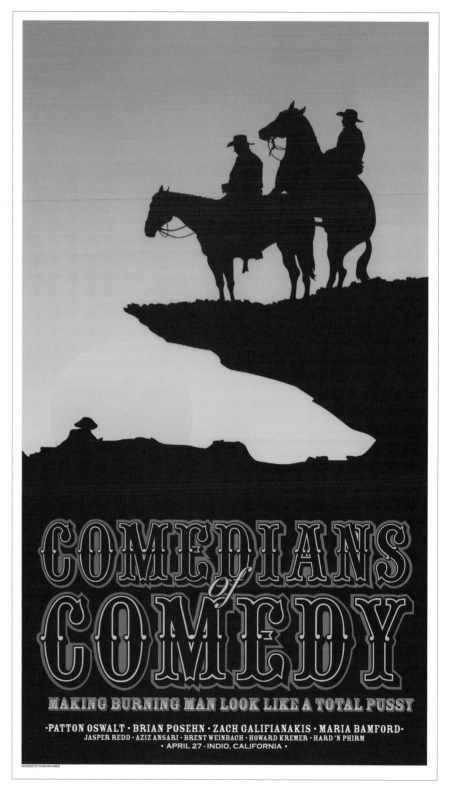

0731—0738 > CHRIS BILHEIMER

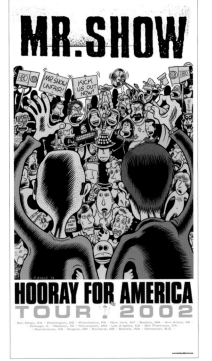

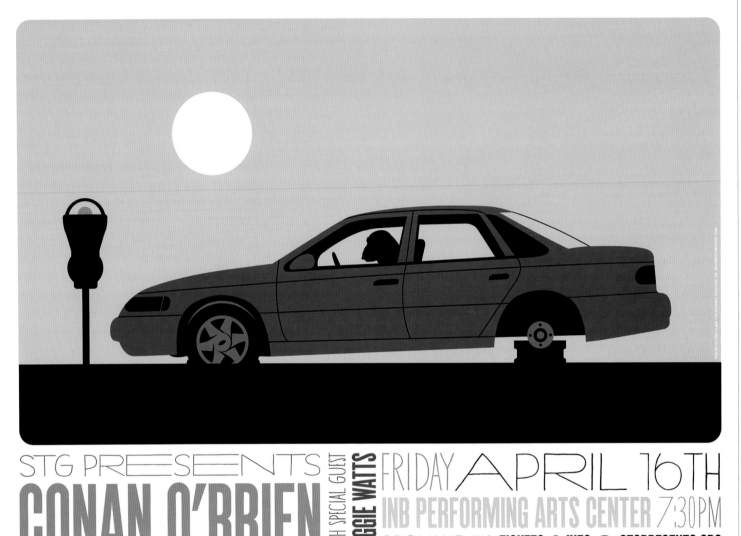

STG PRESENTS
CONAN O'BRIEN
WITH SPECIAL GUEST **REGGIE WATTS**

FRIDAY APRIL 16TH
INB PERFORMING ARTS CENTER 7:30PM
SPOKANE, WA **TICKETS & INFO** @ STGPRESENTS.ORG

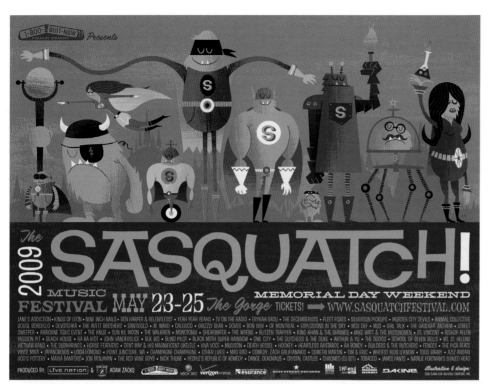

bottom left 0740 > INVISIBLE CREATURE
upper left 0741 > INVISIBLE CREATURE
upper right 0742 > TODD SLATER
bottom center 0743 > TODD SLATER

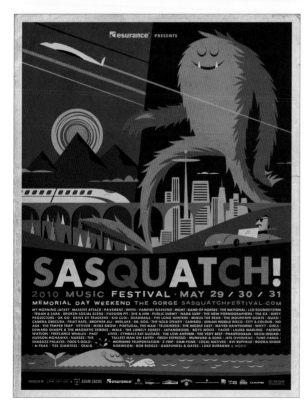

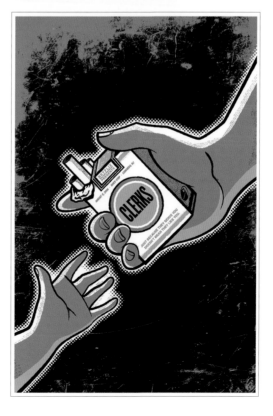

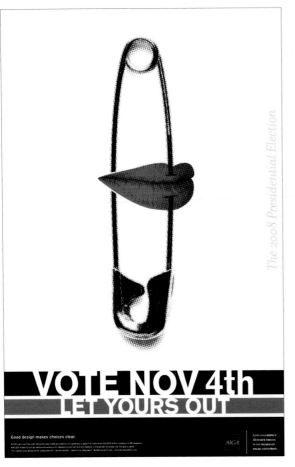

VOTE NOV 4th
LET YOURS OUT

Good design makes choices clear.

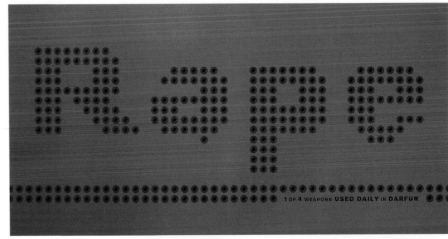

1 OF 4 WEAPONS **USED DAILY** IN DARFUR

upper left 0744 > **GREG BENNETT**
upper right 0745 > **GREG BENNETT**
bottom right 0746 > **FANG CHEN**
bottom center 0747 > **FANG CHEN**

AIDS

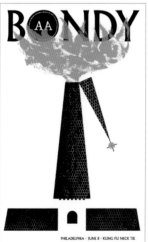

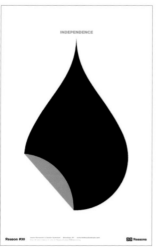

0748—0751 > THE HEADS OF STATE

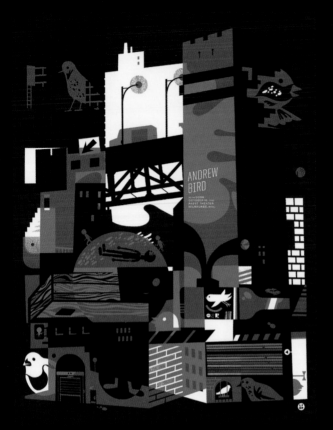

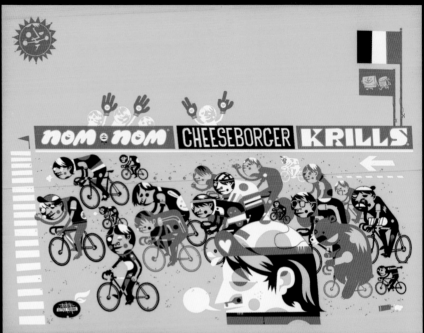

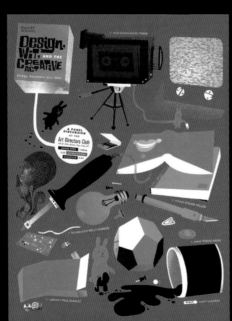

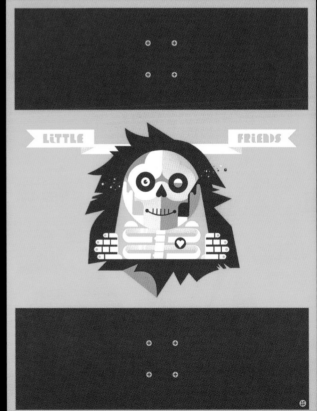

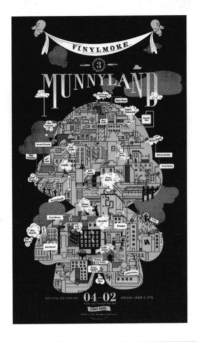

upper 0756—0759 > **EXIT10**
bottom 0760—0761 > **STUBBORN SIDEBURN**

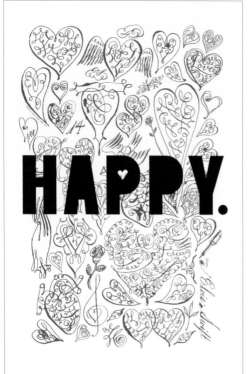

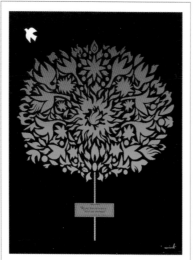

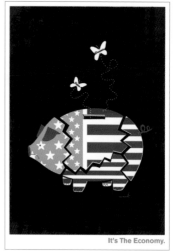

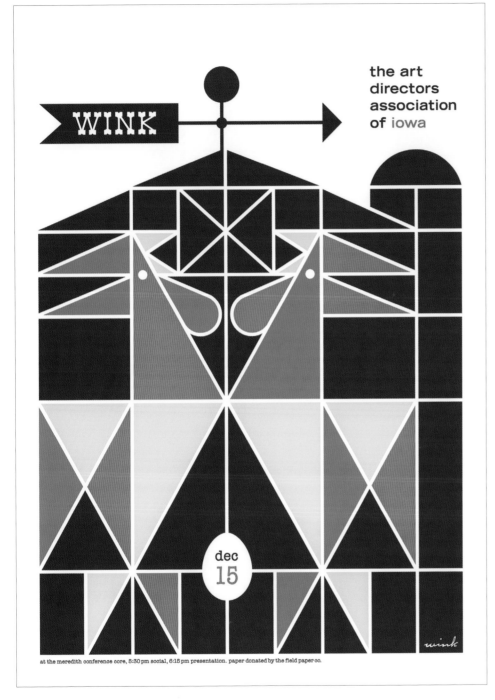

0768–0770 > WINK, INC.

APRIL 24, 2009 / with THE TWILIGHT SAD / CAT'S CRADLE / CARRBORO, NC

SONIC YOUTH

JULY 24, 2009 / with AWESOME COLOR
KNITTING FACTORY / SPOKANE, WA

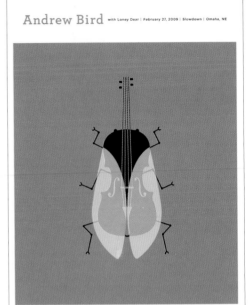

Andrew Bird with Loney Dear | February 27, 2009 | Slowdown | Omaha, NE

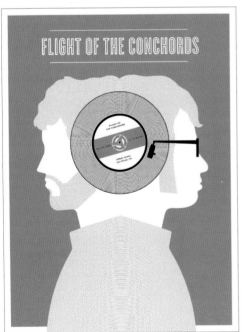

FLIGHT OF THE CONCHORDS

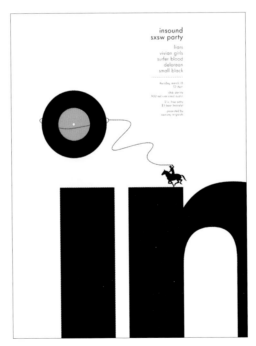

insound
sxsw party

liars
vivian girls
surfer blood
delorean
small black

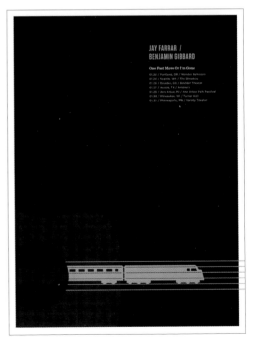

JAY FARRAR /
BENJAMIN GIBBARD

One Fast Move Or I'm Gone

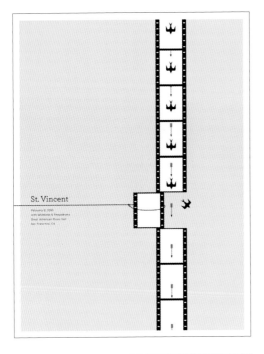

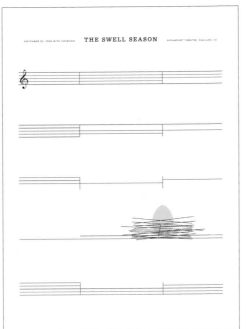

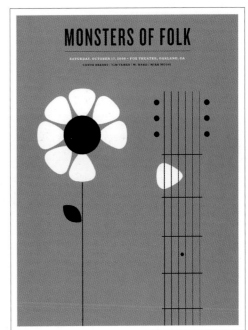

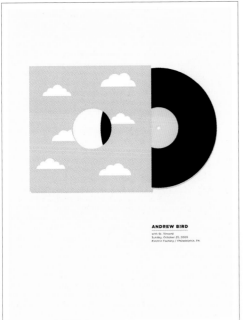

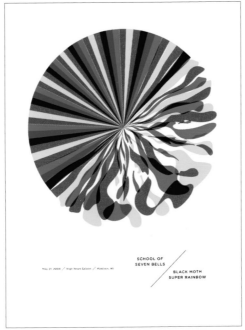

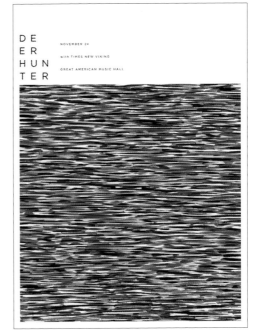

0771—0782 **> THE SMALL STAKES**

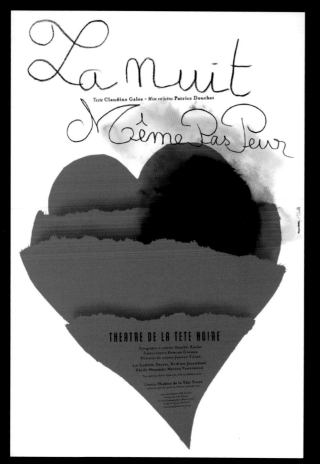

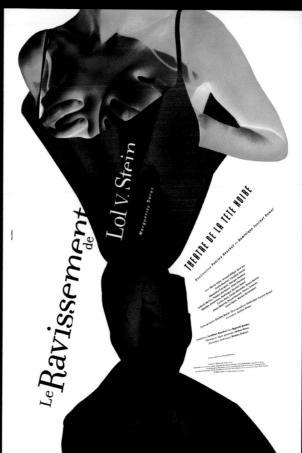

bottom left 0783 > **FRANÇOIS CASPAR**
upper left 0784 > **FRANÇOIS CASPAR**
upper right 0785 > **THE SMALL STAKES**
bottom center 0786 > **THE SMALL STAKES**

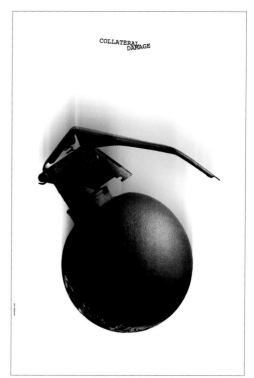

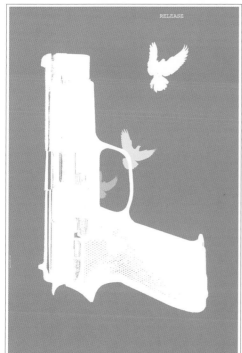

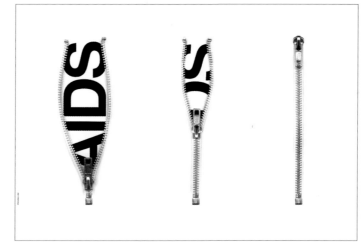

0787–0791 > RYAN RUSSELL

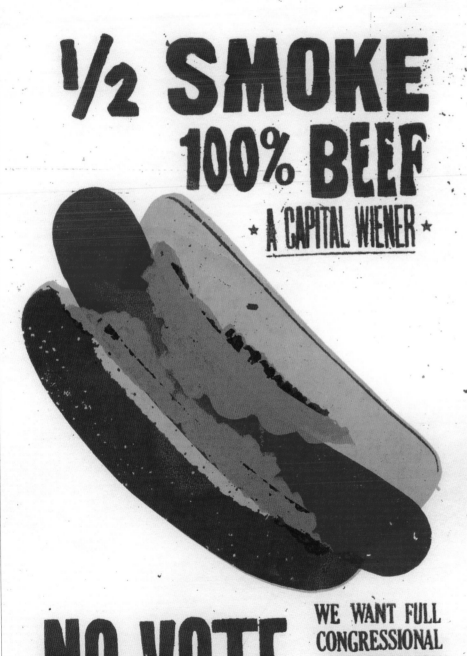

0795–0797 > DIRTY PICTURES

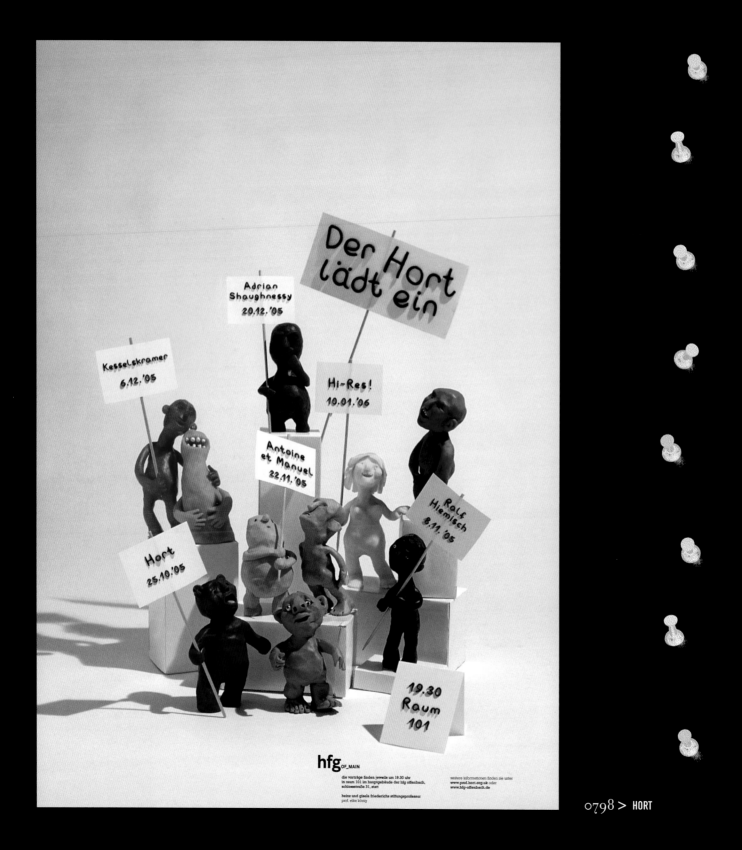

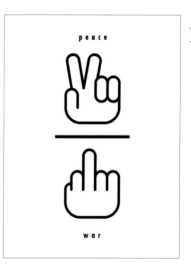

0799–0804 > **RONALD J. CALLA II**

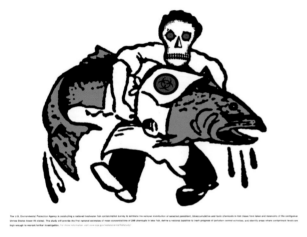

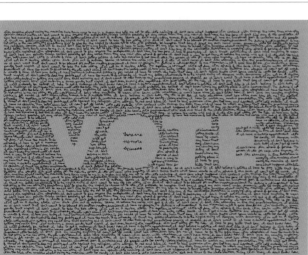

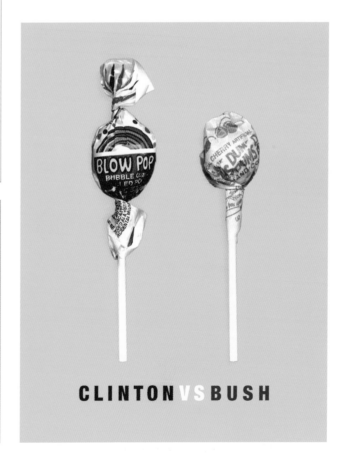

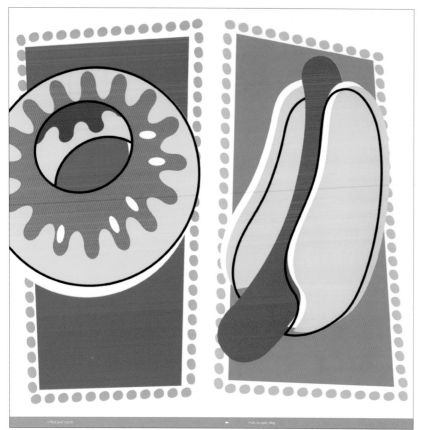

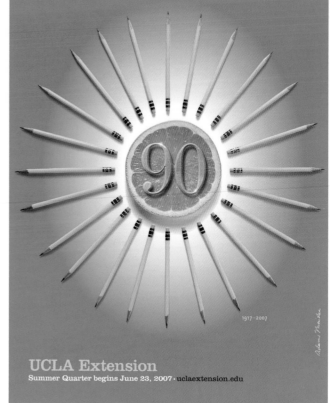

UCLA Extension
Summer Quarter begins June 23, 2007 · uclaextension.edu

1917–2007

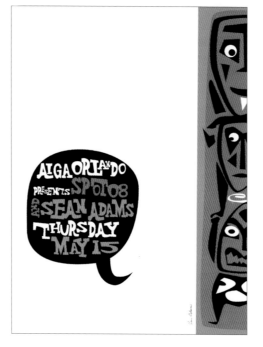

AIGA Los Angeles presents

What Would Dana Do?

Deep theology from the frozen plain.

Wednesday, February 22nd, 2006

0805—0810 > **ADAMSMORIOKA**

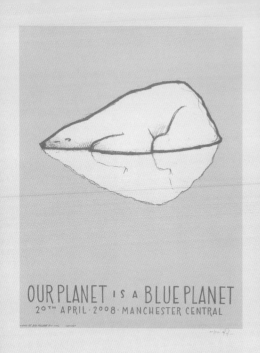

OUR PLANET IS A BLUE PLANET
20TH APRIL·2008·MANCHESTER CENTRAL

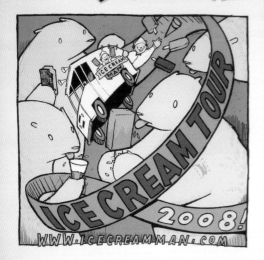

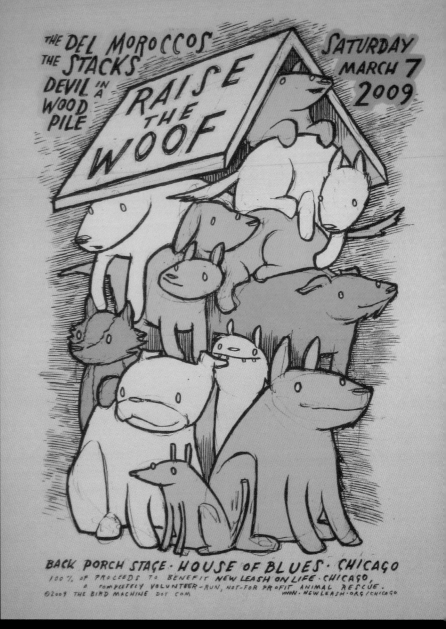

0811–0813 > JAY RYAN

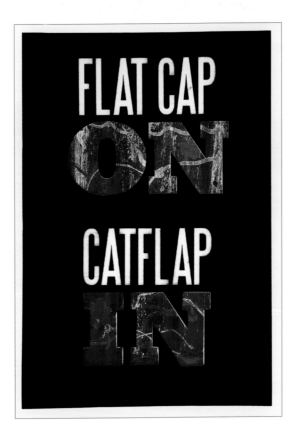

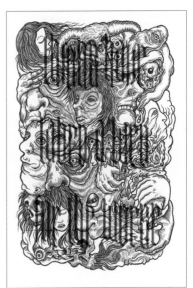

0814—0818 > ANDY COOKE

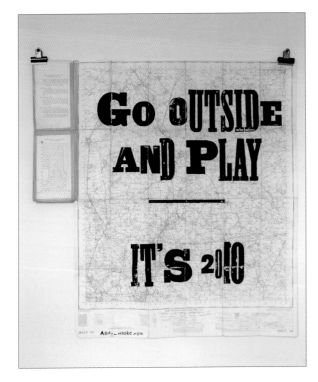

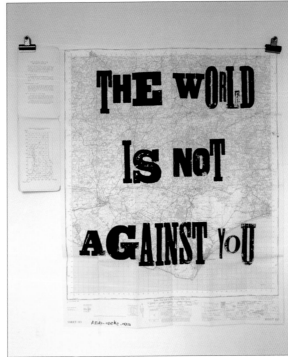

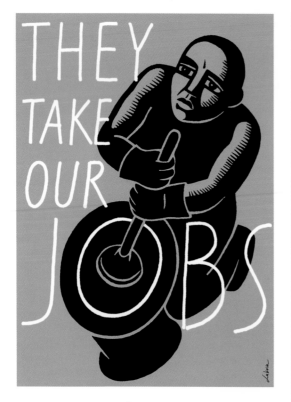

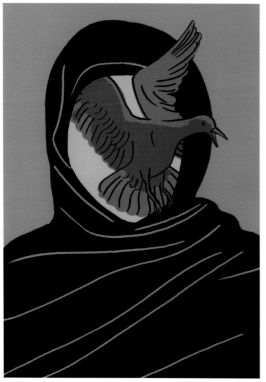

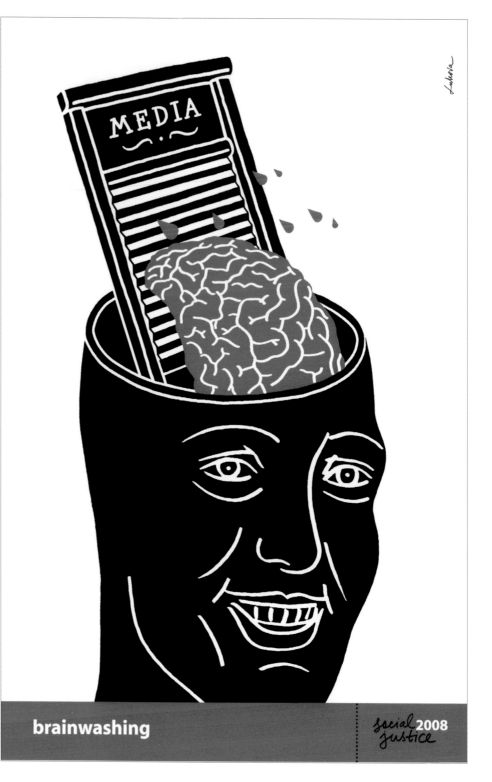

An indiscreet window into the life of tango dancers

0819–0826 > LUBA LUKOVA

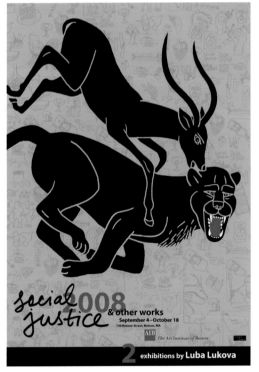

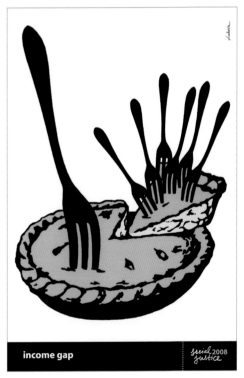

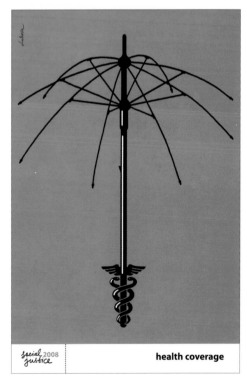

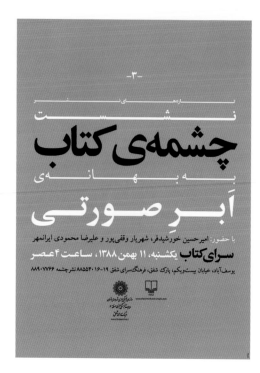

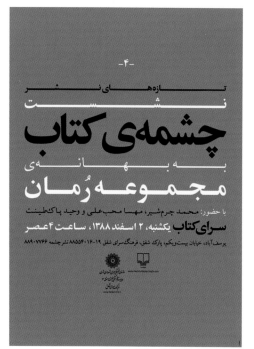

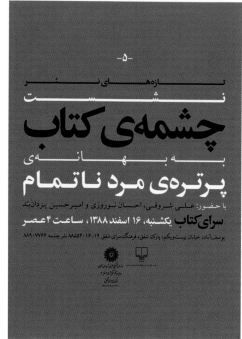

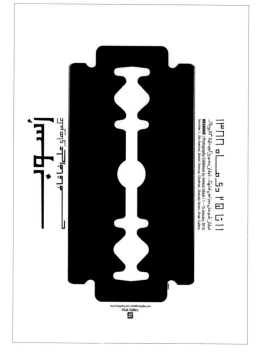

0827–0836 > PEDRAM HARBY

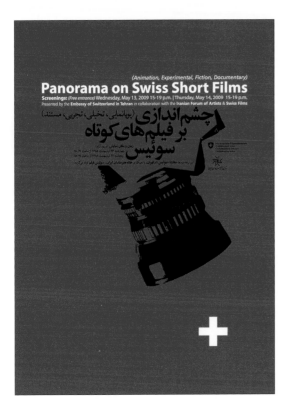

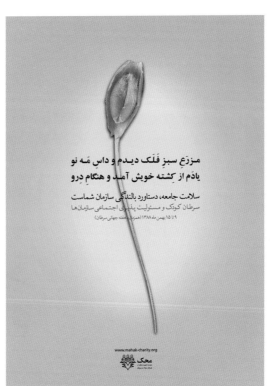

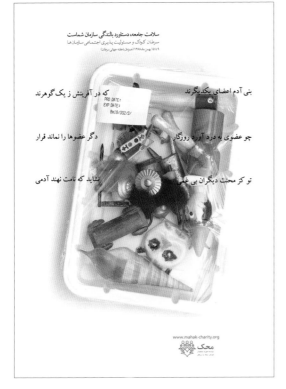

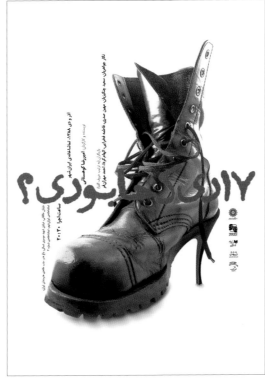

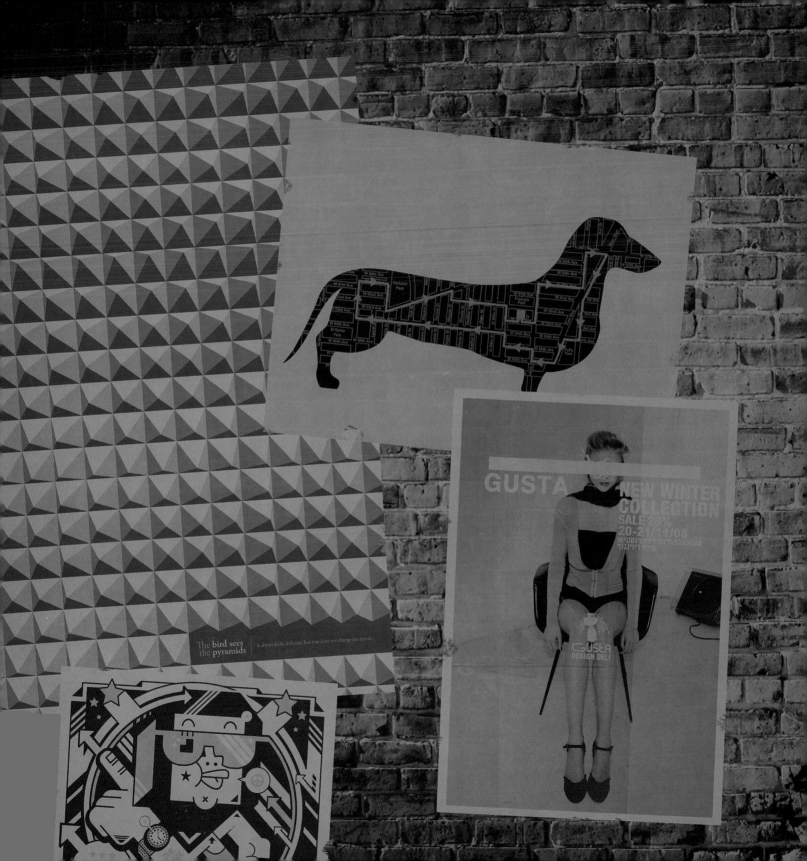

The bird sees
the pyramids It always looks different, but that does not change the nature.

GUSTA NEW WINTER
COLLECTION
SALE 20%
20-21/11/08

GUSTA
DESIGN DELI

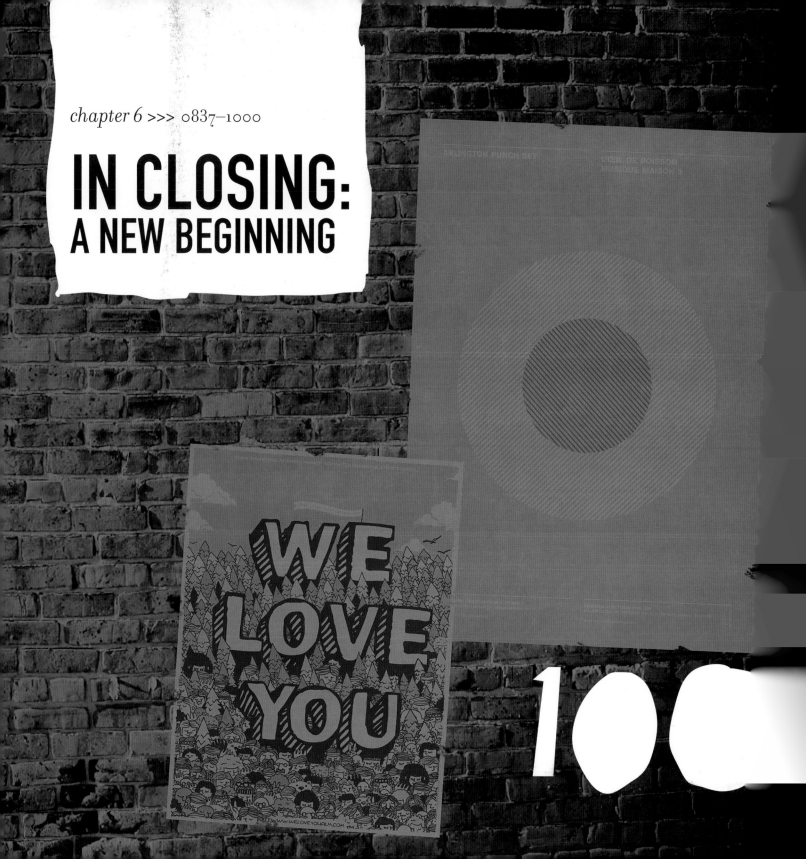

IN CLOSING:
A NEW BEGINNING

WE LOVE YOU

10

GET PHYSICAL
FULL BODY WORKOUT
VOL. 4

0837–0846 > HORT

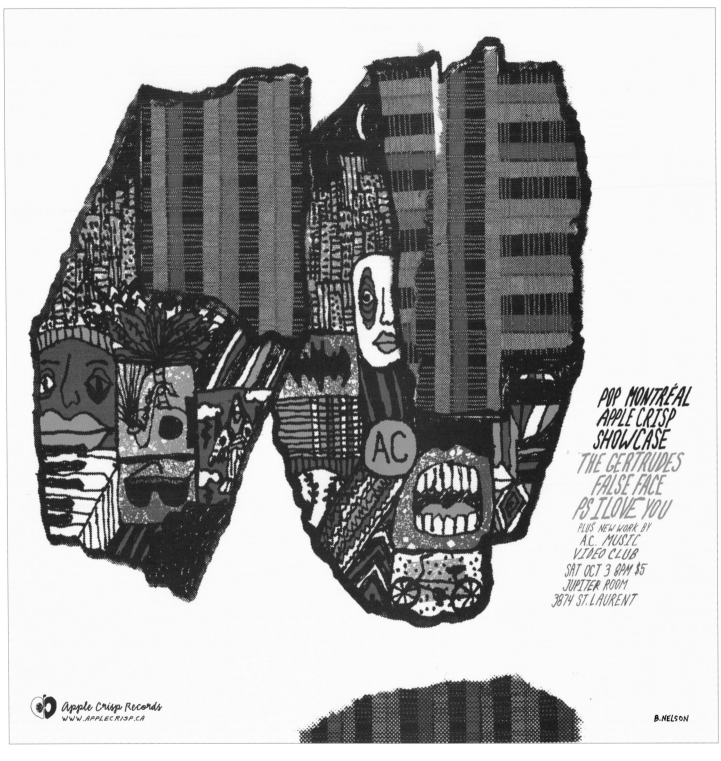

POP MONTRÉAL
APPLE CRISP
SHOWCASE
THE GERTRUDES
FALSE FACE
PS I LOVE YOU
PLUS NEW WORK BY
A.C. MUSIC
VIDEO CLUB
SAT OCT 3 8PM $5
JUPITER ROOM
3874 ST. LAURENT

Apple Crisp Records
WWW.APPLECRISP.CA

B.NELSON

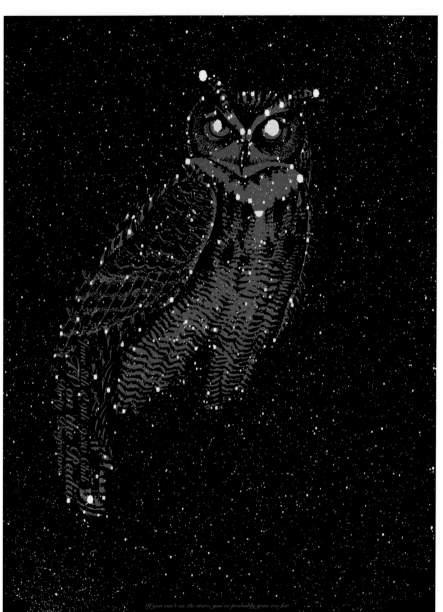

upper left 0850 > **MORNING BREATH INC.**
upper right 0851 > **CERNOCH**

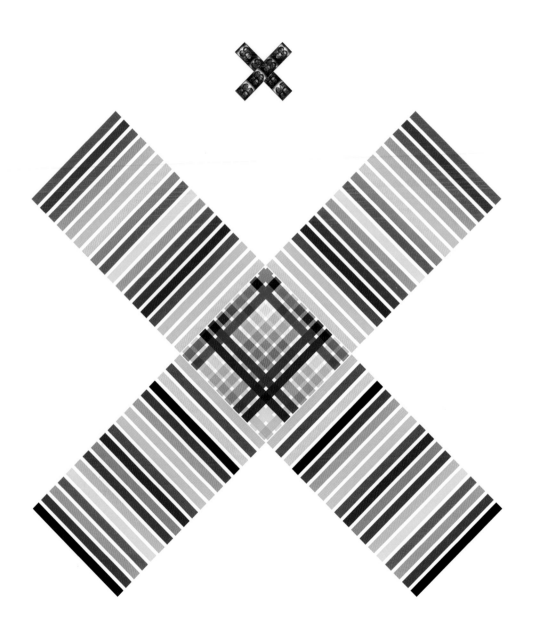

Teen—Beat
Holiday Card, 2009-2010
Happy New Year from us to you.

TEEN-BEAT 471
JANUARY 1 . 2010

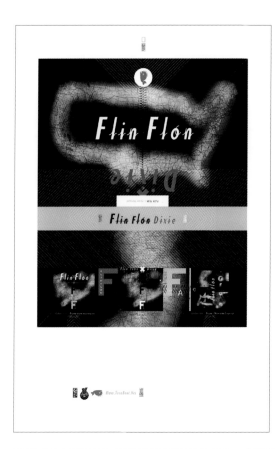

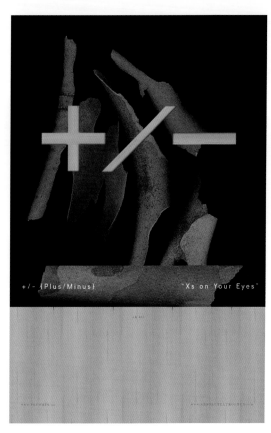

+/– {Plus/Minus} "Xs on Your Eyes"

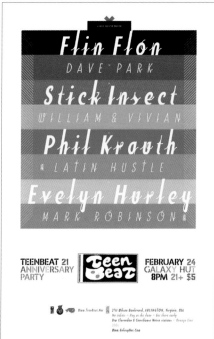

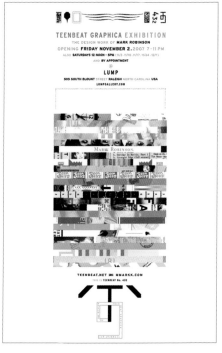

0852–0856 > TEENBEAT GRAFICA

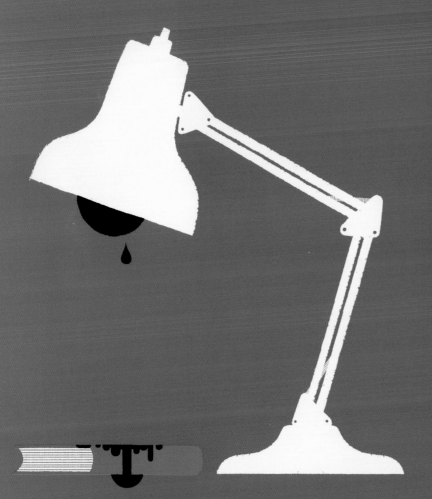

Anglepoise at the BBC
1949

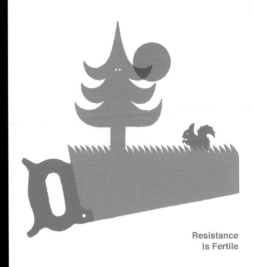

Resistance
is Fertile

o857—o858 > ADRIAN JOHNSON

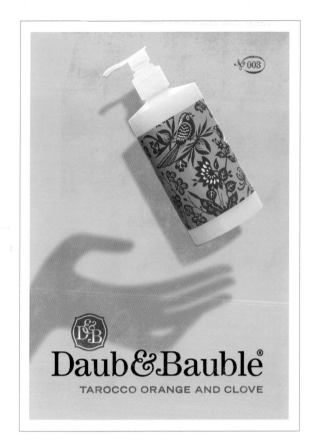

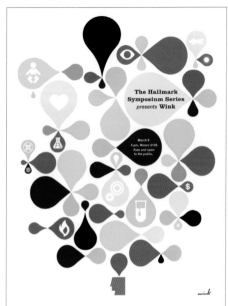

bottom left 0859 > ANDY SMITH ILLUSTRATION
upper left 0860 > WINK, INC.
upper center 0861 > WINK, INC.
bottom center 0862 > ANDY SMITH ILLUSTRATION

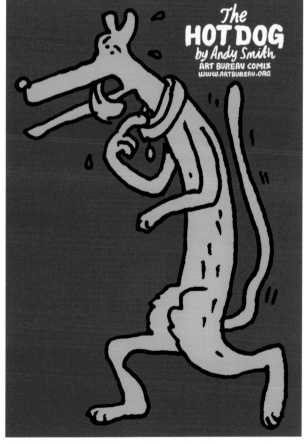

o863–o868 > CYAN

0869–0877 > POST TYPOGRAPHY

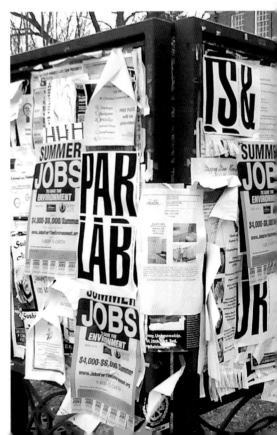

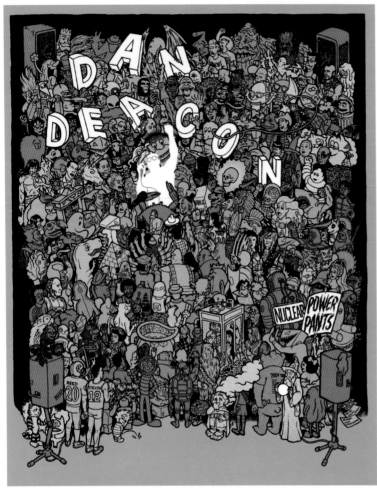

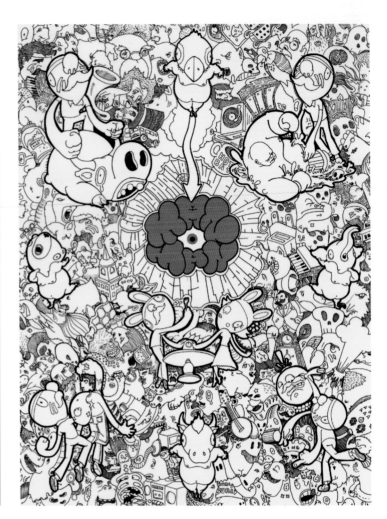

upper left 0878 > **POST TYPOGRAPHY**

upper right 0879 > **AESTHETIC APPARATUS**

bottom right 0880 > **POST TYPOGRAPHY**

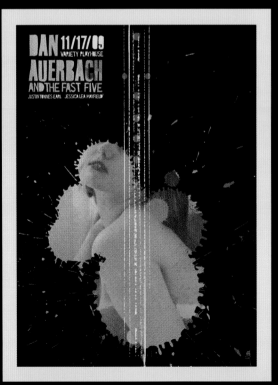

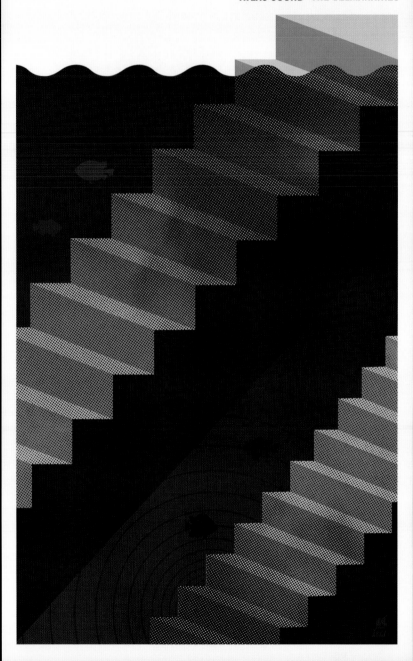

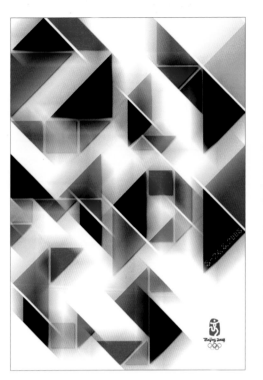
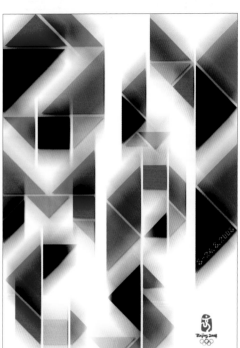

0885—0889 > FANG CHEN

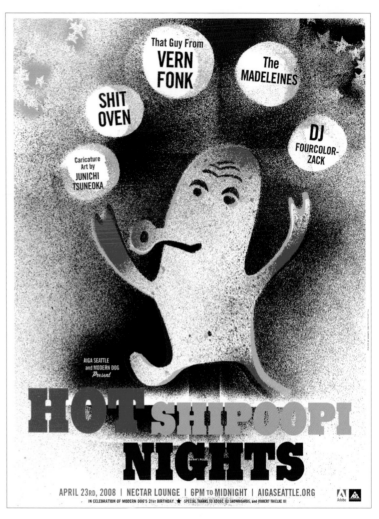

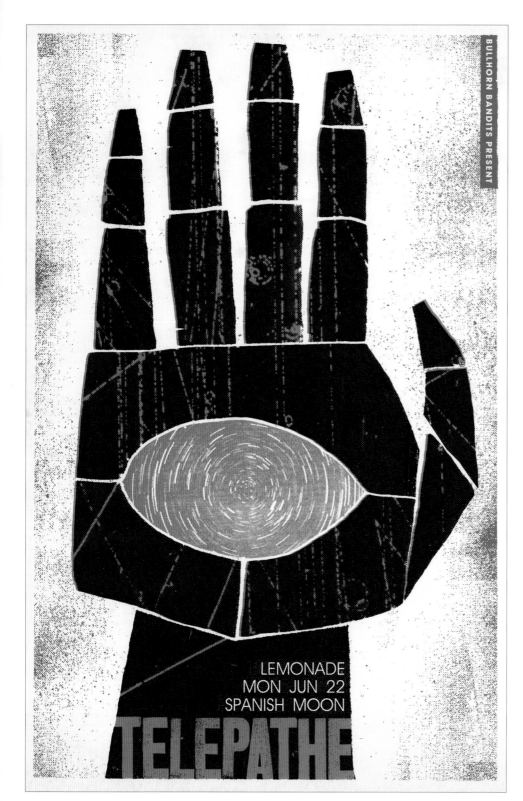

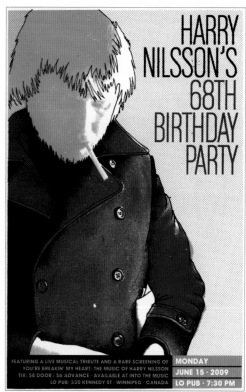

0894–0895 > SCOTT CAMPBELL

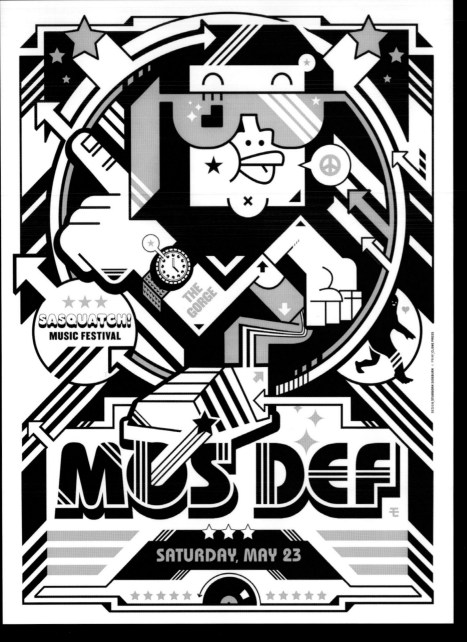

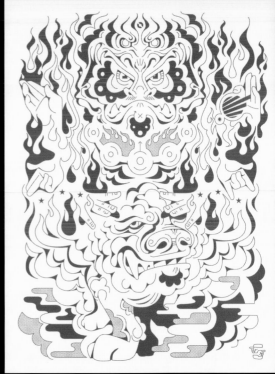

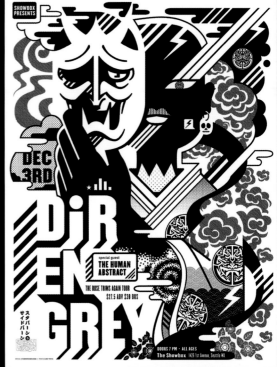

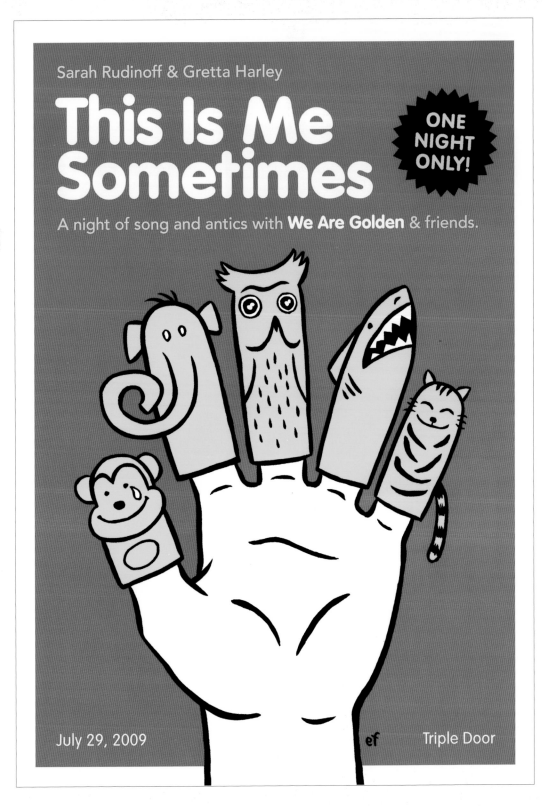

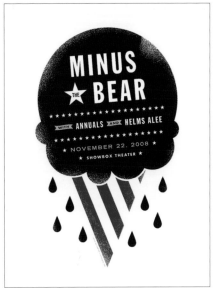

0899—0900 > SLEEP OP

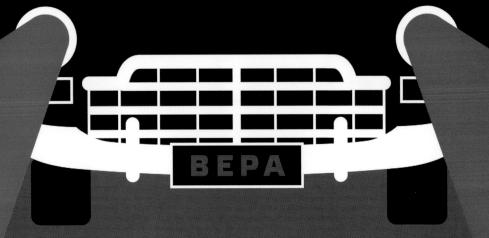

Kierowca dla Wiery

reż. Paweł Czuchraj | Warszawski Festiwal Filmowy – Plebiscyt Publiczności – Nagroda

BEPA

TYLKO W KINACH STUDYJNYCH

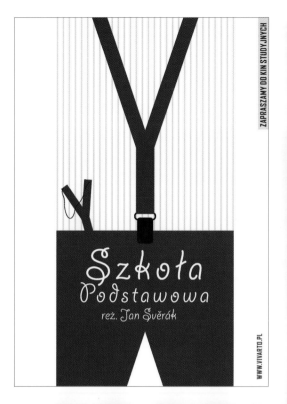

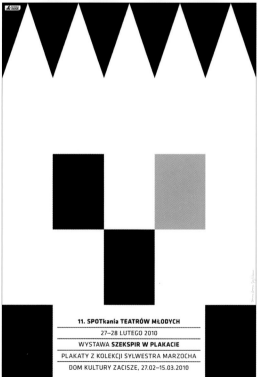

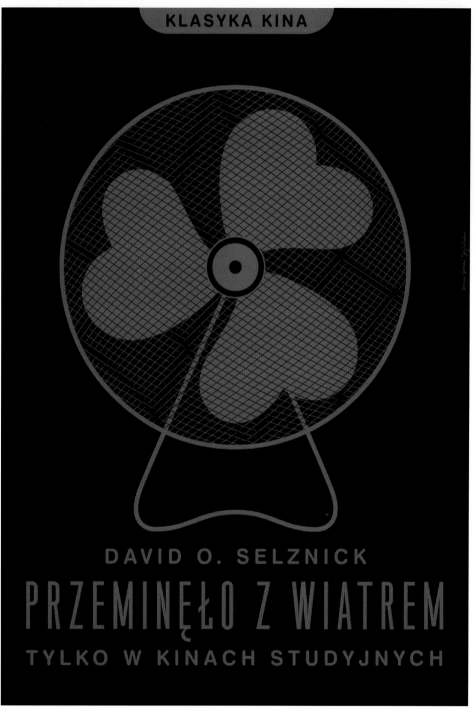

GUCZA!
POJEDYNEK NA TRĄBKI
produkcja Emir Kusturica

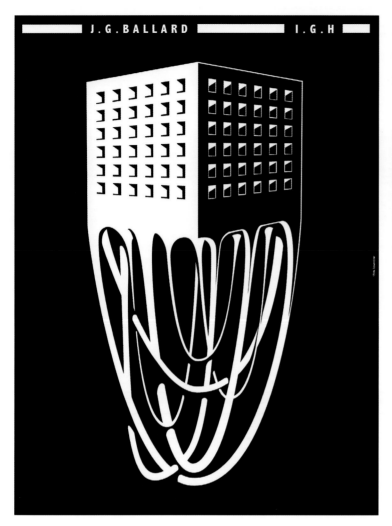

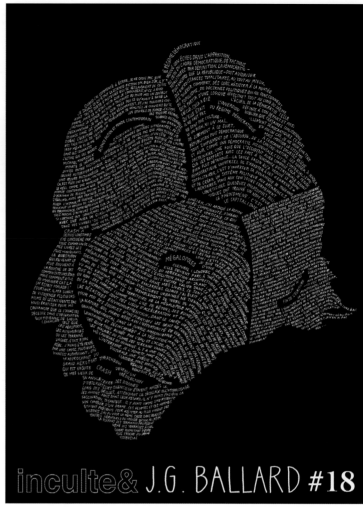

0906—0907 > YANN LEGENDRE

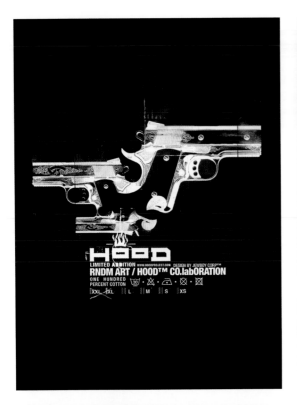

GUSTA **NEW WINTER COLLECTION**
SALE 20%
20-21/11/08
077-3230038 ז'בוטינסקי 19
פינת דיזינגוף

GUStA
DESIGN DELI

GUSTA **NIGHT SHOP**
22:00-02:00 **FRIDAY 11/8/08**
ז'בוטינסקי 19 077-3230038
פינת דיזינגוף

GUStA

GUSTA **BIRTHDAY PARTY**
10:00-17:00 **FRIDAY 29/8/08**
ז'בוטינסקי 19 077-3230038
פינת דיזינגוף

GUStA

0914–0918 > JEWBOY CORPORATION

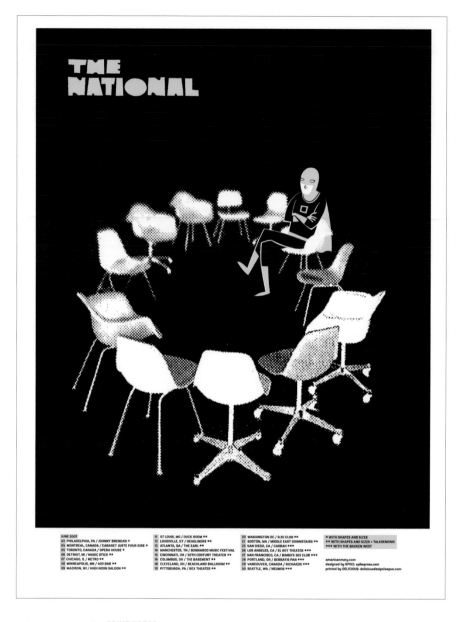

TME NATIONAL

JUNE 2007
02 PHILADELPHIA, PA / JOHNNY BRENDA'S *
04 MONTREAL, CANADA / CABARET JUSTE POUR RIRE *
05 TORONTO, CANADA / OPERA HOUSE *
06 DETROIT, MI / MAGIC STICK **
07 CHICAGO, IL / METRO **
08 MINNEAPOLIS, MN / 400 BAR **
09 MADISON, WI / HIGH NOON SALOON **

11 ST LOUIS, MO / DUCK ROOM **
12 LOUISVILLE, KY / HEADLINERS **
13 ATLANTA, GA / THE EARL **
14 MANCHESTER, TN / BONNAROO MUSIC FESTIVAL
15 CINCINNATI, OH / 20TH CENTURY THEATER
16 COLUMBUS, OH / THE BASEMENT **
18 CLEVELAND, OH / BEACHLAND BALLROOM **
19 PITTSBURGH, PA / REX THEATER **

20 WASHINGTON DC / 9:30 CLUB **
21 BOSTON, MA / MIDDLE EAST DOWNSTAIRS **
25 SAN DIEGO, CA / CASBAH ***
26 LOS ANGELES, CA / EL REY THEATER ***
27 SAN FRANCISCO, CA / BIMBO'S 365 CLUB ***
28 PORTLAND, OR / BERBATIS PAN ***
29 VANCOUVER, CANADA / RICHARDS ***
30 SEATTLE, WA / NEUMOS ***

* WITH SHAPES AND SIZES
** WITH SHAPES AND SIZES + TALKDEMONIC
*** WITH THE BROKEN WEST

americanmary.com
designed by SPIKE: spikepress.com
printed by DELICIOUS: deliciousdesignleague.com

0919—0920 > SPIKE PRESS

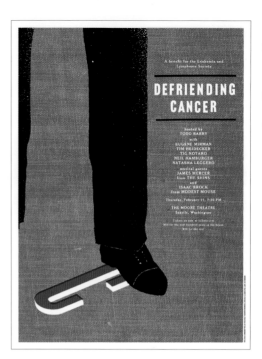

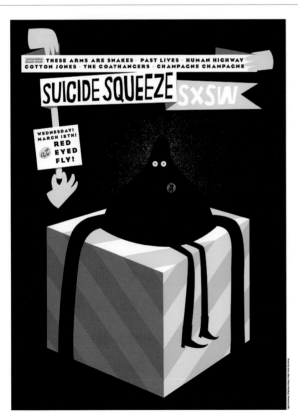

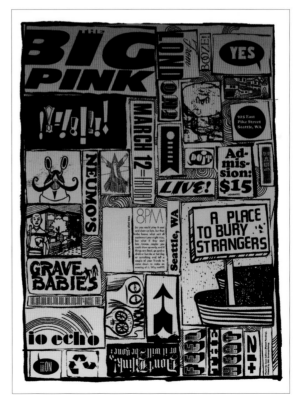

0921—0925 > PATENT PENDING DESIGN

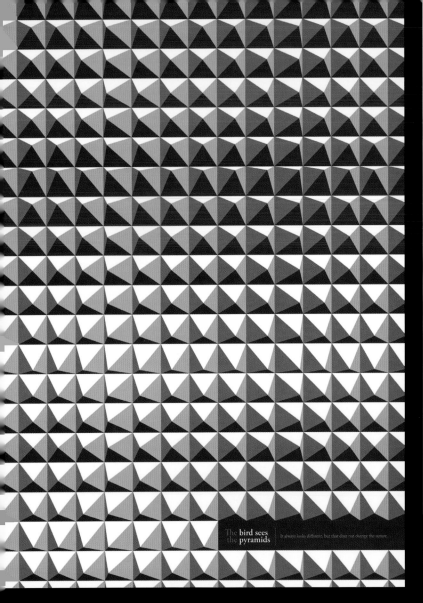

The bird sees the pyramids. It always looks different, but that does not change the nature.

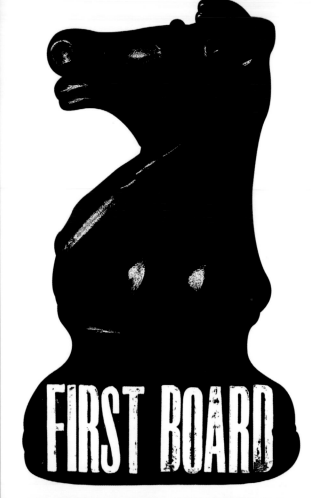

FIRST BOARD

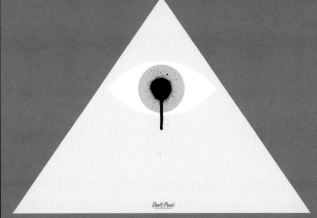

Don't Panic

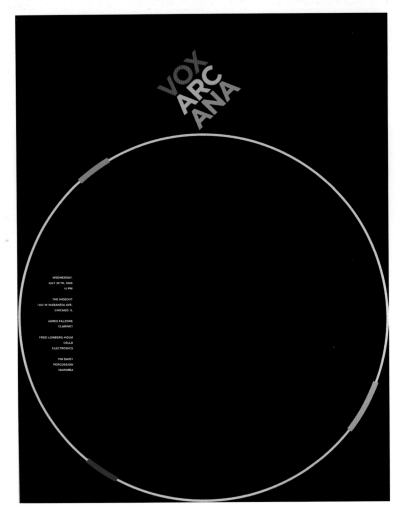

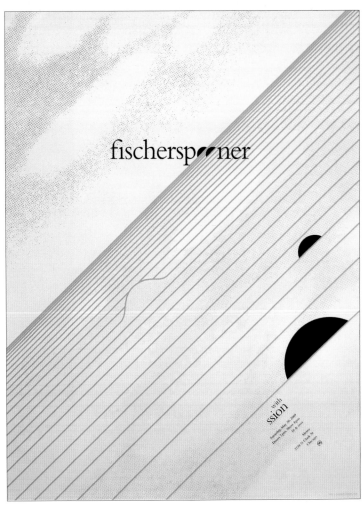

0929—0932 **> SONNENZIMMER**

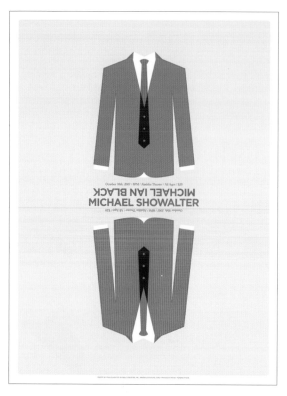

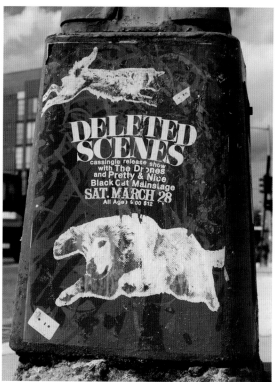

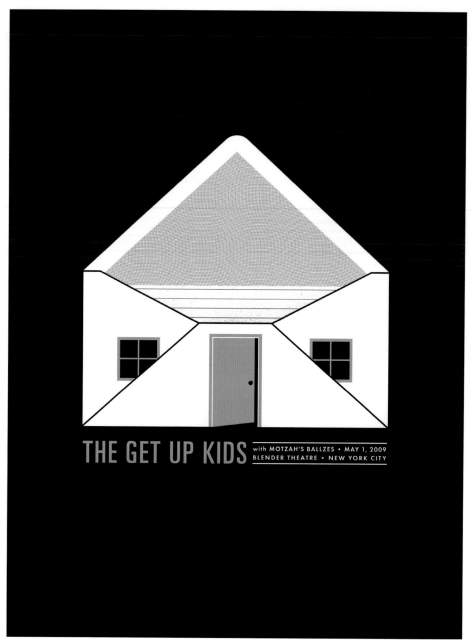

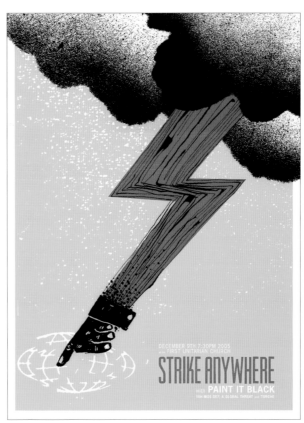

0936–0940 > TIM GOUGH

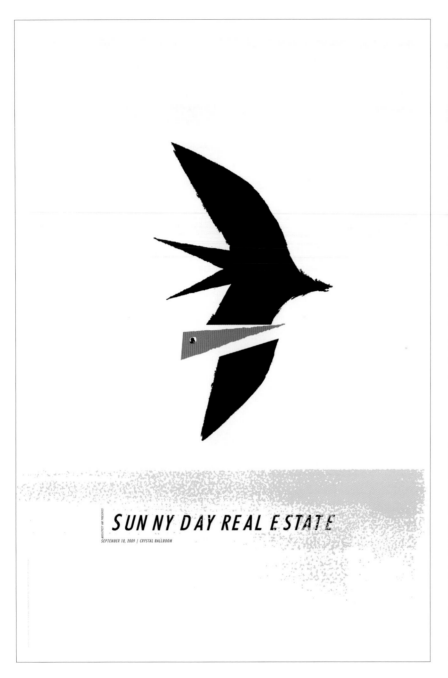

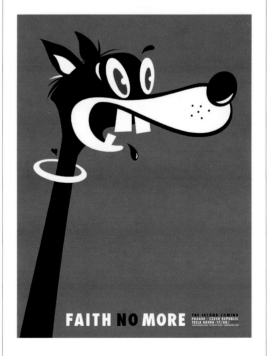

upper left 0941 > **PATENT PENDING DESIGN**
upper right 0942 > **CHRIS HENLEY**
bottom right 0943 > **TOOTH**

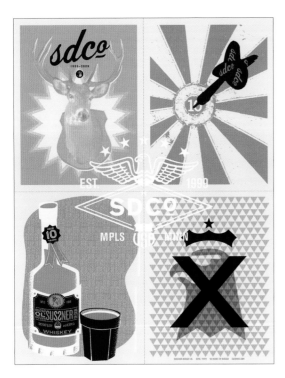

0944—0945 > SUSSNER DESIGN CO.

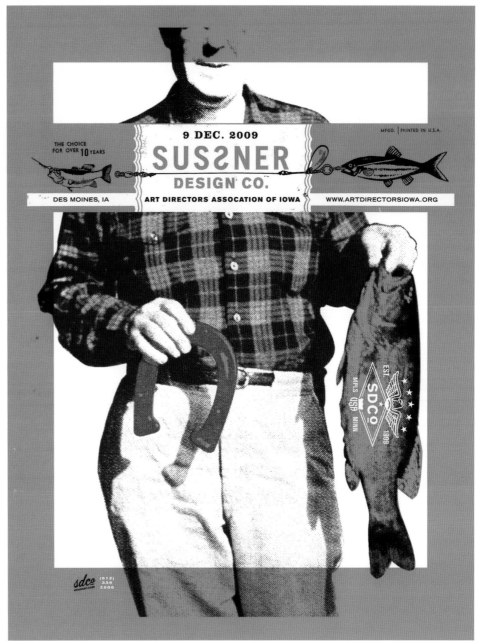

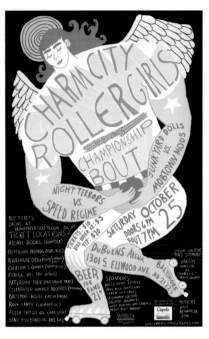

upper left 0946 > **ANA BENAROYA**

upper center 0947 > **ANA BENAROYA**

right 0948 > **DIRTY PICTURES**

bottom center 0949 > **DIRTY PICTURES**

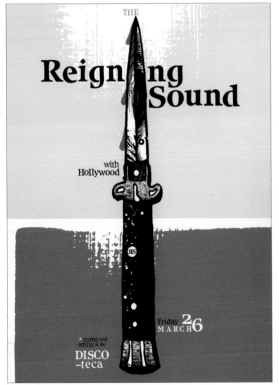

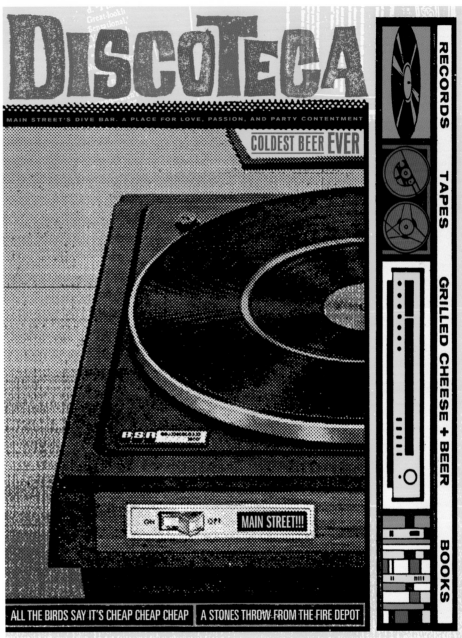

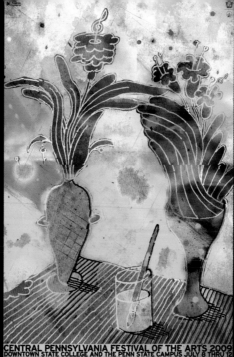

CENTRAL PENNSYLVANIA FESTIVAL OF THE ARTS 2009
DOWNTOWN STATE COLLEGE AND THE PENN STATE CAMPUS JULY 8 THRU 12

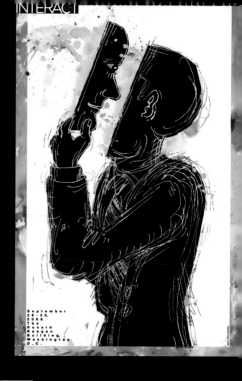

0953–0956 > LANNY SOMMESE

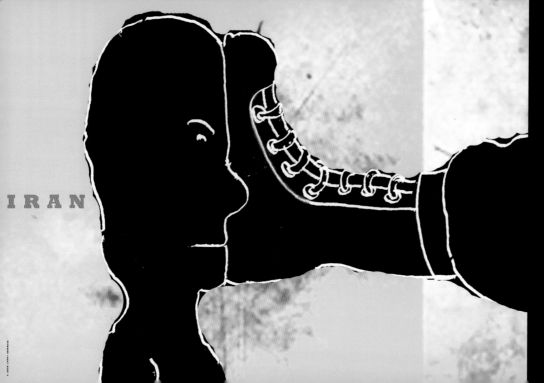

IRAN

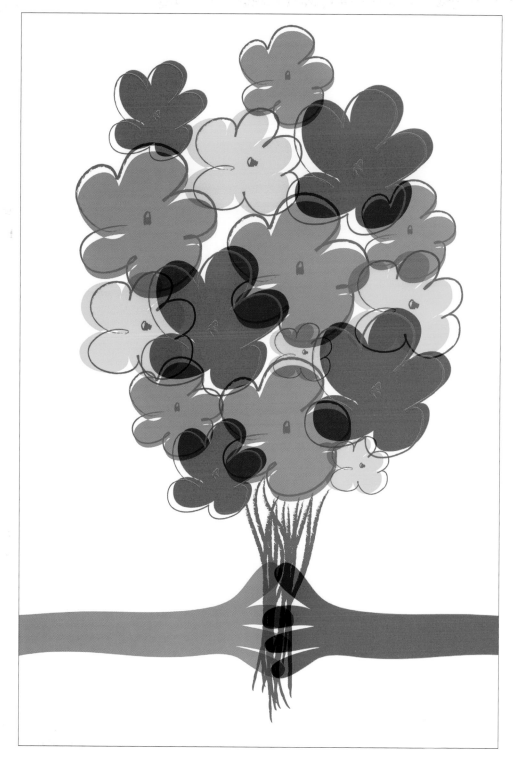

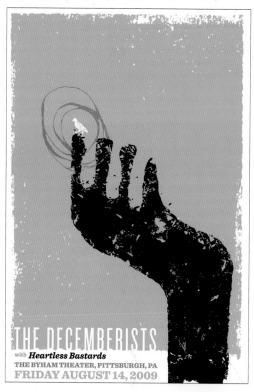

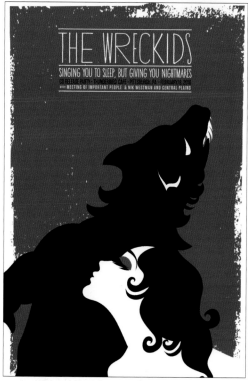

0957—0959 > **STRAWBERRYLUNA**

The **Mysterious Girl** *Lives on, Despite Changing Times*

0960–0962 > JOANNA WECHT

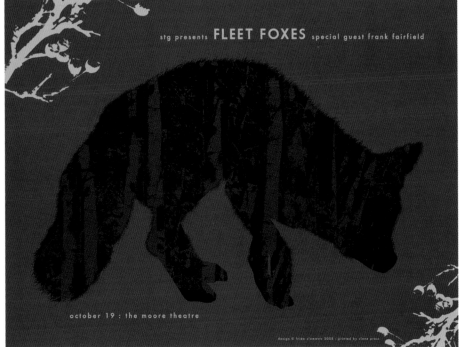

bottom left 0963 > **FRIDA CLEMENTS DESIGN**
upper left 0964 > **JOANNA WECHT**
upper right 0965 > **JOANNA WECHT**

THE TALLEST
MAN ON EARTH
& RED CORTEZ

4.15 - BOWERY BALLROOM - NYC

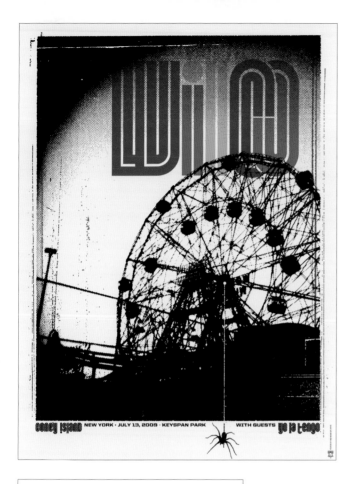

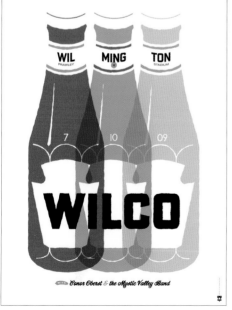

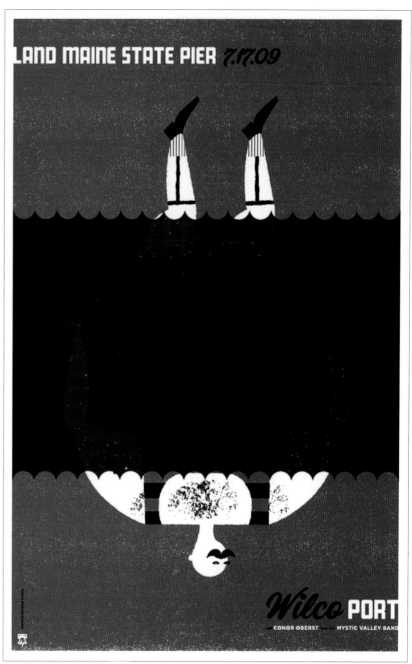

0966–0969 > THE HEADS OF STATE

0970–0973 > ANDY BABB

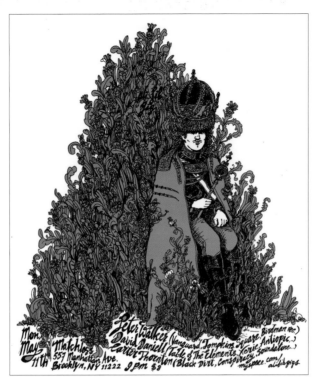

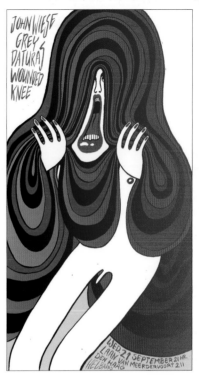

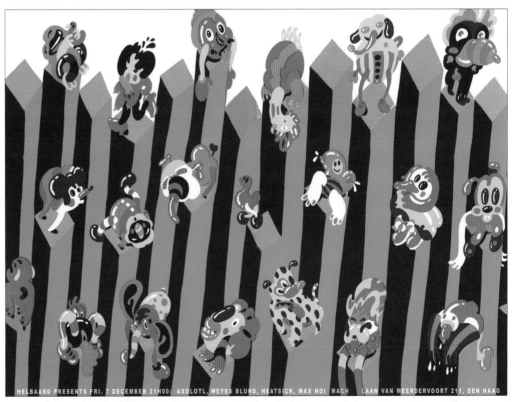

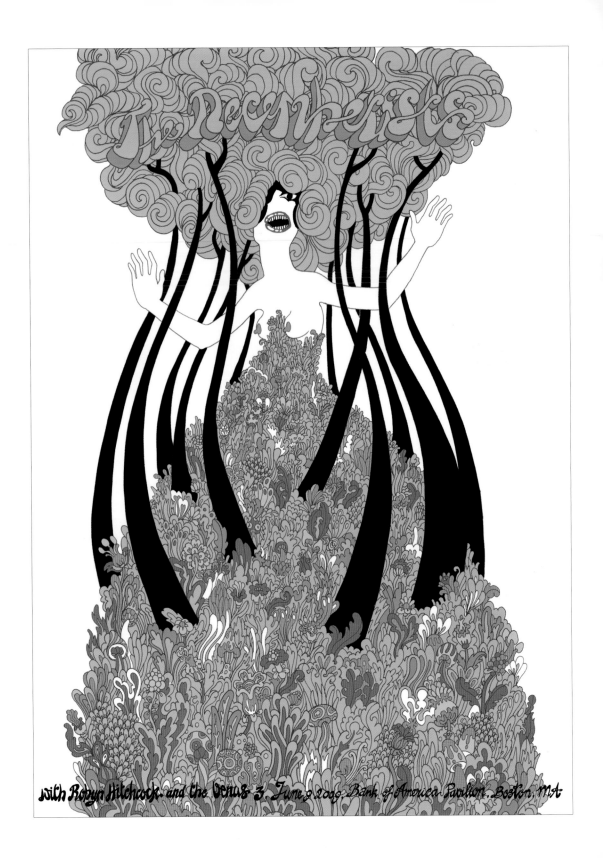

with Robyn Hitchcock and the Venus 3. June 9 2009. Bank of America Pavilion. Boston, MA

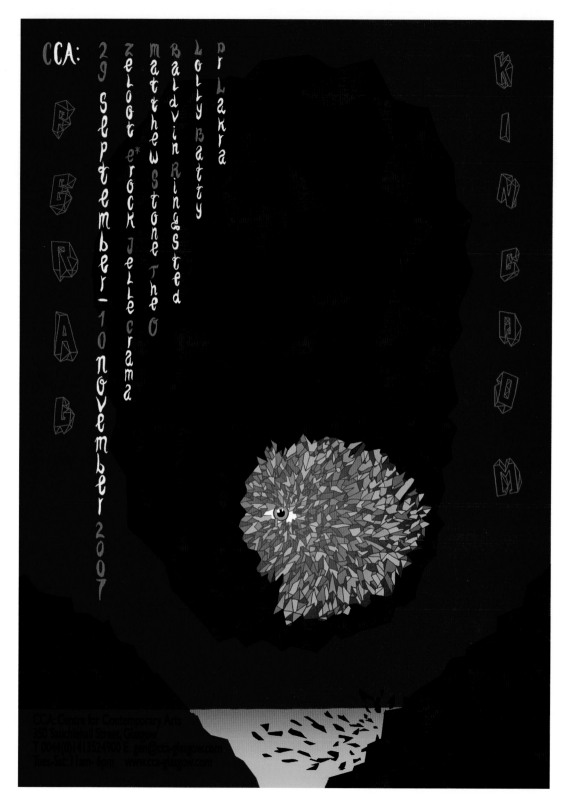

CCA:

29 September–10 November 2007

Zeloot e*rock Jelle crama
Matthewstone Theo
Baldvin Ringsted
Lolly Batty
pi2nra

FERAL

KINGDOM

CCA: Centre for Contemporary Arts
350 Sauchiehall Street, Glasgow
T 0044(0)141 352 4900 E gen@cca-glasgow.com
Tues-Sat: 11am–6pm www.cca-glasgow.com

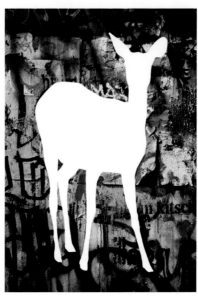

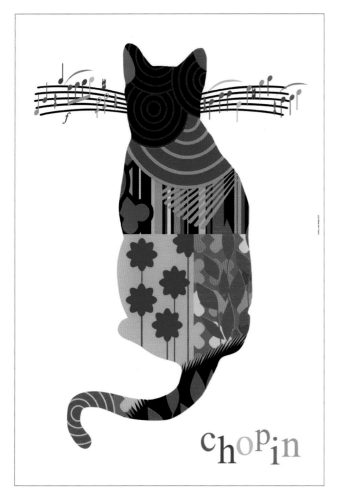

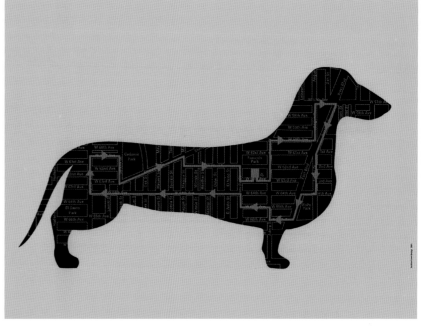

0988—0991 > NODIVISION

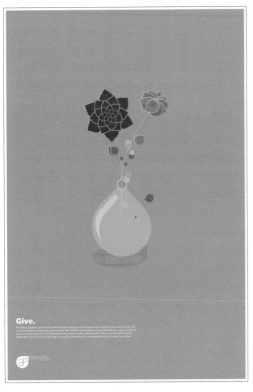

Give.

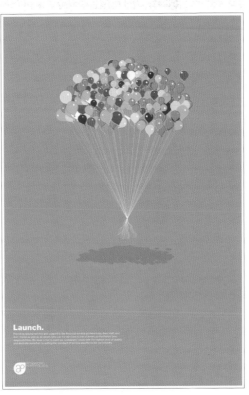

Launch.

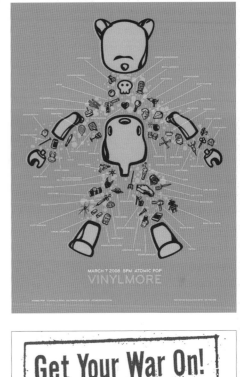

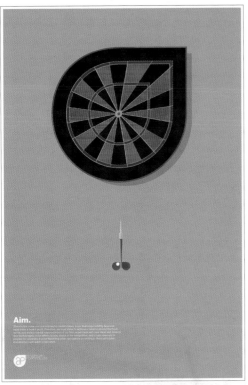

Aim.

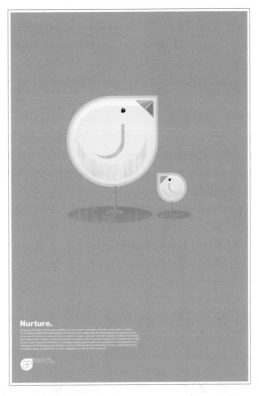

Nurture.

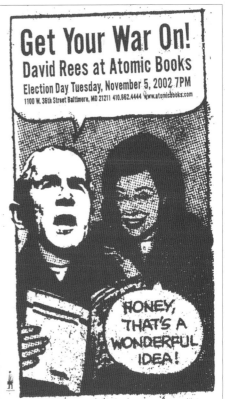

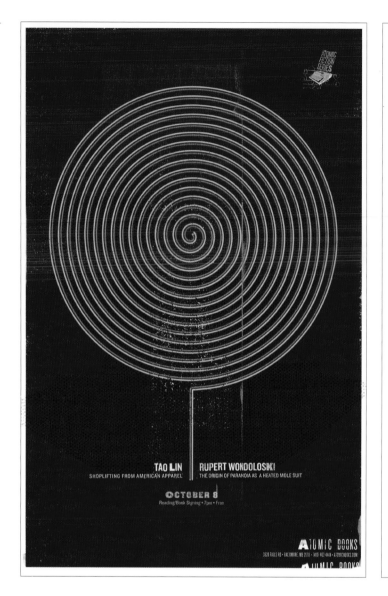

I have been influenced by my father telling me that my back would become crooked because of my maniacal desire to masturbate ; by reading "Gloryosky Zero" in Annie Rooney; by listening to Uncle Don and Clifford Brown; by smelling the burnt shell powder at Anzio and Salerno; torching for my ex-wife; giving money to Moondog as he played the upturned pails around the corner from Hansen's at 51st and Broadway; getting hot looking at Popeye and Toots and Casper and Chris Crustie years ago; hearing stories about a pill they can put in the gas tank with water but the "big" companies won't let it out—the same big companies that have the tire that lasts forever; and the Viper's favorite fantasy: "Marijuana could be legal, but the big liquor companies won't let it happen"; Harry James has cancer on his lip; Dinah Shore has a colored baby; Irving Berlin didn't write all those songs, he's got some guy locked in the closet; colored people have a special odor. I am influenced by every second of my waking hour. *Lenny Bruce, 1960*

CONTRIBUTOR INDEX

THE HEADS OF STATE
www.theheadsofstate.com
0166–0169, 0236–0243, 0298–0302,
0499, 0748–0751, 0966–0969

HENDERSONBROMSTEADART
www.hendersonbromsteadart.com
0533, 0699–0710

CHRIS HENLEY
www.24exp.co.uk
0373, 0378, 0942

HERO DESIGN
www.heroandsound.com
0118, 0288, 0291, 0572–0575

HOAX
www.hoaxhoaxhoax.com
0303–0308

ZACH HOBBS
www.weareyoungmonster.com
0470–0479

BENNETT HOLZWORTH
www.typebpress.com
0114, 0271

HOMEWORK
www.homework.com.pl
0144–0147, 0417, 0578–0583,
0901–0905

HORT
www.hort.org.uk
0330, 0616–0617, 0798, 0837–0848

HUIZAR 1984
www.huizar1984.com
0527, 0530, 0711–0714

INVISIBLE CREATURE
www.invisiblecreature.com
0076–0080, 0556–0558,
0739–0741, 0934

JEWBOY CORPORATION
www.jewboy.co.il
0908–0918

ADRIAN JOHNSON
www.adrianjohnson.co.uk
0536–0539, 0857–0858

VHAN KIM
www.vhan-artwork.com
0926

JEFF KLEINSMITH DESIGN
www.jeffkleinsmith.com
0672

LARGEMAMMAL
www.largemammalprint.com
0014–0016, 0482

YANN LEGENDRE
www.yannlegendre.com
0127–0128, 0172–0183,
0692–0693, 0906–0907

RON LIBERTI
www.ronliberti.awwwesome.com
0521–0523

THE LITTLE FRIENDS OF PRINTMAKING
www.thelittlefriendsofprintmaking.com
0202–0203, 0317, 0593–0596,
0752–0755

LUCKY BUNNY COMMUNICATIONS
www.luckybunny.net
0270, 0272

LUBA LUKOVA
www.lukova.net
0170–0171, 0819–0826

LURE
www.luredesigninc.com
0681–0685

METHANE STUDIOS
www.methanestudios.com
0139, 0322–0323, 0495, 0882–0884

MISS AMY JO
www.missamyjo.com
0196–0201

MODERN DOG DESIGN CO.
www.moderndog.com
0364–0369, 0890–0893

ERICK MONTES
www.thedecoderring.com
0124–0126

MORNING BREATH INC.
www.morningbreathinc.com
0185–0188, 0346, 0673–0674,
0676, 0850

MOTHERBIRD
www.motherbird.com.au
0636, 0640–0653

JEN MUSSARI
www.jenmussari.com
0135–0138

MY ASSOCIATE CORNELIUS
www.myassociatecornelius.com
0044–0046, 0343, 0552–0555,
0935

SUSSNER DESIGN CO.

www.sussner.com

0598–0602, 0715, 0717, 0944–0945

TEENBEAT GRAPHICA

www.mmarkk.com

0852–0856

TOOTH

www.ramenroyale.com

0155–0158, 0943

PAULA TROXLER

www.paulatroxler.com

0394–0398, 0524–0526

JAY VOLLMAR

www.jayvollmar.com

0505–0509

JOANNA WECHT

www.joannawecht.com

0540–0542, 0545, 0960–0962, 0964–0965

WERNER DESIGN WERKS

www.wdw.com

0349, 0589, 0762–0763

WINK, INC.

www.wink-mpls.com

0764–0770, 0860–0861

YEE-HAW INDUSTRIES

www.yeehawindustries.com

0065–0075, 0590, 0794

ZELOOT

www.zeloot.nl

0034–0036, 0497–0498, 0974–0978

ZWÖLF

www.zwoelf.net

0452–0457, 0459–0460

ABOUT

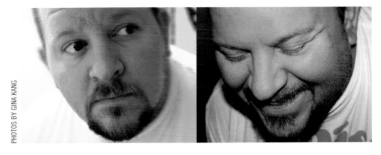

PHOTOS BY GINA KANG

About the Author

John Foster is a designer and writer in Washington, D.C, as the principal and superintendent of Bad People Good Things LLC. He is the author of *Dirty Fingernails: A One-of-a-Kind Collection of Graphics Uniquely Designed by Hand* (Rockport), *For Sale: Over 200 Innovative Solutions in Packaging Design* (HOW Books), *New Masters of Poster Design* (Rockport), *Maximum Page Design* (HOW Books), as well as an upcoming monograph on the work of Jeff Kleinsmith for Sub Pop Records. He writes a weekly column on music packaging, "Judging a Cover by Its Cover," for brightestyoungthings.com, and he performs musically under the guise of Sad Crocodile. He is an international speaker on design issues and has appeared several times at the world's largest design gathering, the HOW Design Conference. His work has appeared in every major industry publication, and he is the proud recipient of a Gold Medal from the Art Directors Club of Metropolitan Washington and a Best in Show from the ADDYs. His work has been shown in galleries all over the globe and is also a part of the Smithsonian's permanent collection. Foster resides in Maryland with his lovely wife and daughter and two of the world's goofiest foxhounds.

Special Thanks:

Thanks to my enormous and ever-growing family, especially my wife, Suzanne, and amazing daughter, Lily! My talented intern Gina Kang. Winnie Prentiss, Mary Ann Hall, David Martinell, Betsy Gammons, Cora Hawks, and everyone at Rockport Publishers. Svetlana Legetic, Cale Charney, and everyone at BYT. Clive Solomon and James Nicholls at Fire Records, my old friends Bill Vierbuchen, Dave Bradbury, Chad Lafley, Rich Westbrook, and many more I am forgetting—you all have a sloppy kiss accompanied by beard burn in your immediate future. You can't make a book like this without a cadre of talented designers to draw on—so thank you to everyone included in this collection. I adore you all.

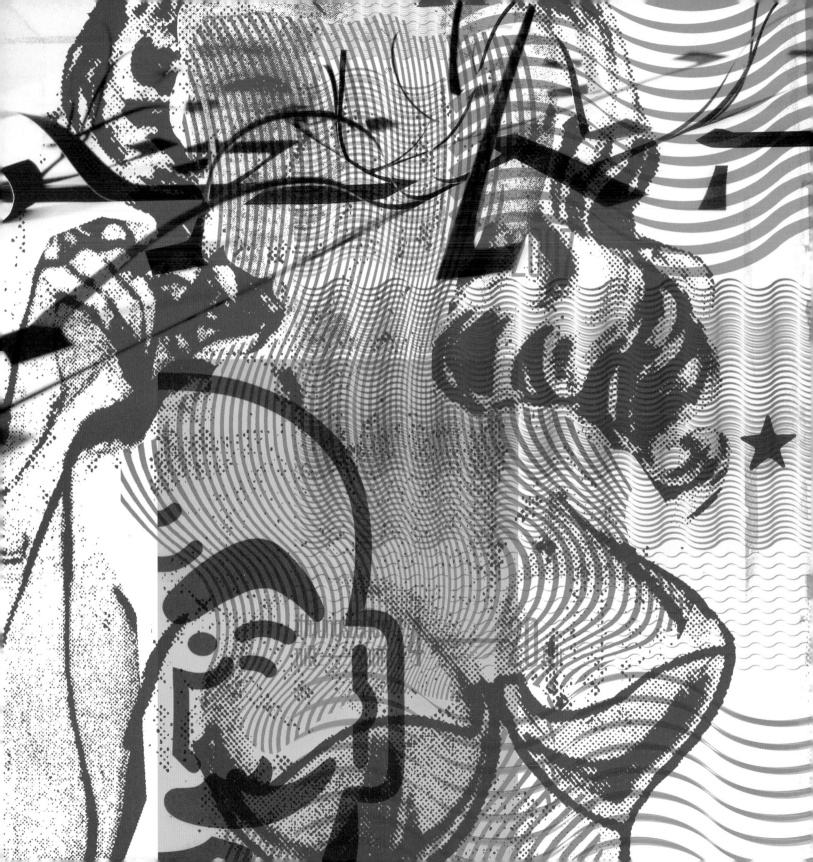